10051567

WITHDRAWN
759.13 DE k

KU-526-718

WILLEM
DE KOONING

THE LATE PAINTINGS, THE 1980s

SAN FRANCISCO MUSEUM OF MODERN ART

WALKER ART CENTER, MINNEAPOLIS

DIRECTORS' FOREWORD

Willem de Kooning is admired as one of the great painters of the twentieth century, and the achievements of his remarkable artistic career — one spanning more than sixty years of activity — have been the subject of numerous museum exhibitions. None of these exhibitions, however, has thoroughly examined the final body of de Kooning's work: his paintings from the 1980s, which represent a coherent and distinguishable period in his career. With this exhibition the public will have its first opportunity to view, firsthand and in depth, this final decade of de Kooning's work and to appraise it in the context of a serious scholarly examination.

Embracing the style and spirit of Matisse's own late, lyrical paper cutouts, de Kooning added another artistic dimension to that of his five-decade-long engagement with Cubism and in the 1980s produced his most freely conceived, fluid compositions. These works, which are concerned with painting in its purest sense and with the notion of abstraction at its highest level, allow images and forms, gestures and materials, to speak for themselves. Reflecting de Kooning's roots in Abstract Expressionism, they fuse technical mastery with the freedom of the subconscious and possess, in addition to an incredible beauty, a highly sophisticated aesthetic sensibility. It is a body of work that further marks a distinct and extremely contemporary chapter in the unfolding development of modernist innovation.

Yet questions have been raised in a number of quarters about these paintings in light of the diagnosis at the end of the decade that de Kooning was suffering from Alzheimer's disease. The complexity of this issue is addressed at length in the essays in this catalogue, where scrupulous attention has been paid to studio practices, the chronology of the paintings, and medical assessments. The research that has formed the basis of this volume and the resulting consideration given to the manifold factors that contributed to the making of these works should help to clarify the arguments and judgments that have been brought to bear on them. Against the critical background provided by these essays, it may be possible to see the paintings themselves with renewed clarity and to appreciate the discipline and command of the creative process summoned by de Kooning in their realization.

Willem de Kooning: The Late Paintings, The 1980s was organized collaboratively by the San Francisco Museum of Modern Art and the Walker Art Center, Minneapolis. The exhibition was conceived more than three years ago by Gary Garrels, former senior curator at the Walker and now Elise S. Haas chief curator and curator of painting and sculpture at SFMOMA, and by the late John Caldwell, SFMOMA curator of painting and sculpture. We thank Garrels for carrying this project forward alone on behalf of the partnership of our two institutions. We wish especially to acknowledge the assiduity with which he has addressed the complex issues raised by de Kooning's late work and the deep feeling for the paintings that have accompanied his organizational endeavors.

Robert Storr, curator of painting and sculpture at the Museum of Modern Art, New York, joined Garrels in researching the studio practices that accompanied the making of de Kooning's late paintings. We offer our warm appreciation to both authors for the resulting essays that inform this catalogue and illuminate the work. We thank as well the members of the publication team: at the San Francisco Museum of Modern Art, Eugenie Candau, librarian, who compiled the bibliography; John Losito, curatorial assistant, who prepared the annotated checklist; and Kara Kirk, publications manager; at the Walker Art Center, Laurie Haycock Makela, design director, and Santiago Piedrafita, graphic designer; Michelle Piranio, projects manager; and Janet Jenkins, editor. At the Museum of Modern Art, thanks are also due to Alina Pellicer, assistant to Robert Storr, and to Jody Hauptman and Joan Pachner, research assistants.

Understanding the weight of our responsibility to make a highly discerning choice among the late de Kooning paintings to be sought for inclusion in this exhibition, we, along with Gary Garrels, asked a number of colleagues with special expertise in de Kooning's career and in the history of modern and contemporary painting to join us for a two-day examination of this specific body of de Kooning's work. It proved to be among the most exhilarating and enlightening art convocations that we have been privileged to enjoy and we offer our warmest thanks to Jasper Johns, New York; Richard Shiff, Effie Marie Cain Regents Chair in Art at the University of Texas, Austin; Robert Storr; and John Walsh, director of the J. Paul Getty Museum, Malibu, California.

We are deeply obliged to lenders to the exhibition for sharing their works of art and take this opportunity to make a grateful, special note of the collectors who have made fractional or promised gifts of late de Kooning paintings to our two museums: Peggy and Ralph Burnet to the Walker Art Center; Frances and John Bowes, Mimi and Peter Haas, Helen and Charles Schwab, and Phyllis Wattis to the San Francisco Museum of Modern Art.

Express thanks for their contributions to the organization of the exhibition are due to SFMOMA staff members Inge-Lise Eckmann, director of curatorial affairs; John Losito, curatorial assistant; Barbara Levine, exhibitions manager; Tina Garfinkel, head registrar; Jane Weisbin, associate registrar; Sandi Poindexter, assistant in the department of painting and sculpture; and Kent Roberts and the installation crew. At the Walker Art Center we thank staff members Richard Flood, chief curator; Siri Engberg, assistant curator and coordinator of the exhibition in Minneapolis; Gwen Bitz, registrar; Matthew Siegal, associate registrar; Howard Oransky, assistant to the director for program planning; and Cameron Zebrun and the exhibition crew.

We are very pleased that, in addition to San Francisco and Minneapolis, *Willem de Kooning: The Late Paintings, The 1980s* will be seen in Bonn, Rotterdam, and New York. We thank our colleagues at the following institutions for their interest in presenting the exhibition: at the Städtisches Kunstmuseum, Dieter Ronte, director, and Klaus Schrenk, deputy director; at the Museum Boymans-van Beuningen, Chris Dercon, director, and Karel Schampers, chief curator; and at the Museum of Modern Art, Glenn D. Lowry, director; Kirk Varnedoe, chief curator of painting and sculpture; Cora Rosevear, associate curator of painting and sculpture; and Robert Storr.

Willem de Kooning: The Late Paintings, The 1980s has enjoyed the full cooperation of Lisa de Kooning and John L. Eastman, Willem de Kooning's conservators, and we are enormously indebted to them for their support and belief in the project. We also sincerely appreciate the many contributions of the staff of the Willem de Kooning Conservatorship office — Roger Anthony, Jennifer Johnson, and Amy Schichtel — and of John Silberman, attorney.

We recognize with appreciation the studio assistants and friends of the artist who gave interviews and provided documents: Susan Brooke, Robert Chapman, Tom Ferrara, Conrad Fried, Antoinette Gay, Jennifer McLauchlen, and Joan Ward. Substantial assistance was kindly provided by James Demetrion, Neal Benezra, Judith Zilczer, and Phyllis Rosenzweig of the Hirshhorn Museum and Sculpture Garden. The Anthony d'Offay Gallery, London, and Matthew Marks Gallery, New York, were extremely helpful as well, and we offer Matthew Marks our special acknowledgment as an important friend of and counselor to this undertaking.

We wish to thank other individuals who were instrumental in assistance with loans for the exhibition, including Jeffrey Deitch, Julius Galacki, William Katz, Laura Carey Martin, Stephen Szczepanek, and Jennifer Wells. By necessity this presentation is limited to a relatively small number of the paintings by de Kooning from the 1980s, but in preparation for the exhibition Gary Garrels reviewed nearly every painting from the decade. Many collectors, galleries, and dealers provided crucial assistance in gaining access to these paintings and in opening their storage areas, viewing rooms, and homes to Garrels. We thank them for their cooperation, and especially wish to acknowledge Margo Leavin, Wendy Brandow, and Steve Henry of the Margo Leavin Gallery, Los Angeles; Paul Gray of the Richard Gray Gallery, Chicago; Doris Ammann of Thomas Ammann Fine Art, Zurich; Marc Glimcher and Susan Dunne of PaceWildenstein Gallery, New York; Robert Mnuchin of C & M Arts, New York; Vivian Horan; and Stephen Mazoh.

We are very grateful to the Modern Art Council of the San Francisco Museum of Modern Art, USL Capital, and Mimi and Peter Haas and Leanne and George Roberts of San Francisco for their very generous support of the exhibition and publication of this catalogue during the inaugural year of programs in the new San Francisco Museum of Modern Art.

KATHY HALBREICH
WALKER ART CENTER

JOHN R. LANE
SAN FRANCISCO MUSEUM OF MODERN ART

The San Francisco Museum of Modern Art is a privately funded, member-supported museum receiving major support from the San Francisco Publicity and Advertising Fund/Grants for the arts program and the National Endowment for the Arts, a Federal agency.

Major support for Walker Art Center programs is provided by the Minnesota State Arts Board through an appropriation by the Minnesota State Legislature; the National Endowment for the Arts; the Lila Wallace-Reader's Digest Fund; The Bush Foundation; The McKnight Foundation; Target Stores, Dayton's, and Mervyn's by the Dayton Hudson Foundation; the Northwest Area Foundation; the General Mills Foundation; the Institute of Museum Services; Burnet Realty; the American Express Minnesota Philanthropic Program; the Honeywell Foundation; Northwest Airlines, Inc.; The Regis Foundation; The St. Paul Companies, Inc.; the 3M Foundation; and the members of the Walker Art Center.

CONTENTS

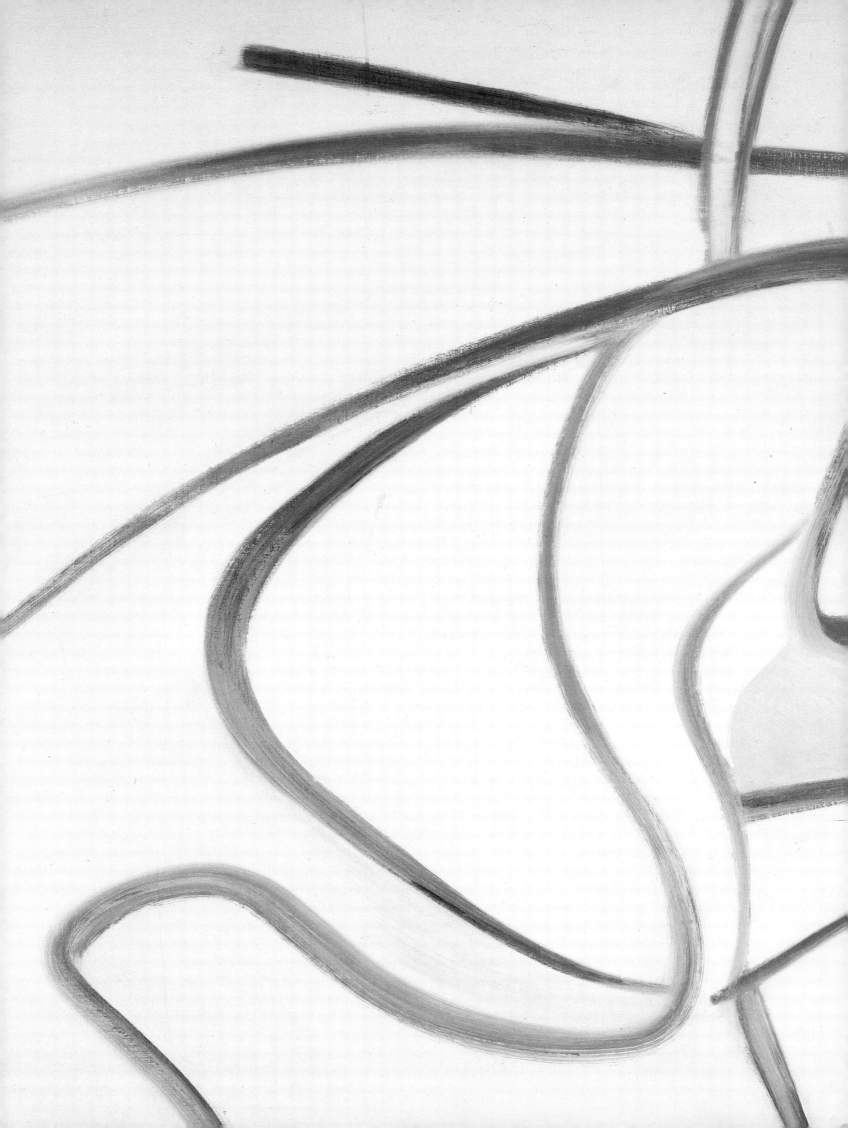

THREE TOADS IN THE GARDEN: LINE, COLOR, AND FORM

GARY GARRELS

I HAVE TO CHANGE TO STAY THE SAME. WILLEM DE KOONING[1]

In order to understand the paintings Willem de Kooning made in the 1980s, one must understand something of his work from throughout his career and, indeed, something of its essence. Yet de Kooning's works are among the most difficult of any artist's to contain with analytic linearity, to define by category, to reduce to simplifying generalization. Throughout his career, de Kooning periodically would reinvent himself, developing a new style that was seemingly removed from, even at odds with, what had immediately come before. Yet just as characteristically he would double back — taking something from his own past, recombining elements, altering but not abandoning techniques, changing but not rupturing his practice.

Usually gauged under the rubric of Abstract Expressionism, de Kooning's work may have fit this canon at best in a contingent fashion. He never relinquished his fascination with the human figure in favor of the strict imperatives of abstraction. And although nourished by American culture, he never turned his back on the centuries-old traditions of European art in which he was deeply rooted. With the schisms beween American and European art now inextricably blurred and the hegemonies balanced, and with the achievements of Abstract Expressionism securely recognized, perhaps it is less necessary to define so strictly the artists who came to prominence under its singular banner. De Kooning, precisely because of his restlessness and inventiveness, and because of the internal integrity and coherence of his work, is more than an exemplar of a particular movement; he is rather, simply and more importantly, one of the great artists of the twentieth century.

De Kooning had secured initial critical recognition with his first one-person exhibition in New York in 1948, in which he showed a series of original, forceful, and complex black-and-white abstractions (see, for example, fig. l).[2] He then gained the attention of the popular press and the general public with his third solo exhibition in 1953, in which his Woman paintings were first shown (see fig. 2).[3] To a great degree, it is these two bodies of work, from roughly a seven year period, that together continue to set the boundaries by which de Kooning's achievement is measured: the abstractions still are revered by a segment of the critical press as the artist's crowning effort, while the women define him in the popular mind.[4] Granting that these works are pivotal and among the greatest of de Kooning's career, a fixation on them — to the exclusion of other portions of the work — can undermine and distort an understanding of the overall endeavor and, indeed, can obscure the very nature of his art.

1. *Orestes*, 1947
enamel on paper on wood, 24 ⅛ x 36 ⅛ in.
Collection Thomas W. Weisel

Thomas Hess, one of de Kooning's first champions, organized a retrospective exhibition in 1968 at the Museum of Modern Art in New York in which he attempted to give broader scope to the fits and starts, the eruptions, the sheer volume of de Kooning's career and to bring some order to its permutations.[5] In his catalogue essay for that exhibition, Hess developed a typology of the paintings that provided an overview of the artist's work:

1. Early high-key color abstractions, 1934–1944.
2. Early figures (Men), 1935–1940.
3. Early figures (Women), 1938–1945.
4. Color abstractions, 1945–1950.
5. Largely black with white abstractions, 1945–1949.
6. Largely white with black abstractions, 1947–1949.
7. Women, series II, 1947–1949.
8. Women, series III, 1950–1955.
9. Abstract urban landscapes, 1955–1958.
10. Abstract parkway landscapes, 1957–1961.
11. Abstract pastoral landscapes, 1960–1963.
12. Women, series IV, 1960–1963.
13. Women, series V, since 1963.
14. Women in the country, since 1965.
15. Abstract countryside landscapes, since 1965.[6]

This typology remains most true to the nature of de Kooning's early and mid- career and the most suggestive of his career as a whole, recognizing as it does the overlaps and ambiguities of style and, in the richness of its attempt to categorize the work, revealing the difficulties. Yet it does not begin to cut through the densely intertwined relations that exist between the drawings and paintings throughout de Kooning's career. And it is able to describe only the visible, finished public works, not the stages of their individual gestations in which, to varying degrees, de Kooning many times would recapitulate his own evolutionary development.

At the time of the 1968 Museum of Modern Art retrospective, de Kooning was nearly sixty-five years old. But far from settling into a predictable pattern after this time, he continued for the next twenty years to add new phases to his development. Immediately on the heels of the retrospective, in 1969, he began an altogether new endeavor — making sculpture — that would become an important activity for the next five years.[7] Almost simultaneously, and with a concentration not seen before, he also took up printmaking, with which he remained involved until the early 1970s.[8] He continued to produce paintings during this time, in a very abstract style that retained figural and landscape references. In 1975, however, he

2. *Woman I*, 1950–1952
oil on canvas, 75 ⅞ x 58 in.
Collection The Museum of Modern Art, New York
Purchase

returned his full attention to painting, creating a large and extraordinarily rich and coherent body of predominantly abstract works, which he continued through the beginning of 1978, the year the Guggenheim Museum presented a survey of his East Hampton works.[9] And finally, in 1981, the first lyrical, spare abstractions began to emerge fully, establishing the style he would carry forward for the next several years, at the culmination of a sixty-year career.

While relatively few artists have lived to the advanced age de Kooning has attained, there have been enough, at least since the Renaissance, that in the 1920s art historians began to introduce the concept of *altersstil*, or "late style," to address issues common among artists who lived and continued to work into their seventies and eighties.[10] Some notice of de Kooning's late work, both from the 1970s and

1980s, has been made in relation to the concept of *altersstil*.[11] With regard to the paintings of the 1980s in particular, the most frequent comparison has been made to Matisse. David Sylvester, for example, has written that "the only late style to which [his paintings] of the 80s are really comparable is the highly specialized style of Matisse's papiers collés" (see p. 70, fig. 11).[12]

While Matisse may suggest the most ready comparison, there are other artists whose work should be considered as well. Examples of Monet's paintings from the last decade of his life, for instance — especially his series of Water Lilies (1917–1919) — exhibit a spareness and openness comparable to de Kooning's late paintings.[13] The last paintings of

Picasso, while distant in spirit from de Kooning's, also show an increasingly abstract and schematic character, a flattening of space, and a sometimes subtle blending or muddying of color.[14] Issues surrounding the very late style of artists remain relatively unexplored, however. The topic is one of extraordinary interest, and without question de Kooning's paintings of the 1980s will prove to be one of the crucial bodies of work to be considered. The critical first step in this regard is to set forth these works in as complete a manner as is possible and to begin the task of understanding them.

Until now, the 1980s paintings have been seen only in a handful of gallery exhibitions or in the context of large museum surveys that have included small numbers of the works.[15] Judgments of their merits, therefore, necessarily have been based on limited examples or, more often, on reproductions. But the distinguishing qualities of these paintings — as much if not more so than any of de Kooning's previous work — cannot be conveyed by photographic documentation in any adequate way. And while some serious critical assessments have been made, it has been extremely difficult, given the paucity of examples available for public view, to trace the development of work within any given year or, more importantly, to investigate the degree to which the paintings of the 1980s differ year by year.[16]

Most of the commentary on the late paintings, in fact, has been limited to journalistic discussions in newspapers and magazines or on television. In many cases these reports, often speculative and supported by negligible research, have been based on gossip and rumor. Testimonials regarding de Kooning's personal affairs and physical condition, necessarily shaped by subjective assessments, frequently substitute as critical analysis of the work itself. Any such sources, of course, should be approached with great caution.[17]

The present exhibition, in an attempt to correct these representations, affords the first full-scale overview of de Kooning's paintings from the 1980s. To prepare its contents and focus, the first efforts at critical research around this work have been initiated. It is my hope in displaying a central core of representative paintings from this decade that the stylistic shifts that occurred over a several-year period will be revealed and that, at last, an informed and considered view of the work may begin to be constructed. Avoiding a didactic approach, the exhibition does not attempt to delineate fully the transitions or boundaries between the paintings or to illustrate all the variations between the works. It is far from an exhaustive survey. There remain a large number of canvases that are equal in quality to those included here. Works have been selected both for their individual character and as they begin to suggest comparisons and contrasts when seen together. My aim, in brief, has been to lay the groundwork that may establish this last decade of de Kooning's work as an essential one in his career and one that must be fully integrated within any consideration of his overall achievement.

To begin to trace the accomplishments of this decade, it is useful to set them in relief against the conditions that prevailed in de Kooning's career during the years that immediately preceded. For prior to this final productive phase in his artistic development, de Kooning struggled through a period of difficult transition. The end of the 1970s had brought significant changes to the artist's personal life. His bouts with alcohol had been legendary since the days of the Cedar Tavern scene in New York in the 1950s; by the mid-1970s, however, friends had become deeply concerned about the weeks-long binges that would result in blackouts, about his neglect of eating, and about the general deterioration of his health.[18] His condition particularly worsened in 1978. In that year his wife, the painter and writer Elaine de Kooning, from whom he had separated in the mid-1950s, moved to East Hampton to a nearby house and set about to wean the artist from alcohol and to bring a better level of daily care to his life. Due largely to her efforts, by 1980 de Kooning stopped drinking almost completely.

3. *Untitled II*, 1979 or 1980
oil on canvas, 77 x 88 in.
Collection the artist

During this transitional period, de Kooning suffered violent mood swings, depressions, and periods of lethargy — the results of his withdrawal from alcohol. He also came to feel that he had reached a closure after the prodigious period of painting from 1975 to 1977, announcing that his way of working at this time had become "almost a habit."[19] As Hess's typology suggests, this kind of cyclical reassessment was not aberrant for de Kooning; it was characteristic of his entire career. But there were acute differences that distinguish this moment from others when the artist's work was shifting. He had stopped the drinking that had played a large role in his life, certainly since the early 1950s; Elaine (who had been a significant presence from 1937 through the mid-1950s) returned, bringing a new stability and a linkage back to the early years of his career; and, most

elusively but perhaps most significantly, he was beginning to sense the advent of old age and an awareness of his own mortality.

It was not an easy adjustment and, unlike other times in his life when a new subject or approach to his painting would have been taken up more readily, de Kooning labored to move forward. Renowned in the past for his almost complete absorption in his work, he now would paint or draw only intermittently. From 1978 to 1980 he struggled to continue painting, but without the momentum of the immediately preceding years. By all accounts, however, when he did work on a canvas, his concentration was focused and intense.[20] The paintings he produced continued to be linked to those from the previous

4. *Untitled XIV*, 1980
oil on canvas, 80 x 70 in.
Collection the artist

three years, but now they began to exhibit more fluidity and openness, with the density and overall chromatic intensity beginning to lighten. His use of a scraper, which had been a common tool in his work since the 1940s, became pronounced again as he pared back the thickness of the surfaces and created ribbonlike effects, accelerating the feeling of movement across the canvas (figs. 3, 4).

Given his dilatory interest in working, however, there was increasing concern about whether de Kooning might not give up painting altogether. In 1979 Elaine, along with her brother Conrad Fried, whom de Kooning also had known since the 1930s, decided on steps they hoped might reengage the artist with his work. A

previous assistant left and a new assistant, Tom Ferrara, who had been working with Elaine, began to help in de Kooning's studio. The two developed a warm working relationship, and by the fall of 1980 Ferrara shifted solely to working with de Kooning.

An attempt was made to bring greater order to the studio. A more systematic inventory of works was begun. An enormous quantity of paint was ordered.[21] More sophisticated, keyed stretchers by Lebron Brothers began to be used for the canvases.[22] An important change was the decision to add a layer of foam-core board behind the canvas, which would allow the artist to apply more pressure to the surface as he was working. Ferrara noted in 1980 that de Kooning, who was beginning to suffer from back problems, was finding it increasingly difficult to turn his large canvases as he was working on them.[23] Fried

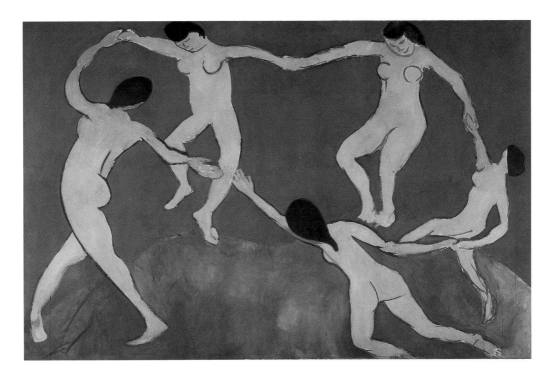

5. Henri Matisse, *Dance (first version)*, March 1909
oil on canvas, 102 ½ x 108 ½ in.
Collection The Museum of Modern Art, New York
Gift of Nelson A. Rockefeller in honor of Alfred H. Barr, Jr.

and Ferrara devised an easel with a system of clamps and an axle that would allow the artist to turn and to raise or lower the canvas mechanically. This was later adapted so that it could be controlled electrically with a switch.

De Kooning produced relatively little work beween 1978 and 1980, and of the paintings that were made during this time only a small number were kept — fewer than a dozen in each of those years.[24] In 1980 his production was particularly scant. Three paintings — *Untitled I*, *Untitled II* (fig. 3), and *Untitled III* — were dated to that year by Xavier Fourcade, de Kooning's dealer, but according to Ferrara's memory they actually had been painted in 1979. One painting, *Untitled XIV* (fig. 4), dated by Fourcade to 1981, can be identified clearly by photographs taken in the studio as a painting from 1980.[25] With these changes to the previously recorded dating, only three large-scale works (each seventy by eighty inches) and three smaller-scale works (sixty by fifty-six inches or fifty-four by sixty inches) can with confidence be dated to that year.

This period of change in the artist's physical condition and in the organization of the studio also coincided with a shift in his aesthetic interest. Since the 1930s de Kooning had consistently measured himself in relation to Picasso.[26] He had been deeply influenced as well by Cézanne and by what he discerned in Cézanne's painting as a way of working for a "fitting-in," a tightly interworked linking of surface and form, gesture and line. But according to many sources, by the early 1980s de Kooning's interest had shifted to Matisse. Tom Ferrara recalls that de Kooning would refer often to Matisse's *Dance* (1909, fig. 5), making a gesture with his hand as he gently waved upward to evoke the rhythm and freedom of movement in the painting.[27] This shift in

focus may have been related in part to de Kooning's awareness of his increasing age. Ferrara recalls that the artist, celebrating his seventy-fifth birthday in April 1979, was aware that he had only a limited time left in his life, a limited time to paint, but that he was not troubled by this recognition.[28]

By very early 1981 de Kooning began to work more steadily and with much greater regularity. By this time he had been completely freed from alcohol. He was no longer taking antidepressants, and the mood swings and lethargy that were the residue of his alcohol withdrawal had subsided. The first paintings to be finished that year, *Untitled I*, *Pirate* (*Untitled II*), and *Untitled III* (pls. 1–3), make a full break with the style of the prior decade. The lush paint application typical of the 1970s, which began to be pared away in the paintings of 1979 and 1980, has here given way to an overall, even, and generally flat surface in which sanding, scraping, and thin layers of glazelike paint become notable for the effects of transparency and lucidity they impart. A subtle counterpoint between matte and reflective surfaces is exploited, a stronger sense of form emerges, and the structure of the overall composition is more fully articulated. Drawing and painting are entirely integrated — the parity between the two now joining in the service of the whole. The palette has been simplified, and primary colors (red, yellow, and blue) dominate, with complementary colors (orange, green, and violet) the occasional counterpoints. In these paintings neither image nor the substance of paint itself, so often the salient attractions of de Kooning's paintings, prevails. Instead, color, light, and the weave of forms across and against the surface absorb the viewer's attention. In his own inimitable way, de Kooning once declared: "There are three toads at the bottom of my garden, Line, Color, and Form."[29] With the paintings of the 1980s, these toads were brought to full light. De Kooning created a garden at the height of summer bloom.

All the characteristics noted above define the paintings of the 1980s as a coherent period, distinguished from any prior work yet calling upon the lessons of the preceding fifty years. They announce a period of renewed activity pursued with intense vigor, sustained attention, and increased production that would last for several years until failing health would begin to attenuate and diminish this last great efflorescence.

It is important to recognize, however, that the works of this decade are not interchangeable from beginning to end. Within the ten-year span one can trace from year to year a continuing development in working method and style that yields a subtly shifting, diverse range of work. Some of the paintings from the 1980s recall de Kooning's lyrical, subdued works from the late 1930s and early 1940s. An especially apt comparison can be made between such paintings from this period as *Elegy* (c. 1939, fig. 6) and *The Wave* (c. 1942–1944, fig. 7) and the later *Untitled XIII* (1985, pl. 27) or an untitled painting from 1984 (pl. 23). In these earlier works, just as in the paintings of the 1980s, the remnants of the pentimenti have been reduced for the most part to almost indiscernible traces, and the relationship between drawing and painting has been inseparably fused. The simplification of form, the uninterrupted flow and contour of line, the large areas of color, sometimes subtly bled and modulated, are recalled directly in the paintings of the late period.

Others of the 1980s paintings evoke the animated and layered abstractions of the mid- and late 1940s (compare fig. 12 and pl. 14). And as a whole they share much with the landscapes of the late 1950s. Marla Prather captures this affinity in her description of these earlier works:

Color was pared down to a few hues, and the diminished number of strokes was countered by an enlargement of their scale. . . . Though these paintings reveal considerable evidence of scraping, they did not evolve through the repeated cancellations and revisions of earlier work. The immediacy of the initial gesture is retained, and the unified images that result can be apprehended in a single glance. These compositions were among de Kooning's leanest before the 1980s. A statement he made in 1959 — "It seems that a lot of artists, when they get older they get simpler" — would be a refrain for years to come.[30]

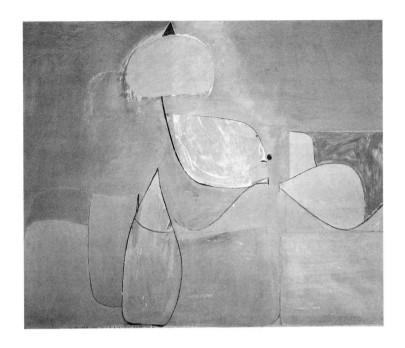

6. *Elegy*, c. 1939
oil and charcoal on composition board
40 ¼ x 47 ⅞ in.
Private collection

7. *The Wave*, c. 1942–1944
oil on fiberboard, 48 x 48 in.
National Museum of American Art,
Smithsonian Institution, Washington, D.C.
Gift from the Vincent Melzac Collection

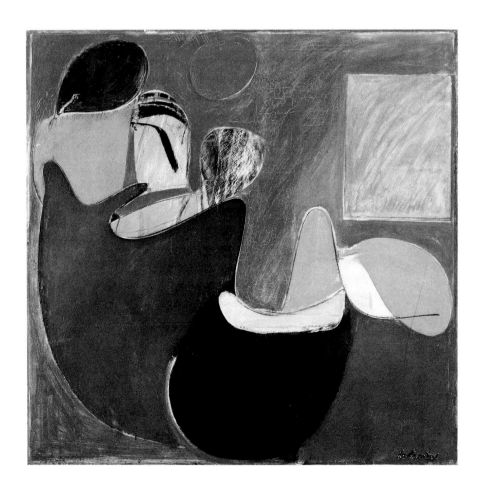

The stylistic and formal relationships between the paintings of the 1980s and de Kooning's prior work, however, are not limited to particular periods but are as manifold and fissured as his practice in general. Many of the 1980s paintings, for example, are characterized by looping and stylized linear gestures, which resemble alphabetlike forms. These Richard Shiff securely traces back to works from the 1960s: "Many of the women, especially in drawings, appear in a configuration that renders vulva, anus, and buttocks all visible. In both drawings and oil paintings, the configuration in question can readily be recognized as a bold, thick stroke (or set of strokes) in the form of a curving **W**; sometimes it will look more like an **M** or like a **J** back to back with its mirror image."[31] These forms, retained as a favored motif, are clearly evident in late works such as *Morning: The Springs (Untitled I)* (1983, pl. 13) and others.[32] Harry Gaugh had earlier noted this practice of recycling forms when he wrote that "elements from his earlier work slip in and out. The splayed **V**, accordianlike zigzag, priapic triangle, double prong, and baggy loop reappear, usually fuller in form and less acerbic than in younger days."[33] Gaugh, however, evokes such works from the 1950s as *Gotham News* (1955–1956) as a source for these forms. But just as surely, again, they can be deciphered in works from the early 1940s and throughout that decade as well. In 1959, at a relatively early point in de Kooning's career, Hess observed:

Throughout his career de Kooning has invented, enlarged and perfected an extraordinary repertory of shapes, some simple, some complex, and in the work of inventing and perfecting them he has gone back continuously to older shapes, re-creating new ones from them, as if he were impelled to bring a whole life's work into each section of each new picture. One is reminded of *delectatio morosa*, the temptation to which medieval monks were susceptible, an obsession that comes from a profound and sustained concentration on recurring forms and ideas — the idea becomes a part of the thinker's body; he returns to it over and over again.[34]

But as much as de Kooning's painting extends the forms of the body, it is grounded no less in landscape. Formal reverberations again extend back from the 1980s to prior decades. The black-and-white abstractions of the late 1940s have been likened to "urban nocturnes" with their "interplay of shadow and daylight in urban space."[35] The paintings of the late 1950s have long been associated with a variety of landscapes—those from the mid-1950s described again as urban, from the later 1950s as parkways, and from the early 1960s as pastoral.[36] Hess described the early 1960s paintings as images that had moved to the countryside itself, "the summer Long Island country: very flat and sunny — green grass, yellow beach, green water, blue sky, powdery brown earth."[37] Shiff, in his focus on the paintings of the 1960s, eloquently describes the indissoluble link between these works and the specific landscape of Louse Point, near de Kooning's studio in Springs, on eastern Long Island, where the artist would bicycle every day: "Louse Point, a narrow, curving peninsula marking an uncertain boundary between inlet and ocean, sheltered enclosure and extended openness." In his painting, Shiff conjectures, perhaps "de Kooning was responding to the satisfying linear edge where water meets sky, or to the finely articulated contrast between the qualities of color or of light reflected back by the two different mediums. He may also have been absorbed by the way light slips or glides along water — light floating like oil on water."[38]

In their abstractness, the paintings of the 1980s surely confound body and landscape, their sinuous forms echoing not only the bodily fragments that were drawn and underlie the paint but also the reflections of landscape that resided in the artist's mind. The surfaces of these paintings, impossible to capture in reproduction and fundamental to their experience, skate between shimmering reflectiveness and matte softness.

Only two paintings of the 1980s bear titles — *Pirate (Untitled II)* (1981) and *Morning: The Springs (Untitled I)* (1983) — and these bring to mind specific allusions. Some writers have thought that the title *Pirate* perhaps was an homage to a pair of early

1940s paintings of the same name by Arshile Gorky, the close friend and mentor of de Kooning early in his career, and that de Kooning's change in style in the early 1980s, which this painting heralds consciously, was inspired by the lucid, transparent colors and sinuous forms redolent of Gorky's style. Ferrara, however, recalls simply that de Kooning saw the billowing, light form that dominates the center of the painting as a sail on a pirate's ship. In the studio the painting thus came to be referred to as "the pirate," and the name stuck beyond the studio banter. *Morning: The Springs* surely refers to the landscape in which de Kooning lived and worked, and probably again to Louse Point, where land and sea, grass and sky, light and color, would dissolve into one another. How this title became attached to the painting is unclear, however. Throughout his career de Kooning paid little attention to titles, which, when made at all, were usually given by someone else around him — sometimes by Elaine, sometimes by a studio assistant, a dealer, or other associate.[39]

In de Kooning's work, as noted before, formal resolutions are inextricably bound to technique and conceptual principles. Here the relationship between the work of the 1980s and earlier periods in de Kooning's career is no less joined. A critical topic in this regard is the question of closure.

One traditional gauge of an artist's decision to regard a canvas as finished has been the time at which the painting was signed. In de Kooning's case, however, from 1975 onward he signed paintings on the front with exceptional rarity. Only two canvases from the 1980s are on record as having been signed on the front: *Untitled I* (1981, pl. 1) and *Untitled III* (1981, pl. 3). The latter, in the collection of the Hirshhorn Museum, was signed by de Kooning in response to the personal urging of Joseph Hirshhorn, his long-time patron, and his dealer, Xavier Fourcade, acting on Hirshhorn's behalf. Other canvases are signed on the stretcher in the back, but generally this was done, as it typically was throughout de Kooning's career, at the time the painting was being prepared to leave the studio, not when it was removed from the easel.

Throughout the 1980s, de Kooning generally would work on only one painting at a time, and the painting would remain on the easel from the time it was begun until he ceased to work on it. Documentation confirms that there were, however, a few paintings, done between 1981 and 1983, that were removed from the easel and later returned for continued work. From visual evidence alone it is impossible to determine exactly how de Kooning would arrive at the decision that he would no longer work on a painting. Photographs of successive stages of paintings made between 1981 and 1984 document many works that to an outside observer would appear to be complete at an early state; de Kooning painted out or reworked them so extensively, however, that the earlier state often became unrecognizable (see pp. 54–56, figs. 3a–n). Generally, the later states show increasing simplification of form and color.

According to the various studio assistants who worked with him in the 1980s, de Kooning would not verbally declare that a painting had been finished; he would simply let the painting remain on the easel, having stopped working on it. At this point the assistants would remove the canvas and bring a fresh one to the easel, and the artist would begin to work again. As was often the case throughout his career, he would place the last painting on which he had been working to the right of the easel so that it could be referred to as he developed the next picture. All of the recently finished paintings of a given time would be propped up around the studio, creating the appearance of a kind of house of cards.

For the entirety of his career, the question of when a painting was finished, or even whether it was finished, preoccupied de Kooning extensively and became central to the myth that grew up around him. Critical discussions of de Kooning's work for the last forty years return to this issue time and again. Hess, in his writings of 1953 and 1959, and especially in his essay for the 1968 retrospective at the Museum of Modern Art, dealt with it at length. He noted that

early in his career, de Kooning had developed a repu-
tation for never finishing a painting. With his first
subterranean fame among the small world of artists
in downtown Manhattan in the 1940s, he had made
a "number of enemies, whose line of attack was: Gorky
is brilliant, but completely derivative, and de Kooning
is the genius who can never complete a picture."[40]
Hess crystallized the myth for the general public in his
1953 *ARTnews* article "De Kooning Paints a Picture,"
in which he desribed the artist's struggle and process
to paint *Woman I* (1950–1952, fig. 2).[41] In brief,
de Kooning worked on the painting for eighteen
months, at which point he abandoned it and removed
it from the stretcher. It was only through the judgment
and encouragement of his friend, the art historian
Meyer Schapiro, that six months later he retrieved
the painting, worked on it slightly more, and allowed
it to be taken from the studio and exhibited. This open-
endedness in de Kooning's process was evident as early
as 1939, when he left the painting *Portrait of Rudolph
Burckhardt* (fig. 8) unfinished,[42] and as late as 1955,
when the uncompleted *Woman As Landscape* (fig. 9)
was "permitted to leave his studio at the importu-
nity of his dealer."[43] This was the case as well with
Police Gazette (fig. 10), from the same year.[44]

In a well-documented discussion in 1950 among
a group of artists that included Barnett Newman,
Ad Reinhardt, and de Kooning at the downtown
New York Studio 35, Robert Motherwell asked
de Kooning how he knew a painting was finished:

I refrain from "finishing" it. I paint myself out of the picture, and
when I have done that, I either throw it away or keep it. I am
always in the picture somewhere. The amount of space I use I am
always in, I seem to move around in it, and there seems to be a time
when I lose sight of what I wanted to do, and then I am out of it. If
the picture has a countenance, I keep it. If it hasn't, I throw it
away. I am not really very much interested in the question.[45]

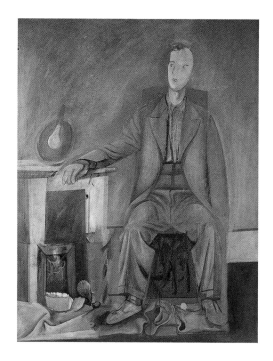

8. *Portrait of Rudolph Burckhardt*, c. 1939
oil on canvas, 49 x 36 in.
Private collection

Hess pointed out that de Kooning, like many
painters of the New York School, was reacting against
the then dominant aesthetics of the School of Paris,
with its emphasis on balance and refinement. Instead,
"de Kooning, like Pollock, omitted the last stages of
'finish.' The picture exposed the obstacles and how
the artist had tried to overcome them."[46] Considering
these issues, he concluded that "de Kooning by tem-
perament dislikes conclusions almost as much as he
hates systems."[47] Most recently, Richard Shiff, in his
essay for the National Gallery of Art survey of
de Kooning's paintings, updates the consideration
of closure, closely linking de Kooning's technical pro-
cedures with his philosophical and psychological
attitudes: "Just as he never celebrated an absolute
beginning, to finish an individual work never marked
an end for him. It was instead a time to transfer atten-
tion to a new painting surface, one that might con-
tain a very similar image. There was always some
little thing more to see and to do, to pass on to."[48]

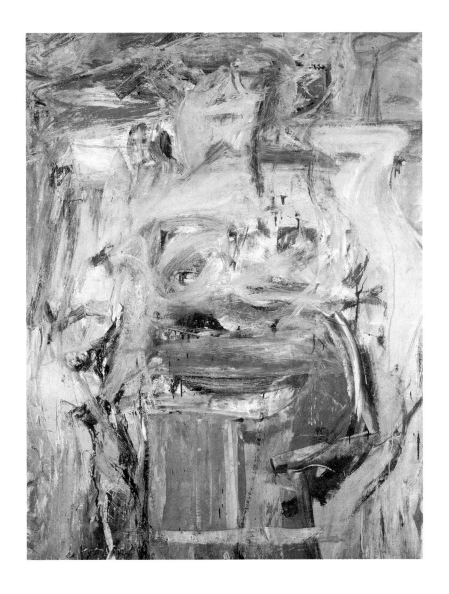

9. (above) *Woman as Landscape*, 1955
oil on canvas, 65 ½ x 49 ½ in.
Collection Steve Martin

10. (right) *Police Gazette*, 1955
oil, enamel, and charcoal on canvas, 43 ¼ x 50 ¼ in.
Private collection

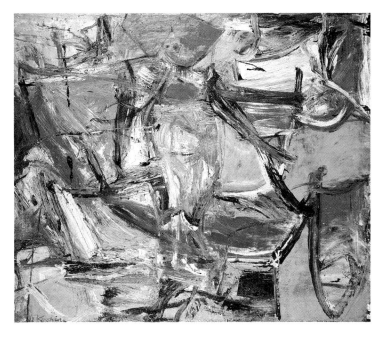

Even once de Kooning had finished working on a canvas, the consideration of its completion was not final until he had made a decision about the orientation of the painting. At least as far back as the 1950s, just as he would sometimes turn a canvas 90 or 180 degrees while he was still painting on it, he occasionally would change the orientation after the last paint had been applied. As Hess at that time observed: "De Kooning's is a slippery universe made of expanding numbers of indications and changing points of view—a finished painting is turned upside-down at the last moment, an eye becomes a tack, a thumb becomes a mountain."[49] This practice continued well into the 1980s, as can be documented when photographs of paintings completed and still on the easel are compared with their final orientations.[50]

The related question, of course, is how de Kooning would begin a new painting. For the first canvases of 1981, he started by working with Ferrara to sand down the surfaces of paintings from the late 1970s that had been abandoned. Laying the canvas flat on sawhorses, the surface would be covered with a thin layer of turpentine to keep the paint dust from rising, creating a highly polished surface. The technique, which he used in his early painting—for example in *Seated Man* (c. 1939, fig. 11) and *Seated Woman* (1940)— probably dates to de Kooning's days as a housepainter in the 1920s and 1930s.[51] It was a "calculated process," according to Marla Prather, that "was one of many the artist invented to retain previous incarnations of the work."[52] The resulting canvas face would be alive with ghostlike forms, offering up points of departure for de Kooning to begin again.

He would start new work on a painting by sketching a drawing as a cartoon across the canvas, whether working on an earlier piece that had been sanded or on a fresh canvas with no underpainting. Consistent with his working method of prior decades, in the early 1980s de Kooning used a variety of techniques for rendering the cartoon. In some cases, he

11. *Seated Man*, c. 1939
oil on canvas, 36 ¼ x 34 ¼ in.
Hirshhorn Museum and Sculpture Garden,
Smithsonian Institution, Washington, D.C.
Gift of the Artist through the Joseph H. Hirshhorn Foundation, 1972

had already made a drawing on both sides of a large sheet of vellum (see p. 49, figs. 2a – b), which he would tack to the canvas and, tracing over the drawing, transfer the charcoal line. Sometimes he would hold a small drawing or a photograph of a small drawing in his hand, sketching directly from it onto the canvas. A large selection of drawings, photographs of drawings, and paintings was kept in the studio, and there seemed to be no pattern to de Kooning's choice of them. He would simply sift through sheafs until he found one that caught his eye. Many of these drawings dated back to the 1960s, and some came from even earlier periods.[53] Often he would look to a painting immediately to the right of the canvas, taking lines from forms in the painting as a way to make a drawing on the new canvas. Many times this painting would be the most recently completed one, although a pair of paintings from the early 1970s for a time was kept to the right of the easel and referred back to repeatedly. Any of these procedures might also be used in combination.

Page 23

13. *Study for Pink Angels*, 1945
pastel and graphite on paper, 12 x 13 ⅞ in.
Private collection

12. *Pink Angels*, 1945
oil on canvas, 52 x 40 in.
Collection Frederick Weisman Company, Los Angeles

Once he would begin painting, de Kooning might fill in forms or accentuate lines, or these could be erased or covered over. He might go back in with charcoal, adding lines, clarifying or transforming shapes, shifting relationships. As Richard Shiff has written: "Just as his 'positive' movements were subject to negation by scraping, so scraped or erased shapes could be recharged with color because traces of the forms remained visible. A movement or motif could be turned on and off repeatedly."[54] For de Kooning there was no set method but rather an ongoing process of observation and discovery.

De Kooning's basic approach again harks back to practices he had developed in the 1930s and 1940s for both figurative and abstract painting. It was at this time that the artist had developed a complex and varying set of procedures that, while allowing for multiple possibilities, essentially link all of the various ostensible styles of these decades. To a great extent, his style was created out of his process. Judith Zilczer, for example, notes that with *Seated Man* (fig. 11) "he painted over areas of the composition and allowed evidence of both underpainting and underdrawing to bleed through layers of paint. He intensified this visual evidence of his evolving creative revisions by drawing with charcoal over the surface of the painting."[55] He would go on to do "drawings on transparent tracing paper, scatter them one on top of the other, study the composite drawing that appears on top, make a drawing from this, reverse it, tear it in half, and put it on top of still another drawing."[56] In a key abstract painting, *Pink Angels* (1945, fig. 12), this approach to composition became in part the subject of the painting itself.

In the 1940s, de Kooning's paintings and draw-
ings informed one another, resulting in a series of
black-and-white abstractions that Hess described
as "a new kind of painting, or perhaps a new kind
of drawing."[57] Hess noted that this practice was
often sparked by the search for a shape to initiate
the composition of a painting: "Other drawings do
not search for ideas about form, but are about inter-
stices, connections, edges. Some drawings have
nothing to do with line, but indicate how two shapes
will meet with a crunch on a surface. And others,
reassembled and torn, indicate how one passage
can jump to the next one."[58] Looking back over
de Kooning's entire career, Richard Shiff has been
able to discern a general principle in the artist's
work: "In devising a set of studio practices to suit
his perpetual desire for reconsidering, de Kooning's
physical principle was fluidity—the material ana-
logue of conceptual change and transition."[59]

Direct analogues to the 1980s paintings can be
found particularly in his drawings. One especially good
example can been seen in a 1945 drawing (fig. 13)
believed to be a study for *Pink Angels*, which pre-
sages such paintings as *Untitled X* (1984, pl. 21).
Some of the most linear of the early 1950s black-
and-white abstract drawings foretell some of the
most delicate and linear paintings of the 1980s (see,
for example, pl. 29). Hess's description in 1968 of
de Kooning's technique and the relationship between
drawing and painting applies presciently to many
of the paintings of the 1980s:

The move from drawing to painting could be as natural, at the
inception of a painting, as the shift from black ink to black paint.
De Kooning began painting some of his abstractions in the 1940s
by drawing an object chosen at random, sometimes his own
thumb, with a long, supple liner's brush whose hairs bend into an S
as it distributes pigment on the surface, moving in a quick razor-
thin line or, when an edge is flipped down, distributing streaks or
crescents five inches wide."[60]

14. *Lobster Woman*, 1965
oil on tracing paper, 18 ⅞ x 23 ⅞ in.
Collection Hirshhorn Museum and Sulpture Garden,
Smithsonian Institution, Washington, D.C.
The Joseph H. Hirshhorn Bequest, 1981

Other works from the 1980s, particularly from
1985 and after, are more like large-scale color draw-
ings and suggest precedents from later periods of
de Kooning's work. *Lobster Woman* (1965, fig. 14)
is an example of a painted drawing on vellum, in
which de Kooning probably simplified and traced
over forms from a canvas or from another drawing.
Paintings such as *Untitled VI* (1986, pl. 31), in fact,
are most likely the result of working from a simpli-
fied tracing of a charcoal drawing. In one case it has
been possible to identify specifically a 1960s char-
coal drawing from which a 1986 painting directly
derives (figs. 15, 16).[61]

From reports of the studio assistants and from
a review of drawings that remained in the studio, it
can be surmised that after 1983 de Kooning ceased
to draw on paper almost entirely.[62] From that point
onward he began to work with the paintings them-
selves in a manner more directly analogous to draw-
ing. Each painting began with a fresh canvas on
which a cartoon would be sketched in charcoal, fol-
lowed by the process of filling in, accentuating, and
altering, both with paint and charcoal. De Kooning

15. (above) *Untitled (Seated Woman on the Beach)*,
1966–1967
charcoal on canvas, 28 ¾ x 24 in.
Collection the artist

16. (right) no title, 1986
oil on canvas, 80 x 70 in.
Collection the artist

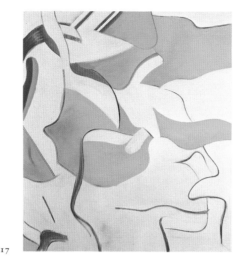

17

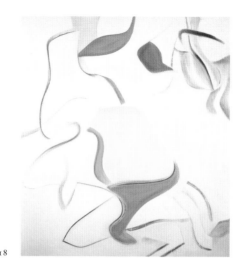

18

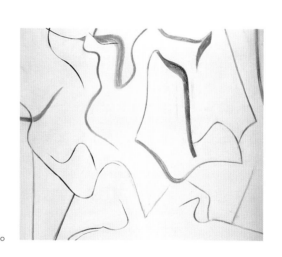

19

20

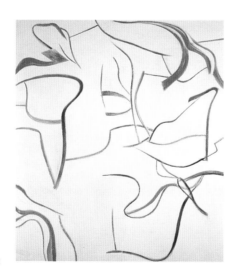

21

17. *Untitled VI*, 1984
oil on canvas, 80 x 70 in.
Collection Museum Ludwig, Cologne
Ludwig Collection

18. no title, 1984 (pl. 23)
oil on canvas, 80 x 70 in.
Collection the artist

19. *Untitled IX*, 1984
oil on canvas, 80 x 70 in.
Collection the artist

20. no title, 1984
oil on canvas, 77 x 88 in.
Collection the artist

21. no title, 1984
oil on canvas, 88 x 77 in.
Collection the artist

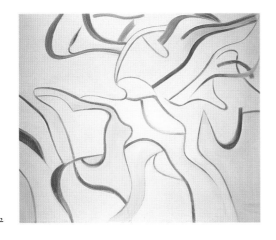

22

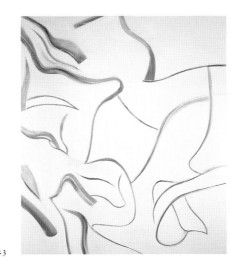

23

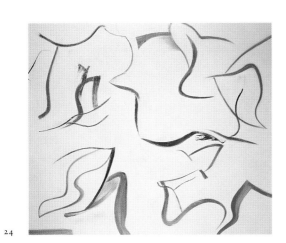

24

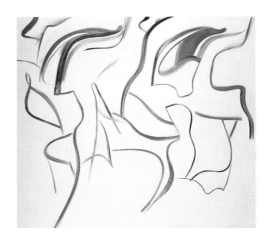

25

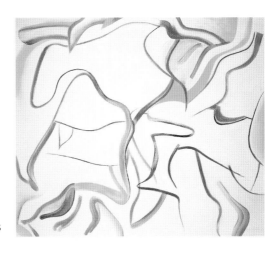

26

22. no title, 1984
oil on canvas, 77 x 88 in.
Collection the artist

23. no title, 1984
oil on canvas, 88 x 77 in.
Collection the artist

24. no title, 1984
oil on canvas, 77 x 88 in.
Collection the artist

25. no title, 1984
oil on canvas, 77 x 88 in.
Collection the artist

26. *Untitled X*, 1984 (pl. 21)
oil on canvas, 77 x 88 in.
Collection San Francisco Museum of Modern Art
Fractional gift of Helen and Charles Schwab

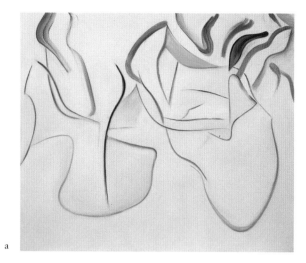

a

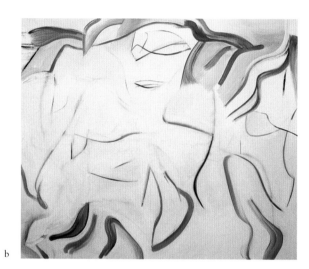

b

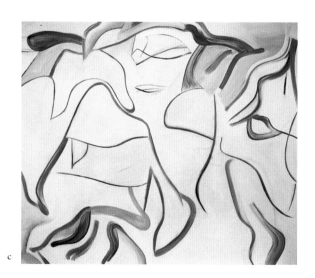

c

27a–c. Three early stages of *Untitled X*, 1984 (pl. 21)

continued to scrape and to sand, or to rub with his finger, palm, or paper towels in order to blend, obscure, and highlight. Working with concentration and sustained attention, sometimes over many days at a stretch and for several hours each day, de Kooning might finish a painting in two or three days. But sometimes up to two weeks would elapse before he would stop working on a canvas.

Many of the paintings from 1984 can been seen as closely related ensembles of work, as is evident in a sequence of paintings from that year (figs. 17–26).[63] Instead of working over and destroying painting after painting on the same canvas as he had done earlier, he would now allow each painting to remain in its immediacy, moving on to the next with a rapidity unprecedented in his work. But in a single canvas many permutations could still take place as the artist would work through the resolution of the composition (figs. 27a–c). His approach had become much freer and more open than the one he had used in creating the Woman paintings of the 1950s, when, as Hess noted, "in two years of work on one rectangle of canvas, *Woman I* was completed then painted out literally hundreds of times."[64] In the 1980s works, the essential procedures and techniques were not changed but simplified, and the vocabulary of forms was retained but clarified. Particularly in the works from 1984, the results are paintings of an openness and freedom not seen before, paintings that are extraordinarily lyrical, immediately sensual, and exhilarating. Of all the paintings of the 1980s, they are the most diaphanous and drawinglike.

In the fall of 1984, Xavier Fourcade was asked by St. Peter's Church in New York to approach de Kooning to create a triptych for the wall behind the altar.[65] The idea of inviting the artist to consider such a commission had been suggested to the church by a 1983 article by Curtis Bill Pepper that had appeared in the *New York Times Magazine*. Pepper recalled a statement de Kooning had made in 1959 when he had first interviewed him in Rome. "I can't figure out," de Kooning had said, referring to Titian and Michelangelo, "how those old guys kept at it, kept painting the way they did. . . . Titian, he was ninety, with arthritis so bad they had to tie on his

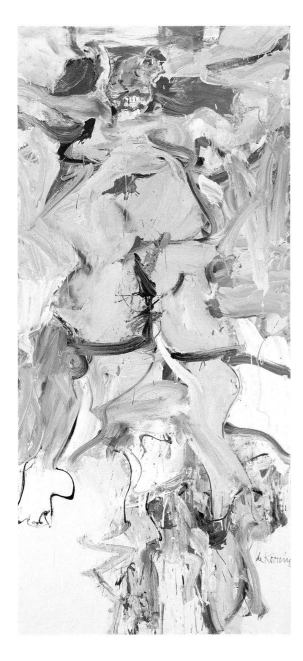

28. *Woman, Sag Harbor*, 1964
oil and charcoal on wood, 80 x 36 in.
Collection Hirshhorn Museum and Sculpture Garden,
Smithsonian Institution, Washington, D.C.
Gift of Joseph H. Hirshhorn, 1966

paint brushes. But he kept on painting Virgins in that luminous light, like he'd just heard about them. Those guys had everything in place, the Virgin and God and the technique, but they kept it up like they were still looking for something. It's very mysterious."[66] Reminded of this comment twenty-four years later, de Kooning protested. "I'm not those guys. They were something else." But prodded by Pepper to recall that Matisse had been seventy-eight when he began his work in the chapel in Vence and eighty-one when he finished it, de Kooning softened: "I'd like to do something like that if somebody would commission me to do it."[67]

In late 1984 or early 1985 de Kooning's studio assistants assembled a triptych that the artist worked on as a joined set of canvases, in which even the interstices between the panels were painted. At least twice before in his career de Kooning had considered the idea of joining canvases. Hess recounted that in 1959 the artist had shown him "his idea for placing two large pictures one flush on top of the other to make a third, vertical painting, using the arbitrary cut in the center as a kind of connecting jump."[68] But the idea did not work and de Kooning abandoned it. Later, in 1964, he completed a series of paintings of women on door panels (see, for example, fig. 28). Hess notes that in these paintings de Kooning wanted the anatomy to fill the whole surface, to give the figures a monumental scale and an iconic, Byzantine look. "De Kooning played with the idea, for a time, of assembling the panels of Women in a polyptych, like the parades of saints in Greek monastery frescoes. But to make a multiple painting, each part has to yield a bit of its identity to the ensemble. And each of de Kooning's Women is filled with such a savage egocentricity that the scheme had to be abandoned."[69] By the 1980s, however, de Kooning was ready to reconsider the idea of a multipanel work, perhaps in part because he was working in a different way, moving readily from one canvas to the next.

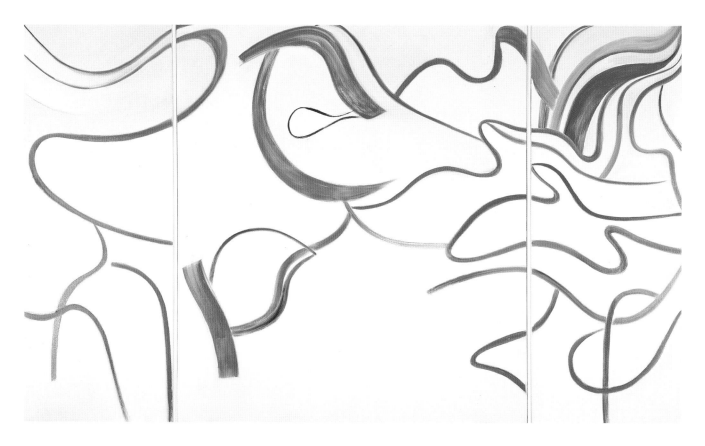

29. triptych, 1985
oil on canvas, 80 x 131 in.
Collection Donald L. Bryant, Jr., Family Art Trust, Saint Louis
Promised gift to the Saint Louis Art Museum

Although de Kooning did finish the triptych (fig. 29), the completed work was not presented to the church.[70] Instead, probably through Fourcade's suggestion but with de Kooning's involvement and agreement, three of the first canvases the artist had completed in 1985 were selected and juxtaposed to form a triptych (pl. 25) that was larger in scale and bolder in design than the interconnected three-panel painting. This was the work that was placed behind the altar of St. Peter's Church in the fall of 1985. It aroused intense controversy at the church, however, when some members of the congregation found the colors inappropriate or the forms distracting and questioned whether "such a personal form of art can be used to further the goals of group worship and prayer."[71] After seven weeks the painting was removed, and, aside from its exhibition at the Xavier Fourcade gallery in the fall of 1985, it remained in storage until it was again publicly shown in the summer of 1994 at Guild Hall in East Hampton.[72] This painting is an extraordinarily exuberant, celebratory, and life-affirming work. Apart from the question of its appropriateness in a religious setting, the triptych reveals the closely interwoven seriality of many of de Kooning's paintings from this period and clarifies one of the crucial shifts between the paintings of the 1980s and earlier periods.

By 1985 de Kooning had again begun to work with sharper contrasts, bolder and broader lines, and larger areas of filled-in color. And there was more variety between paintings. The first canvases finished that year bridge the gentler, softer "ribbon paintings"

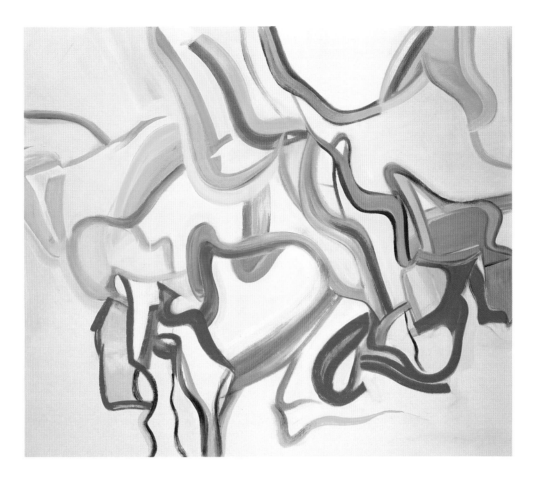

30. no title, 1988
oil on canvas, 77 x 88 in.
Collection the artist

of the preceding year but are now more assertive and flamboyant (compare pl. 21 with pl. 25). Two of the last works of that year stand in sharp contrast to each other. One, an untitled work (pl. 29), is composed only of sinuous blue and black lines that articulate an expansive field of white, while the other, *Untitled XIII* (pl. 27), is dominated by large, flowing, biomorphic expanses of color, rhythmically interlocked.

In some of these paintings from 1985, and increasingly in the paintings from 1986, yet another change in style can be noted (see pls. 30 and 33). The earlier fluidity and animation slow down. The surfaces become more encrusted. Both linear elements and areas of color show more overworking and less crispness. Tonal color becomes more pronounced as the ground becomes less white or creamy. In some cases the linear forms take on a more cartoonlike appearance (pl. 31).

De Kooning continued to paint in this style well into 1987 (pls. 34, 35), at which time yet other changes emerged. In the paintings from late 1987 and through 1988 (figs. 30, 31) the palette changes quite markedly as it turns away from primaries and their complements to a wide range of colors, including an array of pastels. The forms become less linear and more loosely brushed. The formal tautness and overall composition begin to disappear so that structure becomes much looser as well. There were significant changes in the studio at this time that probably influenced the resulting canvases.[73] It seems certain that de Kooning's physical health took a downturn, that he could sustain the energy to paint for shorter periods of time, and that his ability to concentrate was weakening.

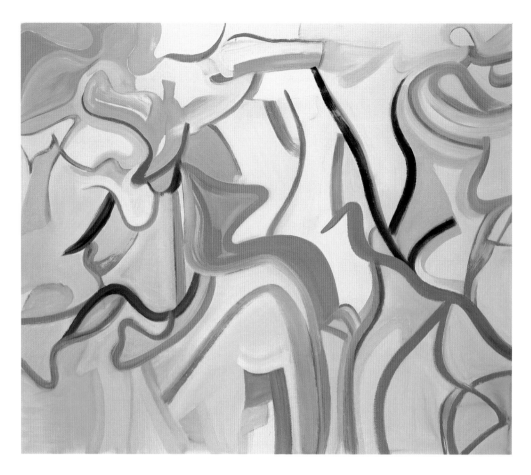

31. no title, 1988
oil on canvas, 70 x 80 in.
Collection the artist

By the end of the decade it had become clear as well that de Kooning was suffering from diminished mental capacities. He was diagnosed in 1989 as having what in all probability was Alzheimer's disease.[74] Robert Storr discusses the issues surrounding Alzheimer's at length in his essay in this book, but a short summary of our understanding may still be helpful here. Alzheimer's disease is a progressive illness that takes years to develop fully and that affects different individuals in different ways. The effects do not develop consistently and are frequently episodic, so that an individual may in certain periods evidence more or fewer symptoms. Some faculties such as short term memory are lost at an early stage of the disease. Only at the final stage does the individual completely lose the capacity to understand cause and effect, to recognize people, and to make sense of the surrounding environment.

The aim of this exhibition is not to attempt a diagnosis of de Kooning's illness by using the paintings as a chronological index of its development. That, in all probability, is an impossible task. The exhibition rather offers an opportunity to view and evaluate the paintings of the 1980s as fully as possible — on their own terms and in relation to the artist's entire oeuvre. Yet one of the issues to consider must be the point at which the symptoms of the disease overwhelm the artist's ability to continue to create paintings that remain of critical interest. It is probable that a consensus will develop around this issue over time —

recognizing, of course, that differences of opinion will never be resolved. (As noted above, some critics assert, following Clement Greenberg's lead, that all of de Kooning's works after 1950 are critically deficient.) As a first step, however, a group of distinguished professionals in the visual arts was brought together in New York in February 1995 to spend two days examining and discussing the late work. The colleagues that joined me in this undertaking included Kathy Halbreich, director of the Walker Art Center, Minneapolis; the artist Jasper Johns; John R. Lane, director of the San Francisco Museum of Modern Art; Richard Shiff, of the University of Texas, Austin; Robert Storr, curator of painting and sculpture at the Museum of Modern Art, New York; and John Walsh, director of the J. Paul Getty Museum, Malibu, California. Scores of paintings were viewed and discussed, including the bulk of the work de Kooning made after the mid-1980s and examples of his last paintings from 1989 and 1990. My hope was that out of these discussions a more fully informed opinion could be brought to bear on determining the proper scope of the exhibition with respect to the artist's last paintings.[75]

The discussions of the group were far ranging and no single point of view predominated. General issues were raised: Should critical distinctions be made between specific groups of works or should works be judged simply on indivdiual merits? As an artist's work changes, how are criteria established? To what extent are judgments shaped and informed by criteria developed around prior works? How much familiarity with an artist's work in general and with a group of specific works in particular is required in order to establish a judicious critical appraisal? To what degree do the parts of a painting that are at odds with expectations either engage or deflect positive appraisal? To what degree does an understanding of intentionality influence appraisal and by what criteria can intentionality be discerned?

Everyone in the group agreed that the last paintings from 1989 and 1990 were of interest only insofar as they were from the hand of de Kooning; as such, they were important for the historical record but could not stand on their own as fully realized works of art. But apart from this general assessment, no clear cutoff point could be determined. Some members of the group felt that some of the paintings from the mid-1980s evidenced signs of faltering control; yet paintings from a later date were seen as highly controlled and sophisticated. Some members perceived distinguishing characteristics and visual appeal in a group of paintings made as late as the end of 1987 and into 1988, such as the work included in the 1994 exhibition at Guild Hall (see fig. 30). By and large, however, these paintings seemed to mark yet another transition, with a distinct change of palette and style of paint application and a shift in compositional structure. There was a consensus that, in time, a full catalogue raisonné of de Kooning's late paintings would be a crucial scholarly resource.

These discussions have been invaluable to my own thinking about the presentation of de Kooning's paintings from the 1980s and have prompted my conviction that a great need exists to establish as clearly as possible the coherence and achievement of de Kooning's work in this decade. Thus the exhibition begins with the paintings from 1981 and ends with those from 1987. Seen together, the works from these years define a distinct style and mark an extraordinarily sustained development. Among them are paintings that may be included as some of de Kooning's finest. I am convinced, in fact — and hopeful that the exhibition will bear out this belief — that these paintings of the 1980s are among the most beautiful, sensual, and exuberant abstract works by any modern painter.

The 1980s canvases recall the works from the early categories of Hess's classifications — paintings that predate both the groundbreaking abstractions of the late 1940s and the Woman series of the early 1950s, which, as noted before, more than any other bodies of de Kooning's work have defined him as an artist. The mythological stature of the image of the Woman in particular, in tandem with the mythologizing accounts of its creation, have skewed an understanding of the totality and complexity of the artist's aesthetics, as well as his career. The paintings from the 1980s reinforce the necessity to reconsider de Kooning's work in its completeness; to question how periods are understood, evaluated, weighted, and appreciated; to further underscore the complexity of relationship between drawing and painting; in sum, to pose again the fundamental question that seeks to understand the essence of his art.

De Kooning's work, at its core, is about neither style nor myth, but more profoundly incites an exploration of transformation and change. The last decade of de Kooning's painting clarifies something of the vital character of his art: the insistence on invention, freedom, risk. These are the same qualities that had brought renown to him as an Abstract Expressionist. In the 1980s de Kooning renewed their meaning as he renewed his vision of his own art. The old existentialist issues that have surrounded de Kooning's work now appear all the more relevant, transformed as the paintings of the 1980s are from the paintings of the 1940s and 1950s.

These facts explain in part, perhaps, why de Kooning's work has been and remains of interest to an extraordinary range of the best artists of our time, including Robert Rauschenberg, Jasper Johns, Bruce Nauman, and Brice Marden, among others.[76] Artists such as these do not look to de Kooning's work as a source of style, as was true of many of his followers in the 1950s; rather they discern in the artist's technique, perceptual explorations, and spirit a method of problem solving, a way of going forward that can be used in the service of their own work. Nurturing creativity both for himself and others, de Kooning's art, in the end, stands as a refutation of closure and an affirmation of renewal and discovery.

NOTES

1 From 14 April 1981. Quoted in Judith Wolfe, *Willem de Kooning: Works from 1951–1981*, exh. cat. (East Hampton, New York: Guild Hall of East Hampton, 1981), p. 16. Tom Ferrara, one of de Kooning's principal studio assistants from 1980 to 1987, attributed the same remark to de Kooning in an interview with the author and Robert Storr, 11 February 1995. Richard Shiff also cites this remark (again from an interview with Ferrara) in his essay "Water and Lipstick: de Kooning in Transition," in *Willem de Kooning: Paintings*, exh. cat. (Washington, D.C.: National Gallery of Art, and New Haven and London: Yale University Press, 1994), p. 63 n. 5.

2 Probably the most influential review of this exhibition was by Clement Greenberg; see his review "Art," *The Nation* 24 (April 1948), p. 448. Soon after the exhibition closed, the Museum of Modern Art acquired *Painting* (1948).

3 Near the time of this exhibition, Thomas B. Hess published an article in *ARTnews* that lionized de Kooning, bringing wide attention to his work and, to a great degree, setting the terms of discussion surrounding it for many subsequent critics. See Hess, "De Kooning Paints a Picture," *ARTnews* 52, no. 1 (March 1953), pp. 30–33, 64–67.

4 For the most recent and succinct summary of this position, see Hilton Kramer, "The Ghost of Willem de Kooning," *Modern Painters* 7, no. 2 (Summer 1994), pp. 32–35.

5 For a long time, de Kooning resisted the idea of a retrospective, dismissing it as an "obituary." Frank O'Hara, a good friend of de Kooning's, had tried for years to secure his cooperation for a retrospective at the Museum of Modern Art in New York, and in June 1966 de Kooning surprised him by agreeing at last to work with him on such an exhibition. Due to O'Hara's sudden death that year in an accident, Thomas Hess, de Kooning's longtime supporter, took over the project. See Brad Gooch, *City Poet: The Life and Times of Frank O'Hara* (New York: A. A. Knopf, 1993), p. 453; reprinted by HarperCollins, 1994. See also Marla Prather, "Catalogue," in *Willem de Kooning: Paintings*, supra, note 1, p. 178.

6 Thomas B. Hess, *Willem de Kooning*, exh. cat. (New York: Museum of Modern Art, 1968), p. 26.

7 See Peter Schjeldahl, "De Kooning's Sculpture," in Philip Larson and Peter Schjeldahl, *De Kooning: Drawings/Sculptures*, exh. cat. (Minneapolis: Walker Art Center, and New York: E. P. Dutton, 1974), unpaginated; and Claire Stoullig, "The Sculpture of Willem de Kooning," in *Willem de Kooning: Drawings, Paintings, Sculpture*, exh. cat. (New York: Whitney Museum of American Art, in association with Prestel-Verlag, Munich, and W. W. Norton, New York and London, 1983), pp. 241–265.

8 See Lanier Graham, *The Prints of Willem de Kooning: A Catalogue Raisonné, 1957–1971* (Paris: Baudoin Lebon Editeur, 1991).

9 See Diane Waldman, *Willem de Kooning in East Hampton*, exh. cat. (New York: Solomon R. Guggenheim Museum, 1978).

10 One of the most recent and general discussions of *altersstijl* can be found in *Art Journal* 46, no. 2 (Summer 1987), pp. 91–133, a special issue on the subject. See especially the article in this issue by David Rosand, "Editor's Statement: Style and the Aging Artist," pp. 91–93.

11 Ibid., p. 92. See also Robert Rosenblum, "On de Kooning's Late Style," in *Willem de Kooning: Recent Paintings, 1983–1986*, exh. cat. (London: Anthony d'Offay Gallery, 1986), unpaginated (reprinted in *Art Journal* 48, no. 3 [Fall 1989], p. 249); Robert Rosenblum, "Notes on de Kooning," in *Willem de Kooning: An Exhibition of Paintings*, exh. cat. (New York: Salander-O'Reilly Galleries, Inc., 1990); Lynne Cooke, "De Kooning and the Pastoral: The Interrupted Idyll," in Judith Zilczer, *Willem de Kooning: From the Hirshhorn Museum Collection*, exh. cat. (Washington, D.C.: Hirshhorn Museum and Sculpture Garden, Smithsonian Institution, in association with Rizzoli International, 1993), p. 89; David Sylvester, "Flesh Was the Reason," in *Willem de Kooning: Paintings*, supra, note 1, p. 30.

12 Sylvester, supra, note 11, p. 30.

13 See *Monet: Late Paintings of Giverny from the Musée Marmottan*, exh. cat. (New Orleans: New Orleans Museum of Art, and San Francisco: The Fine Arts Museums of San Francisco, 1994).

14 See the exhibition catalogues *Picasso Das Spätwerk: Themen 1964–1972* (Basel: Kunstmuseum, 1981); Gert Schiff, *Picasso: The Last Years 1963–1973* (New York: George Braziller, in association with the Grey Art Gallery and Study Center, New York University, 1984); and *Late Picasso: Paintings, Sculpture, Drawings, Prints 1953–1972* (London: Tate Gallery, 1988).

15 Exhibitions that centered primarily on de Kooning's paintings of the 1980s were held at Xavier Fourcade, Inc., New York, 17 March–1 May 1982 (ten paintings), 12 May–23 June 1984 (twelve paintings; catalogue), and 17 October–16 November 1985 (sixteen paintings; catalogue); Studio Marconi, Milan, 21 March–April 1985 (seven paintings from 1982–1983; catalogue); Anthony d'Offay Gallery, London, 21 November 1986–14 January 1987 (twelve paintings from 1983–1986; catalogue); Margo Leavin Gallery, Los Angeles, 17 January–21 February 1987 (twelve paintings from 1982–1986); Richard Gray Gallery, Chicago, 1 May–20 June 1987 (nine paintings from 1984–1986); and the Pace Gallery, New York, 17 September–16 October 1993 (eight paintings from 1983–1986, exhibited with fourteen paintings from 1983–1984 by Jean Dubuffet; catalogue). A small number of 1980s paintings have been included in the large museum survey exhibitions of de Kooning's work organized between 1983 and 1994; of these, the recent survey first presented at the National Gallery of Art, Washington, D.C., included the largest group: nine paintings from 1981–1986.

16 The best and most substantial critical discussion to date of the paintings from the 1980s can be found in Prather, supra, note 5, pp. 199–202. The most insightful exhibition reviews of the 1980s include Peter Schjeldahl, "Delights by de Kooning," *Village Voice*, 13 April 1982, p. 79; and Robert Storr, "De Kooning at Fourcade," *Art in America* 74, no. 2 (February 1986), p. 130.

17 The most recent account, which perpetuates much earlier mis-information and, in fact, furthers a sensationalist review of the 1980s work, is a BBC1 *Omnibus* program, produced by the English critic Matthew Collings, that was first broadcast in 1991 under the title "The de Kooning Affair" and was updated, revised, and rebroad-cast in 1995 as "Willem de Kooning: The Greatest Living Painter?" This program was the subject of a public screening and discussion at the Tate Gallery, London, on 19 April 1995. With no announce-ment, Collings, who had been invited to lead that discussion, failed to appear, and no other representative of the BBC, despite invita-tions from the Tate Gallery staff, attended. The participants in the discussion included Dr. Peter Davies, a neuroscientist from the Albert Einstein College of Medicine in New York, whose interview had been excerpted in the program and who refuted the interpretations brought to his words by the film's context. The other discussion par-ticipants, including writer Michael Ignatieff and art historian Fred Orton, along with several distinguished members of the audience, concluded a highly critical discussion around factual inaccuracies, elisions of dates and events, interpretative misreadings and over-simplifications, and conceptual flaws at basic levels. Similar argu-ments can be made in relation to the book by Lee Hall, *Elaine and Bill, Portrait of a Marriage: The Lives of Willem and Elaine de Kooning* (New York: HarperCollins, 1993), pp. 278–316. Poorly researched, willfully manipulative of dates and events, and without proper scholarly support, this book is at best an extremely personal and subjective account.

18 See Rose C. S. Slivka, "Willem de Kooning," *Art Journal* 48, no. 3 (Fall 1989), pp. 219–221; special issue, "Willem de Kooning, On His Eighty-Fifth Birthday," edited by Bill Berkson and Rackstraw Downes.

19 Wolfe, supra, note 1, p. 16.

20 Curtis Bill Pepper visited de Kooning in 1983 and observed the artist through the studio window as he began to work on a painting: "He had lost his shuffle, moving quickly, with the agility of a younger man" (Pepper, "The Indomitable de Kooning," *New York Times Magazine*, 20 November 1983, pp. 47, 66). Several years earlier, in 1975, de Kooning had remarked during a studio visit by Amei Wallach, "I don't paint for a living. I paint to live" (Amei Wallach, "My Dinners with de Kooning," *Newsday*, 24 April 1994, Fanfare section, p. 9). As late as 1988, in videotapes made by studio assis-tant Robert Chapman, the intensity of de Kooning's concentration while painting could be observed.

21 Robert Chapman, interview with the author, 9 February 1995; and Ferrara interview, supra, note 1.

22 Ferrara interview, supra, note 1.

23 Ibid.

24 The Willem de Kooning Conservatorship office has assembled an archive and record of de Kooning's work that traces as fully as possible his production year by year.

25 All other paintings dated 1981 in the Fourcade records, how-ever, can be verified as having been painted in that year.

26 "Picasso is the man to beat," de Kooning once said; see Harry F. Gaugh, *Willem de Kooning* (New York: Abbeville Press, 1983), p. 112 n. 17.

27 Ferrara interview, supra, note 1. Wallach (supra, note 20), in her interviews from the early 1980s, captured several of de Kooning's remarks regarding Matisse: "When I look at a book of Matisse . . . he makes a drawing of one of those girls, you know. I know he's very serious. It's so ordinary—not the drawing of it—but I mean he doesn't throw his weight around. Like he's reasonable. And he makes it so joyous. I would like to be that way, too, more or less. The painting should be joyous" (p. 24, from an interview 15 April 1981); "I don't want the pictures to look too easy, too slick. . . . It's more like Matisse. He has such ordinary contents: a table, a woman sitting there. But he has that quality. He took the work out of it, you know? I would like to do that in the new ones. I don't know if I can, but it's a nice thing to look forward to" (p. 24, from an inter-view 27 June 1983).

28 Ferrara interview, supra, note 1.

29 Hess, supra, note 6, p. 46.

30 Prather, supra, note 5, p. 156.

31 Shiff, supra, note 1, p. 42.

32 Ibid, p. 43.

33 Gaugh, supra, note 26, p. 104.

34 Thomas B. Hess, *Willem de Kooning* (New York: George Braziller, 1959), p. 15.

35 Judith Zilczer, "De Kooning and Urban Expressionism," in Zilczer, supra, note 11, p. 35.

36 See Hess's typology, reproduced on p. 10 of this essay. See also Cooke, supra, note 11.

37 Hess, supra, note 6, p. 103.

38 Shiff, supra, note 1, pp. 55, 56.

39 Prather (supra, note 5, p. 203 n. 40) notes that *Morning: The Springs* was named following its exhibition in Amsterdam in 1983. Throughout the literature there are many references to the general lack of interest de Kooning had for titling his paintings and to the fact that when titles were given, they were made with other people. See, for example, Zilczer, supra, note 35, p. 182 n. 57; and Prather, supra, note 5, p. 103 n. 26, and p. 181 n. 35.

40 Hess, supra, note 6, pp. 21–22.

41 Hess, supra, note 3.

42 Gaugh, supra, note 26, p. 14.

43 Hess, supra, note 6, p. 102.

44 Ibid.

45 Diane Waldman, *Willem de Kooning* (New York: Harry N. Abrams, in association with the National Museum of American Art, Smithsonian Institution, 1988), pp. 59–60. Also cited in Prather, supra, note 5, pp. 99–100.

46 Hess, supra, note 6, p. 23.

47 Ibid, p. 25.

48 Shiff, supra, note 1, p. 54.

49 Hess, supra, note 34, p. 14.

50 Former studio assistant Tom Ferrara retains a large number of slides, taken in the studio from 1981 to 1985, of paintings at various stages of development as de Kooning worked on them, including the last stage as they were finished and left on the easel. By 1985 this kind of documentation was done only intermittently and incompletely, and it was abandoned altogether after that time. The practice of taking photographs of a painting at various stages in the studio had been initiated in the mid-1960s, but it was not followed consistently over the years. (See Prather, supra, note 5, p. 181 n. 34. With regard to a particular situation involving the orientation of *Unititled V* [1981] for a publicity photograph, see idem, p. 203, n. 38.) From April through August 1988, studio assistant Robert Chapman undertook the production of a series of videotapes of de Kooning painting; these effectively took the place of the earlier slide documentation.

51 Ferrara interview, supra, note 1.

52 Prather, supra, note 5, p. 82.

53 De Kooning generally did not date his drawings, and he was not concerned with keeping a precise order to them.

54 Shiff, supra, note 1, p. 56.

55 Zilczer, supra, note 35, p. 20.

56 Hess, supra note 6, p. 47. Waldman (supra, note 45, p. 68) discusses de Kooning's techniques in relation to Hans Arp and his use of biomorphic forms and chance collage.

57 Hess, supra, note 6, p. 50.

58 Ibid, p. 47.

59 Shiff, supra, note 1, p. 35.

60 Hess, supra, note 6, p. 50.

61 I would like to thank the Willem de Kooning Conservatorship office, New York, for bringing this relationship to my attention.

62 Ferrara interview, supra, note 1; and Chapman interview, supra, note 21.

63 The numbers given as titles to de Kooning's paintings of the 1980s, which were assigned by Xavier Fourade for purposes of identification and exhibition, generally bear no correlation to the sequence in which they were painted. Apart from the exceptions noted here on p. 15, Fourade was accurate in the designation of the year in which a painting was made.

64 Hess, supra, note 6, p. 75.

65 John Cook, "A Willem de Kooning Triptych and St. Peter's Church," *Theological Education* 31, no. 1 (1994), pp. 59–73.

66 Pepper, supra, note 20, p. 45.

67 Ibid, p. 47.

68 Hess, supra, note 6, p. 102.

69 Thomas B. Hess, *De Kooning: Recent Paintings* (New York: Walker and Company, 1967), p. 24.

70 This triptych is now in the collection of the Donald L. Bryant, Jr., Family Art Trust, Saint Louis, Missouri, and is on view at the Saint Louis Art Museum.

71 Douglas C. McGill, "Triptych Is Focus of Church Debate," *New York Times*, 25 February 1986, p. C13.

72 For an extended discussion of the circumstances of the commission, the controversy and political situation within the church with regard to the triptych, and the possible spiritual and religious meanings of the work, see Cook, supra, note 65, pp. 59–73. An earlier and more extended version of this text was first prepared as a lecture entitled "A Willem de Kooning Triptych," delivered by Cook at the Yale Divinity School, Yale University, New Haven, Conn., on 23 May 1992.

73 Robert Storr discusses these changes in detail on pp. 53–58 of his essay in this book.

74 Alzheimer's disease cannot be diagnosed definitively, except through a postmortem procedure.

75 The tape recordings and transcriptions of these discussions are now on deposit at the Willem de Kooning Conservatorship office, New York.

76 See artists' statements in *Willem de Kooning: Het Noordatlantisch licht/The North Atlantic Light, 1960–1983*, exh. cat. (Amsterdam: Stedelijk Museum, 1983), pp. 62–63, 83, and 102–103; and artists' statements in Bill Berkson and Rackstraw Downes, guest editors, special issue "Willem de Kooning, On His Eighty-Fifth Birthday," *Art Journal* 48, no. 3 (Fall 1989), pp. 214–250. The importance of de Kooning's work for Rauschenberg, Johns, and Marden has been widely noted. For a discussion of de Kooning's importance for Bruce Nauman, see Kathy Halbreich, "Social Life," in *Bruce Nauman*, exh. cat. (Minneapolis: Walker Art Center, 1993), pp. 93–95.

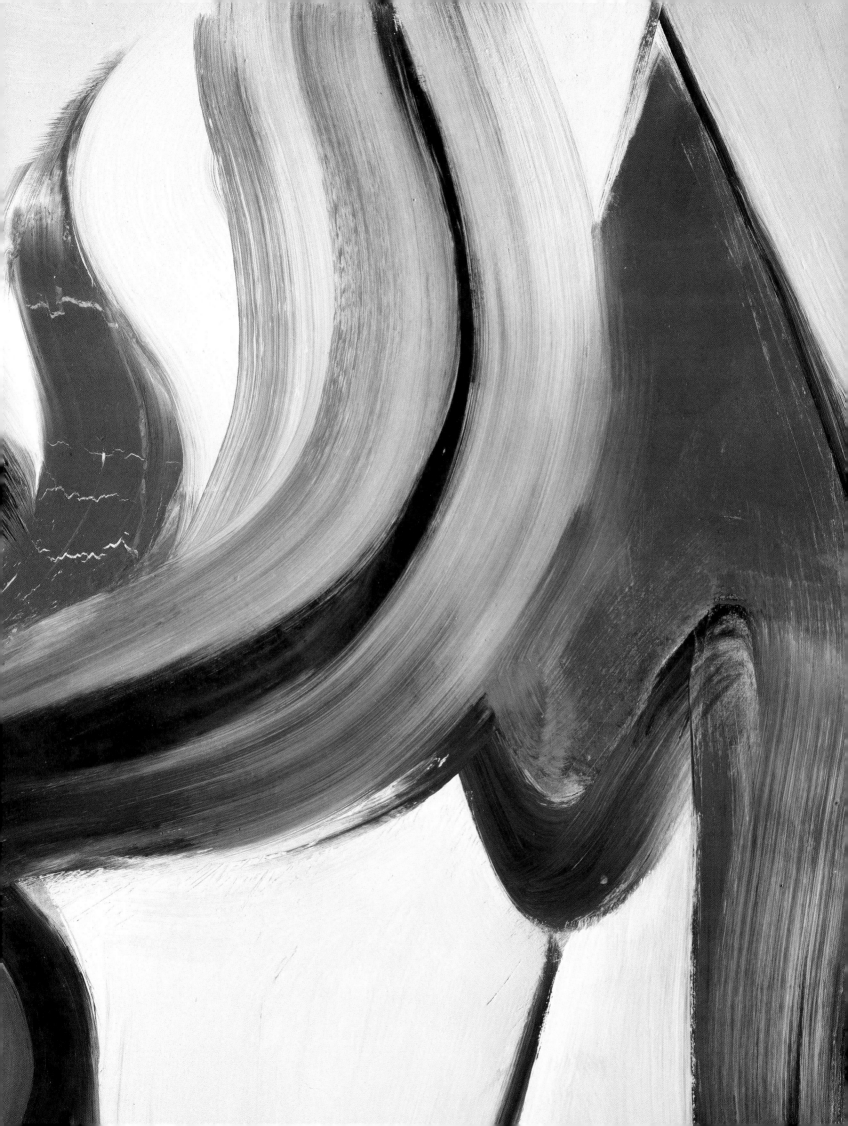

AT LAST LIGHT

ROBERT STORR

I. IT'S ALL VERY PUZZLING, BUT I'M NOT A PUZZLE. WILLEM DE KOONING[1]

Willem de Kooning's paintings of the 1980s might not have been. Circumstances very nearly aborted them. Ingrained procedure, a countervailing will, and brinkman's invention bodied them forth. In profusion. Over the course of that ten-year period the artist worked on more than three hundred canvases that survive (as well as others that did not) before he finally drifted away from his brushes in mid-1990. This total, measured against his sometimes halting, other times abundant production of previous decades, represents a considerable percentage of de Kooning's overall output. Of these works, a significant number count among the most remarkable paintings by anyone then active and among the most distinctive, graceful, and mysterious de Kooning himself ever made.

This the eye will confirm in time if not immediately. At the present, however, suspicions shadow these paintings — the least hesitant of this doubt-driven artist. Inverting the usual yardstick of quality, the best of them have been called into question by comparison to those that are partially or plainly unresolved. This tendency furthermore contravenes the cardinal rule in judging de Kooning's art at every point of his career: namely, that all his paintings are *episodes* of painting. The intrinsic value of any self-contained result, therefore, is always contingent upon and altered by the unfolding intuition and ongoing process that spun it off. Author of several of the great masterpieces of modern art — and to no other artist

of his era is the honorific "master," in both its artisanal and paradigm-setting senses, better suited — de Kooning nevertheless regarded his "minorpieces" and outright failures as of almost equal importance. With the works of his final years above all, we should do the same, for we have never before seen their like.

The story of how they came into being is complicated in detail but simple in essence. It is a melancholy and, occasionally, a distressing one as well. The purpose in telling it is not to add to the legends associated with artists of his generation — legends that have tended to obscure their work and caricature their natures in the minds of the general public and specialists alike. Instead, the reasons for the narrative analysis that follows are twofold. The first is to dispel the ill-informed speculation that has tainted the authenticity of these paintings and so endangers the artist's reputation as a whole. The second is to describe the actual conditions and profoundly human constraints under which de Kooning worked during the 1980s so that those approaching the paintings, rather than being distracted by what they don't know about them, can be freed by what they do know to lose themselves, eyes and mind open, in the brilliant, undulating space de Kooning suffused with his ultimate energy and into which he then disappeared.

II. **THE MAIN THING IS THAT ART IS A WAY OF LIVING — IT'S THE WAY I LIVE.** WILLEM DE KOONING[2]

By the end of the 1970s, popular as well as professional views of de Kooning seemed largely set, while the chances for fundamental self-renewal on his part grew increasingly remote. Following his 1968 retrospective at the Museum of Modern Art in New York, a 1974 touring show of drawing and sculpture organized by the Walker Art Center in Minneapolis, and a number of gallery exhibitions, the span of his career and the range of his activity had been fully examined, and there was a general expectation that in his lush but frequently inchoate post-1975 abstractions he had already entered his "late style" and would probably stick with it. In 1978 the Guggenheim Museum mounted *Willem de Kooning in East Hampton*, an exhibition of the work he had done since his 1963 departure from New York. When the show opened the artist was seventy-four. The majority of his Abstract Expressionist peers had died, often prematurely, or had settled into their mannerisms. Philip Guston (with whom de Kooning occasionally spoke on the phone, linking them in their rural exile from Manhattan) was the major exception, but Guston's final creative burst ended in 1980. Once the target of invigorating Oedipal attention from artists such as Larry Rivers, Robert Rauschenberg, and Claes Oldenburg, de Kooning had become a historical figure, but he was no longer the man to top. Meanwhile, Pop, Hard Edge, Color Field, and various contemporaneous "isms" themselves had been superseded in the 1970s by other aesthetic tendencies, many of them frankly hostile to easel painting.

Some critics wrote de Kooning off, dating his supposed decline to various points since the late 1950s, while others regretted his absence from the scene in wistful but equally definitive terms. "About 1960, de Kooning dropped from the charts of public sensation in contemporary art," Peter Schjeldahl wrote. "Ever since, there has been a haunting lonesomeness about the way de Kooning's hand moves in his pictures. . . . The meaning for me is the imagined possession of a perfect instrument with no proper function. I think that state is partly saintly and mostly awful."[3]

What de Kooning felt in this context is impossible to know for sure. The pressure, on a daily basis, must have been enormous and his isolation intense. "I'm stuck," he would say to assistants when a painting was going badly, "all washed up."[4] As detached as he had become from the seasonal novelties and cycles of the art world — which he monitored at a distance by scanning magazines — he still retained a measure of his competitiveness. Already in 1960, he had compared himself to a "performer" who, indifferent to "perfection," pursued his art to see "how far one could go . . . how long you can stay on the stage with that imaginary audience."[5] Edging his way off that stage after his move to Long Island, he apparently became content with the alternative, which he imagined as complete abandon to a wondrous sensory solipsism: "But then there is a time when you just take a walk. You are making your own landscape. It is not my own wish and I think when you stay with a place, then you walk in your own landscape. It has an innocence that is kind of a grand feeling."[6] As far back as 1959, when he first formulated this fantasy-metaphor, de Kooning had anticipated his old age, concluding, "Somehow I have the feeling that old man Monet might have felt like that, just simple in front of things, or old man Cézanne too. I really understand them now."[7] If by the late 1970s he was performing for

any audience, it was for the house sparsely occupied by these venerable masters of early modernism, who, at the same time, constituted his historical, scene-stealing rivals.

The question of whether de Kooning would have a great old age was becoming increasingly uncertain. By the late 1970s it was obvious that he was betting against himself. A heavy drinker since the 1950s (when, as intimates of the era remember, Automat coffee was replaced by beer and in turn by scotch), de Kooning, twenty years later, was prone to cata-strophic benders.[8] By his own disarmingly candid account, alcohol was not just a social addiction; it had been medically prescribed. Anxious in those ear-lier years about what he had left behind in the studio and fearful of losing his creative powers, de Kooning's nights frequently were spent wandering the city. (It was on one such occasion, so the story goes, that he met Mark Rothko on a bench in Washington Square Park.) "Those anxiety attacks scared the hell out of me," de Kooning recalled. "I felt my heart skipping beats. Then this doctor friend told me to take a little brandy in the morning. It worked good, it stopped the attacks, but I became a drunk."[9]

All too many of the people surrounding de Kooning (including Dane Dixon, his studio assistant from 1975–1980, whose own drinking later contributed to his pre-mature death) let slide or even encouraged the artist's binges, which eventually landed him in the hospital with regularity and once nearly caused him to freeze to death. More concerned friends and neighbors tried to intervene with little effect, while de Kooning him-self repeatedly ignored his doctor's urgent warnings. By general agreement, what saved him were the efforts of his estranged wife, Elaine de Kooning. They had met in 1938, married in 1943, and parted ways in 1955, the year before de Kooning's only child, Lisa, was born to Joan Ward, who continued to live nearby and play a role in his life even after Elaine's return in 1978. Having overcome her own drinking problem a few years earlier, Elaine read him the riot act. "I sat him down," she said, "and I said, 'Bill, your genes are sensational. Your mother lived to be 92, and was as strong as a rock. Your father lived to 89, your grandmother to 95. So your body's going to last, but your brain is going to go.' . . . He said, 'You're scaring me,' and I said, 'Good.'"[10]

Persuasion is not recovery, however, and recov-ery necessarily exacts a cost. Elaine took charge of the former, and the artist endured the latter. Steering him away from social engagements at which liquor was served and toward old acquaintances who represented the artistic ethic of their youth, Elaine chose his company, banished the studio hangers-on who might provide him bottles to ingratiate them-selves, and fired Dane Dixon.[11] On her own she took de Kooning to see doctors and a therapist and to meetings of Alcoholics Anonymous. In addition, she set up a regimen of exercise, vitamins, and healthy food, discouraged local merchants from selling him alcohol, and discreetly slipped him a reverse Mickey Finn of Antabuse, a drug that would make him sick if he drank. Unaware that he was on the medication, de Kooning did drink and became ill. "If I mix half a bottle of beer with a quart of water," he told a *New York Times* interviewer in 1983, "I still end up in the hospital."[12] By sometime in 1980, though, these inci-dents stopped, and with the exception of a single lapse in 1985, de Kooning remained sober thereafter.[13]

Although she had started out more less on her own, Elaine soon realized the magnitude of the job ahead of her and turned to her brother, Conrad Fried, who had studied painting with de Kooning in the late 1930s at the time she had. At loose ends following the sudden death of his wife, Fried (still an artist but, among other things, the inventor of the computer bar code) arrived on the scene. When it became clear that de Kooning needed constant attention and stimula-tion, Fried sent for two young men he had befriended while all of them had worked at the Data Control company in Baltimore and who had begun to paint seriously under his tutelage. The pair, Tom Ferrara and Robert Chapman, became the linchpins of de Kooning's studio, serving as his assistants for the next ten years. They first visited the artist together in the summer of 1979. Ferrara began working for him in October 1980 and remained until June 1987; Chapman signed on in October 1982 and stayed until

April 1990. Others joined the team organized by Elaine and her brother for various lengths of time and in various capacities as well: Larry Castagna, a painting student at Southampton College, worked for Elaine as a helper starting in 1982 and then moved over to de Kooning's studio for four years; Susan Brooke, a paper restorer, spent six years with de Kooning from September 1982 to June 1988; Antoinette Gay shared responsibility with Robert Chapman from June 1987 to April 1990; and Jennifer McLauchlen, hired by Elaine to prepare materials for her memoirs, looked after the artist and his studio from March 1988 to September 1993. A number of others — principally Judith Wolfe, Edvard Lieber, Joanne Lowenthal, and Kathleen Fisher — did research and attended to everyday business matters for de Kooning and Elaine or took care of household needs but were not directly involved with his artistic activity.[14]

Meanwhile, de Kooning paid for his sharp about-face with severe depression — the combined effect of a recurrence of the panic attacks that had driven him to drink in the first place, the enervation brought on by drastic changes the detoxification wreaked on his metabolism, and his resulting inability to work consistently. Compounding these problems were the heavy tranquilizers that were used in this early stage of his recuperation to treat his anxiety and angry frustration. It was a terrible moment of transition to an unpredictable future for the artist, and it was hard on all others concerned. "Bill had been living alone and wanted to be alone," Robert Chapman explained, but he could not have survived on his own and knew it.[15] Thus after "Captain Bligh-like" rages, which drove his assistants out but not far, de Kooning would welcome them back when the crisis passed.[16] These outbursts, along with the hours spent pacing the studio and grinding his teeth, were generally nocturnal. Together with the drugs he was then taking (Valium in particular), they account for the late rising and daytime lethargy witnessed by the few visitors allowed into the house at this time.

That he produced so few paintings in 1980 attests to the severity of the situation. Only ten canvases were attributed to that year by de Kooning's dealer, Xavier Fourcade. Of these, Ferrara believes several were in reality works from the late 1970s. "It was," Ferrara states, "a real event if he painted."[17] Elaine, in fact, was prepared that he might never do so again, and prices for existing pictures were raised in accordance with that gloomy forecast. Nevertheless, convinced that his mental and physical health depended upon working, she and others made every effort to urge him into the studio. For instance, in 1979 Fried persuaded de Kooning to place an order for nearly ten thousand dollars' worth of the highest quality Winsor and Newton oil colors, the most exotic selections of which still fill the studio storage bins. Around this time Fried also set up his own easel in de Kooning's space to tempt the artist to follow suit.

With the same goal in mind, strict daily routines based around de Kooning's and Elaine's creative rhythms were established. In the morning Elaine, who lived in a separate house close by, would come over for breakfast and discuss what, if anything, had happened during the previous working day or during the night. (In addition to the emotional seizures he suffered at night, de Kooning often got up in the small hours to continue painting or to look at what he had accomplished the session before.) After that she would leave for her own studio or attend to outside business, leaving de Kooning in the charge of Ferrara, Chapman, or whoever else was on duty. In the evening she would return for dinner, sometimes inviting friends to join them. Afterward de Kooning most often retreated to the living room to watch TV. It was his one harmless and dependable distraction. He liked TV's vulgarity — "Wheel of Fortune" was a favorite — and, mesmerized by its graphic qualities, he would channel-surf for the visual skid and play with the controls to exaggerate shapes and colors.[18]

On Sundays Fourcade would visit to look at paintings and discuss exhibition opportunities with the artist.[19] The dealer's relationship with de Kooning in these years was close, protective, and immensely important to the gradual dissemination of the work. He had become involved with the artist in the 1960s while

working at the Knoedler Gallery, where de Kooning had shows in 1967 and 1969 in New York and in 1968 at the Paris branch. Several years later Fourcade teamed up with Donald Droll to form his own gallery, and in 1974 they organized an exhibition of the artist's lithographs. Soon the gallery was de Kooning's principal representative, exhibiting his new paintings and sculptures at the height of the fall 1975 season and, after Fourcade took over entirely from Droll, following up the next year with the paintings of 1976. Adding Joan Mitchell, Louise Bourgeois, and H. C. Westermann to his stable, Fourcade specialized in consolidating the reputations of first-rate artists temporarily out of the limelight and in promoting their new work. Mindful of de Kooning's precarious condition and of his vulnerability in the art world, Fourcade joined forces with Elaine to keep intruders at bay and to nurture him in every way possible. This included his weekly visits and frequent phone calls to reassure the artist that great prospects lay ahead for him.

When the first evidence of de Kooning's restored confidence and fresh painterly attack emerged in 1980 and 1981, Fourcade was, in Ferrara's memory, as excited "as a little boy."[20] The dealer's assistant, Jill Weinberg, concurs: "It was very exciting not knowing what would come next, and seeing what did."[21] From the flow of new canvases, which began slowly and by 1983 became a torrent, Fourcade, in consultation with de Kooning and Elaine, selected pieces for three exhibitions he held of work from the current decade. The first, entitled "New Paintings, 1981–1982," included ten pictures from those two years and ran from mid-March to May 1982. For the second exhibition, in 1984, Fourcade presented twelve paintings from 1982 and 1983, seven drawings he dated between 1983 and 1984, and five bronze sculptures cast between 1980 and 1983 that had been enlarged from originals made in 1969. This exhibition was scheduled, perhaps with some caution, for May and June, at the tail end of the season. With greater assurance, however, Fourcade mounted a 1985 exhibition in October and November, showing eleven paintings from 1984, four from 1985, and a triptych intended for St. Peter's Church in Manhattan, assembled in collaboration with the artist from three previously individual panels (pl. 25). Caught up by the growing momentum of de Kooning's productivity, Fourcade planned another show for 1987 but did not live to do it. He died suddenly of an AIDS-related illness in April of that year.

As delighted as those surrounding de Kooning were to see the new work when it came, no one in 1979 and 1980 had anticipated the quantity of paintings or the evolutionary changes they entailed. And on this score all the assistants agree: as much as Elaine enjoyed the social and economic rewards of de Kooning's unexpected renaissance, she was scrupulous in not pressing him to make pictures for the market, in not trying to market those that were clearly unresolved, and in allowing him to overpaint states of given works that might have better suited public taste as they were. A recognized critic and painter and for many of the most crucial years of his development de Kooning's closest studio confidant, Elaine had her opinions, but she respected de Kooning's process, gloried in the artistic results, and wished to sustain the man on whom her adult life had for the most part centered.

With the eager anticipation of his output in the background and an almost monastic daily schedule in force, de Kooning's life began to revolve almost entirely around his assistants and his work. Backed by Elaine's encouragement and trust, Ferrara, Chapman, and the others brought a youthful energy and genuine affection for de Kooning into the studio. To the stereo repertoire of Bach, Beethoven, Khachaturian, and Stravinsky that ordinarily filled the house and to which de Kooning hummed and sang when painting, they added the Talking Heads.[22] An element of discipleship entered into this equation, but none of the assistants who were artists directly copied their mentor's style. Instead, the inspiration he offered them was the all-consuming dedication he brought to his art. This was ironic to a degree, since it was the assistants' primary task to inspire de Kooning to re-engage with his work, which all involved were convinced was the only thing likely to shake his depression and restore his vitality.

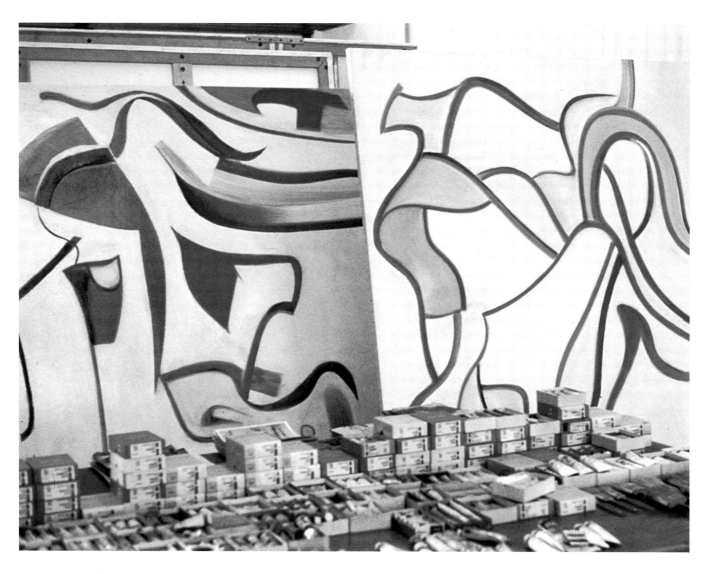

1. Willem de Kooning's studio, Springs, New York, January 1986.

Despite all the difficulties de Kooning had endured, when Ferrara first arrived on the scene in 1980 the artist was "pretty much captain of his own ship" as far as studio routines were concerned.[23] Physically strong, he still moved his own canvases around the space and single-handedly turned them when he wished to change their orientation. He also continued to clean his own brushes and joined in the process of sanding down old paintings to prepare them for a new start. Setting the stretcher flat on sawhorses as he had done with old doors when he was a housepainter in the 1920s, dousing the surface with turpentine to keep the dust down and increase its receptivity to fresh pigments, and then working with fine-grade sandpaper, de Kooning created the amorphous visual depth and tactile suavity of the Pompeian murals he and Arshile Gorky had admired years before in the 1930s and 1940s and which de Kooning in particular had recreated in his paintings of that period. Around the edges and throughout the internal painterly weave of many of the paintings he made between 1980 and 1982 are patches of the soft, ambiguously colored ground he thus prepared from paintings left over from the 1970s.

Other aspects of de Kooning's process changed around this time. While the sometimes visible under-painting just described was a vestige of his subtly modulated chromatic schemes of the previous two decades, the clean paint he applied over it was now radically different in character. Gone were the complex mixtures he would work out, transfer to color charts, and have made up in salad bowl-sized quantities for easy use. Gone, too, was the viscous, slow-drying medium he had used in his sweeping, puckered 1970s abstractions. Instead of this unstable but almost infinitely manipulable emulsion of safflower oil, benzine, and water—often tinctured with oil of clove to further retard its congealing—de Kooning began using a standard half-and-half solution of turpentine and stand oil (linseed oil thickened to the consistency of honey), which he cut into pastes squeezed directly from the tube onto a table-sized glass palette.

These technical simplifications were complemented by a greater sophistication in his painting apparatus, much of it the result of Ferrara's engineering. For years de Kooning had stretched his canvases over rigid wooden strainers or hollow-core doors. The latter provided a uniformly flat surface that made it possible for him to press hard while scraping off paint with a Spackle knife without puncturing the un-backed fabric or leaving marks in the painting, which would happen if the tool were to hit the crossbars of a conventional wooden support. Such scraping was an essential part of his procedure: it erased unwanted passages; created a sheer surface for the next session; eliminated the danger of severe cracking that would have occurred if "lean" (thin, dry) new paint were to have been applied over "fat" (thick, oily) old paint; blended colors in broad tonal sweeps, creating an effect similar to that he got by sanding; and carved usable shapes with the kinds of veering curves and flaring edges delineated in "positive" form by his brushes. (The revised techniques evident in the paintings of 1981 and 1982 continued to justify the observation that Thomas B. Hess, the artist's friend and critical advocate, once made: namely, that de Kooning makes extraordinary demands on the good nature of accidents.) Replacing the tall, narrow doors of the 1960s and the strainers of the 1970s, Ferrara now laid foam-core panels over adjustable Lebron stretchers in the just-off-square rectangular proportion that de Kooning had begun favoring in the 1950s and to which he returned with near total consistency after 1975. Of the 341 paintings he made during the 1980s, all but fifteen measure seventy by eighty inches or seventy-seven by eighty-eight inches; those fifteen are also standard sizes, measuring either fifty-six by sixty inches or fifty-four by sixty inches.

By 1981 Fried had designed a metal-framed, rotating, hinged easel that made it possible for de Kooning, increasingly bothered by back pains, to turn his canvases by hand without lifting them.[24] Until this time he had stood them on gallon paint cans, tilting them against a wooden armature of his own devising. Soon after, Ferrara added an electric motor triggered by a floor pedal to Fried's innovation. Like his black-and-white enamel abstractions from 1947 and 1948, which they resemble in spareness, fluidity, and linear invention, the bulk of de Kooning's late works were composed through a process of repeated reorientation during which they were shifted from vertical to horizontal, side to side, top to bottom, and back numerous times. As Stephen Mazoh, a dealer familiar with the late work has maintained, de Kooning often would begin working on a fresh canvas in the upper right-hand corner. This may be explained in part by his long-standing habit of placing another painting, usually one from the 1960s or 1970s, off to the right of the current canvas, where he could refer to it for forms or colors as he worked. (In 1984 and 1985, for instance, he took his cues for months on end from a small, vertical painting from the 1970s with a loosely defined, hence especially suggestive image.) But whatever his starting point — which in fact varied considerably — with a 180-degree turn the upper right might soon become the lower left, only to shift 90 degrees back again to be further developed as the lower right. If, on the whole, de Kooning's paintings were considered "finished" only insofar as he stopped working on them, then these, in particular, may be said to have been completed only when the revolutions that gathered the shapes within them together and spun them loose again had stopped.

When de Kooning was ready to set a canvas aside or put it into storage, its ultimate disposition would be registered by his assistants on the stretcher with an arrow pointing upward, executed in pencil, charcoal, or ink marker. If, after further consideration, the artist reoriented the canvas yet again, they would redraw the arrow accordingly. Only at the time a painting was to be shipped to the gallery did de Kooning sign it, and after 1975 (with rare exception), he signed only on the back of the stretcher bars.[25] Occasionally, as the signed paintings were being loaded onto the truck for delivery to his dealer, de Kooning would change his mind and decide to keep one that had been selected for exhibition. And even in the mid-1980s, when his mental state began to decline seriously, his wishes were honored.

Aside from their primary duty as alternating, round-the-clock companions, responsible for monitoring de Kooning's health and buoying his spirits, Ferrara, Chapman, and Brooke performed basic studio chores, which were confined to readying canvases, supplying paint and medium, and lending a hand to move the steadily accumulating stock of work. For the rest, they devoted their time to the conservation of existing works and to record-keeping. Chapman and Ferrara restretched paintings taken from old strainers or tailored the latter to reduce the stress on the canvas, while Brooke attended to a backlog of loose works on paper, mounting the usually embellished transfer prints that were a pictorial byproduct of de Kooning's custom of covering the surface of a canvas-in-progress with newspaper to keep it wet. (After 1980, de Kooning stopped using newspapers in this way.) Under Elaine's instructions, all the principal studio assistants numbered new canvases as they went on the easel and renumbered them as they came off.[26] (Ongoing inventory of the artist's production of the 1970s had been haphazard at best.) At de Kooning's request, Ferrara also resumed the practice, initiated in the 1960s by former assistant John McMahon, of photographing the stage-by-stage evolution of paintings (see, for example, figs. 3a–n). Like Henri Matisse before him, de Kooning found this a convenient way of holding on to transitional ideas, and he used the photographs as he did vellums and newspaper pull-offs, as reminders of since-altered designs. Later, in 1988, Fried, Chapman, and Gay videotaped the artist at work over long hours.

This, in sum, was the division of labor instituted under Elaine's guidance between 1980 and 1982. The one factor for which I have not yet accounted involves an opaque projector kept in the basement workshop where canvases were prepared. As far back as 1949, de Kooning had prompted Franz Kline to blow up his small brush drawings into full-scale paintings by that means. Yet in 1982, holding up a four-by-six-inch color print, he told the art journalist Avis Berman, "I can go downstairs and trace these anytime. . . . I've had the projector for years, but I keep postponing it. I haven't had time to do it. But I should try it. Maybe it would be good for me."[27] Three years later, according to notes in Ferrara's diary, the projector was in regular use.

Recycling images, of course, had long been a way for de Kooning to get started on a new canvas. He often painted with a "flash card" in hand — an eight-by-ten-inch photograph or some other reproduction culled from his massive archive of earlier works and affixed to Masonite or a stiff mat-board. Tracings done on forty-two-inch-wide vellum sheets set side by side allowed him to completely superimpose the outlines of such an image onto large paintings (see, for example, figs. 2a – b). Drawings made on vellum cut to smaller sizes were even more freely overlaid onto existing compositions. Thus de Kooning would transcribe motifs from earlier work and introduce them into new paintings, reversing the images at will by flipping the transparent paper and readhering it, and then moving the graphic template easily from place to place until its location suited him.[28] Along with "blind" spontaneous scribbling, executed like a rap disc jockey driving a tonearm needle across the grooves of a record, this tracing technique was de Kooning's way of breaking up the partially formed, gestural patterns of a painting that had gotten stuck mid-course. The projector saved time and made it possible to deal with a whole picture without dividing it into bands the width of the vellum on which he had previously made his adjustments.

Projection became a shortcut de Kooning used to circumvent his waning interest in drawing as a separate activity. Indeed, by 1980 he had virtually abandoned the practice of drawing, as the very few works on paper that can be positively ascribed to the decade attest. Although no artist's painting is more deeply rooted in his draftsmanship, this was not the first time that de Kooning had stopped drawing. Significantly, between 1947 and 1949, when he was working on the black-and-white paintings, he drew very little; this was also the case in the years 1960 to 1963 and 1970 to 1972. During the first of these lapses, as during the last, his two primary expressive means, rather than being dynamically paired as at other times during his career, became inseparably fused. By the mid-1980s, Chapman recalls, "He was just treating painting like a pad of paper. He was just working it out."[29]

De Kooning's increasing reliance on the projection of photographs of old drawings to provide the skeletal structure of new paintings in part explains the stripped-down formal similarity between so many of the canvases from the 1980s and those from previous years. Sometimes he would follow the charcoal-stick contours of the original with care; at other times he would revise or flesh them out during the transcription. Then, brush in hand, he might begin by painting in the enlarged shapes and lines as they had been copied onto the canvas; or he would push off from the graphic armature and start right away to move edges around, crop forms, and recompose the whole picture.[30] Gradually, however, de Kooning even tired of blocking in the projected image and gave the job to his assistants, who (starting around 1984 or 1985) on occasion were called upon to lay in the first coat of white oil paint in the empty spaces between the charcoal lines before bringing the canvas up to the studio, where the artist would take over.

From 1980 (when he worked comparatively little but did almost everything in the studio himself) to 1985 (when he painted at an almost fever pitch but delegated increasing amounts of practical responsibility to his assistants) to late 1987 (when his pace slackened definitively and his work, despite extraordinary passages, lost its overall structural coherence), de Kooning underwent a steady psychological and physical change. I have waited until now to discuss its symptoms in order to separate it to some degree from the effects of his alcoholism. Both had a profound impact on his creative energies and focus, but were it not for his arduous recovery from drinking, no paintings of quality would have been produced after 1979 and no radical stylistic redirection would have occurred. The real causes, exact progression, and full consequences of his growing detachment and confusion are harder to judge.

This much we know. By the late 1970s, friends — well accustomed to de Kooning's elusive bantering and frank indifference toward things irrelevant to his current preoccupations — began remarking upon his forgetfulness and his tendency to withdraw in social situations.[31] Although his memory of the "old days" he shared with such intimates was detailed and clear, he frequently had to be prompted by those around him with a name or event in order for him to make the crucial connection that would summon forth his own recollections. (According to Ferrara, however, what happened in the 1970s, when his drinking was heaviest, was largely irretrievable.[32]) When he lost the thread of talk going on around him, he either fell silent and looked distracted or cut through the awkwardness with one of his characteristically oblique wisecracks. De Kooning was not an educated man in any academic sense, but he was quick on the uptake and had always known how to seize concepts introduced by others, rephrasing them in what Robert Rauschenberg called "his beautiful lingo" to make them his own.[33] Conversation was his curriculum, humor his form of reasoning. "Jokes," noted Connie Fox, an artist close to both Elaine and Willem de Kooning, "were the intellectual currency" of lives otherwise devoted to the solitary endeavor.[34]

De Kooning's wit saw him through the slow contraction of his world. In 1986 I spent an evening with him, and both his absentmindedness and his lightning intelligence were evident. The occasion was dinner at the house of the painter Robert Dash, whom he had known since the early 1950s. Arriving at sundown with Elaine, he shuffled through the door in color-stained overalls and moccasins. With warm recognition he embraced Dash, who asked him how things were going. "Pretty good," he snapped back, "still working for the same firm."[35] Similar quips followed. A black, minimalist drawing on Dash's wall earned the aside "Looks like a pool table," and an extended exchange between us about Holland, which he had bolted in 1926, yielded similarly tart comments. But when asked about his thoughts on Philip Guston's late paintings, de Kooning drew a blank until Elaine, at the other end of the table, prompted him. "You know, *Phil*," she said, in response to which he spoke about Guston, but only in terms of the distant past. In short, he was very alert to his surroundings, playful with words, and even casually profound; but he was incapable of remembering anything without help.

Elaine's intercession that evening was consistent with her general approach to looking after de Kooning and indicative of her motives for doing so. Aware that his lapses were noticed, she cued him when necessary, spoke on his behalf when he did not respond, and made light of his more obviously erratic behavior. She thus offhandedly told a *New York Times* reporter in 1983 how de Kooning had gotten mixed up during an in-flight movie and rose to exit, thinking he was in a theater. "This is a lousy film," he proclaimed. "Let's get out of here."[36] The secrecy surrounding the artist after the early 1980s was an extension of the same attitude. Fearful that de Kooning would be seen by outsiders as diminished by the multiplying signs of age, Elaine, the friends she gathered around, and the studio assistants she marshalled all entered

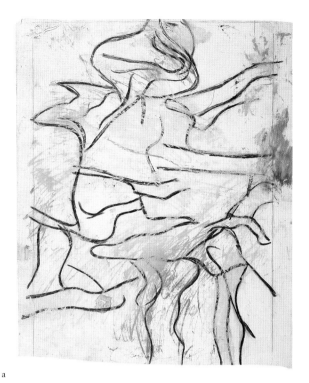

a

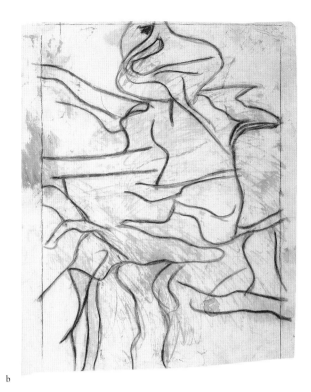

b

2a–b. no title, n.d.
two sides: a. charcoal and oil on vellum, b. charcoal on vellum
52 ½ x 42 ⅛ in., irreg.
Collection the artist

into a practical and emotional compact of protective denial. This apparently dovetailed with de Kooning's own passivity in everyday affairs. Back in the 1950s he had instructed the painter Philip Pearlstein in the rules of art-world survival, and it would seem that he applied the same principles in personal matters as well: "You must not let people know you can take care of yourself," he advised, "because then they won't want to help you."[37] Undoubtedly, he was conscious of his predicament. "I feel like I'm getting a little vacky," he once said to Ferrara in his beguiling accent, pointing to his head.[38] On other occasions, overcome by agonizing frustration, he lashed out against his faltering memory, but such attacks abated as time went on.

The disorientation, vagueness, or uncommunicativeness that caused de Kooning's circle to shield him from the public evaporated, however, when it came to his art. While perusing a monograph of his work with a journalist in 1983, de Kooning stopped at images of *Excavation* (1950) and *Easter Monday* (1955–1956) to discuss where he had started each painting and how he had proceeded from there.[39]

With respect to his own work his memory was vivid, and his ability to reconstruct his decisions from the visual evidence of the reproductions was remarkable. The artist Chuck Close visited de Kooning in May 1982 and found him remote until he crossed the threshold of his studio. At this point his body straightened, his pace quickened, and he launched into a vigorous description of a painting-in-progress, punctuating it with elegant hand motions that were, in Close's recollection, like a mimed version of his sure, painterly gestures.[40] Much the same impression comes from the testimony of Ferrara, Chapman, and other assistants. When idle, de Kooning generally lost his vitality and fell mute; at his easel, or sitting in his rocker studying a work underway, he was alert and decisive. In videotapes made as late as 1988

this intense involvement is very apparent, although by that time the artist's technical control of materials was wavering. In brief, sometime before 1980 de Kooning's short term memory began to fail him, and the confusion this caused hampered and distressed him. But in the here-and-now of painting he proceeded much as he had done all his life, and the doing restored him.

The precise nature of the illness de Kooning has suffered from is a matter of debate and is likely to remain so. The official diagnosis is Alzheimer's disease, but even that has been hedged in a legal statement by an examining physician, who amended his conclusion with the caution "in absence of evidence to the contrary"[41]— properly so, since only a postmortem can provide proof-positive that Alzheimer's is the primary factor in a patient's deterioration. Other hypotheses include stroke or an alcohol-related trauma such as Korsakov's syndrome, which results in acute amnesia. Even if Alzheimer's is indeed the culprit, the fact remains that there is little agreement on the medical etiology of the disease or on how its development would affect a person of de Kooning's special talents. Expert opinion is sharply divided on this score. Some, such as Dr. Harold Klawans, professor of neurology at Rush-Presbyterian-St. Luke's Medical Center in Chicago, have gone on record with the opinion that Alzheimer's produces a progressive loss of mental capacity across the board, from which no particular areas are spared.[42] Other specialists, such as Dr. Jeffrey L. Cummings, director of the Alzheimer's Disease Research Center at the University of California at Los Angeles, are less sure. "People expect that it's a global disease. But all the research says it has a specific profile of deficits. It touches several different areas of intellectual function, but not all areas. We know Alzheimer's affects declarative memory—memory that you are consciously aware of. But it spares procedural memory: the ability to perform complex motor acts. Procedural memory is preserved throughout most of the illness."[43]

For his part, Dr. Norman R. Relkin, director of the Memory Disorders Clinic and program coordinator of the Cornell Neurobehavior Evaluation Program at New York Hospital, provided the following prognosis to art critic Kay Larson, who had inquired about de Kooning's case:

In Alzheimer's, the mind's faculties drop away in stages: first, memory goes, then other functions that are in neighboring regions of the brain, such as the parietal lobe, known to be involved in drawing and construction abilities, spatial relations, and mapping. Color perception, incidentally, is something preserved until quite late in the disease. On the other hand, orientation, size, perspective, motion, all those things are affected quite early in the disease.[44]

Relkin's analysis is provocative on several counts. Like Cummings, he corrects the popular notion that senile dementia is an immutable and all-pervasive affliction. (Much less, parenthetically, is it a cause for shame, although worry about public perceptions partially explains the tendency of Elaine and others to sidestep the issue of what was ailing the artist.) Although Relkin and Cummings concur that some abilities last longer than others, they seem to disagree on which those are. Cummings maintains that complex motor skills survive longest; Relkin, on the other hand, seems to suggest that the faculties associated with drawing weaken early on, while color-perception endures. In de Kooning's case the reverse held true. He sacrificed color to drawing early in the 1980s, and when color returned, in circumstances that I will describe shortly, it seems to have complicated his still authoritative draftsmanship rather than surpassing it in importance, as the general rule advanced by Relkin would predict.

Beyond these clinical exceptions, a more basic question arises: considering the effects of disabilities brought on by age, accident, or illness, is it that which has been lost that most defines a person's identity or that which has been preserved? With respect to the human psyche and its frailties, the question of whether the glass is half empty or half full is especially difficult to decide. When a strength is lost, the whole of one's being readjusts, and to judge someone solely by

the absence or presence of a given capacity is to blind oneself to the subtle ways in which an individual may adapt to his or her predicament. That, in essence, is the lesson taught by Oliver Sacks, whose case studies of neurological anomalies comprise a layman's guide not only to the outer limits of science but to the essential characteristics of the imagination. Sacks's arm's-length response to the problem of de Kooning's probable state of mind confirms, in general, those of Cummings and Relkin, but it goes further:

I have myself seen all sorts of skills (including artistic ones) preserved or largely preserved, even in advanced stages of dementing diseases such as Alzheimer's. Indeed, I think this preservation, if not of artistic skill, at least of aesthetic and artistic feeling, is fundamental. . . . A colleague of mine specializes in this and has some remarkable paintings done by people with Alzheimer's so advanced that they have become incapable of verbal expression. Such paintings are not mere mechanical facsimiles of previous works but can show real feeling and freshness of thought. . . . Similar thoughts arise, I think, with some of Henry Moore's late sculptures, when he was into his eighties, and "not quite all there," in certain respects. . . . I doubt if one can think in simplistic terms of left and right brain or frontal versus occipital lobes, etc. But even in the face of widespread brain damage there can be sudden, remarkable, if transient restitutions of function.[45]

But Sacks's argument is more than technical. It bears on the basic enigmas of the constancy and flux of personality in changing circumstances and over time. "It is, then, less deficits, in the traditional sense, which have engaged my interest," Sacks reports, "than neurological disorders affecting the self. . . . It must be said from the outset that a disease is never a mere loss or excess — that there is always a reaction on the part of the affected organism or individual to restore, to replace, to compensate for and to preserve identity."[46] Sacks makes specific reference to the artistic manifestation of this will to retain one's psychic integrity despite physical or psychic loss:

Personal (and artistic) identity is forged throughout life, becoming richer and richer as one experiences and thinks. It seems to be determined (so the eminent neuroscientist Gerald Edelman postulates) by ever changing "global mappings" of neuronal activity, which involve every part of the brain, and are unique to each individual. Such mappings (with their subjective correlate of "who" one is and what one has to do) may be recalled or reactivated in an instant, even in dementia, and hold their integrity for hours or minutes. "Style," neurologically, is the deepest part of one's being, and may be preserved, almost to the last, in a dementia.[47]

Age and sickness debilitate, but they are also catalysts. Those stricken (and eventually no one is spared) might seem less themselves in gross terms, but in subtler ways they may be simply "other," or different than they were, in order to maintain a more essential continuity of being. Whether a person succeeds in adapting positively to extreme conditions is a consequence of self-knowledge, discipline, support, and unforeseeable good luck in the unfolding of natural misfortune. It is not so much that miracles happen as that the infirmities that inevitably betray us are not always so simple or complete as their onset and symptoms portend. Thus, while the forfeiture of strengths is implicit in the human condition, so too is their constant metamorphosis.

The important thing, finally, is to remember de Kooning's actual situation. The fact is that from 1980, when he touched bottom physically and spiritually, through the end of 1987, when his mental lapses became acute, the artist created 288 of the 341 paintings made during the decade. Rather than slip into inertia or oblivion, moreover, the pace of his creative activity stepped up, even as his horizon closed in. As noted previously, as few as three paintings can be dated to 1980. In 1981 he painted fifteen; in 1982, the year his new style was consolidated,

there were twenty-eight; in 1983, the year of his retrospective at the Whitney Museum, in which six paintings from 1981 and 1982 were shown, he produced fifty-four; in 1984 he held to this level with fifty-one paintings; and in 1985 he exceeded it with sixty-three. He then began to make denser, more labored pictures, of which forty-three were made in 1986 and twenty-six in 1987.

At the peak of this cycle, between 1983 and 1986, de Kooning averaged almost a painting a week for four straight years. By any standard it was an extraordinary effort and a break with past performance. Earlier in his life he had been a notoriously slow worker; during the 1930s and 1940s, and again in the period from 1950 to 1952, during his all-consuming struggle to bring forth *Woman I*, he might, with dazzling facility, completely reconfigure a picture in the course of a single day; but the painting would take months or even years to achieve its "final" form through the partial erasure and gradual sedimentation of these trial resolutions of the image. Even then, a work's state of completion was often contingent. Thus, in 1951 Hess could write, "The only finality is when the painting is carried from the studio to be hung in a gallery."[48] The result, his critical ally Harold Rosenberg later observed, is that "most of the compositions for which he is famous are powerful middles, without beginnings or ends."[49]

Spurred by the concept of Action Painting promoted by Rosenberg, a legend grew around de Kooning's studio agon and, for many, the meaning of his art derived principally from the existential drama of its creation. In this context, a nineteenth-century fable often has been invoked, and for a time it preoccupied the painter himself. It was Honoré de Balzac's apocryphal story of the meeting between the young Nicolas Poussin and a fictional old master, Frenhofer, who had secretly devoted the last ten years of his life to the execution of a crowning work. When the painting was finally unveiled before him in the recluse's dusty atelier, Poussin saw nothing but "a confusion of colored masses circumscribed by a multitude of bizarre lines, forming a strange wall of paint." Out of a corner of this "chaos of colors, indecisive nuances, and formless mist" extended the beautifully limned tip of a young woman's naked foot.[50] One can appreciate how this tale of the quest for the all-encompassing masterwork, with its prescient description of the dissolution of classical figuration into total abstraction, appealed to the creator of so many paintings in which this process was repeated, reversed, and repeated again. Thus the comparatively youthful de Kooning symbolically rehearsed the part of the elderly, obsessed Frenhofer. Upon reaching old age, however, rather than playing out Balzac's scenario to its muddled and pathetic conclusion, de Kooning threw himself into high gear.

If, as Hess once claimed, "to finish meant to settle for the possible at a given moment,"[51] then by 1980, with time running against him, de Kooning was inclined to let the "possible" speak for itself at the moment of its greatest freshness. Even so, the "all-at-once" appearance of many of the works from 1980 to 1983 is often misread. It is as likely as not that the polychrome tracery and sheer whites of those paintings cover up weeks' or months' worth of full-blown, alternative compositions that were scraped or sanded down to leave the smooth, pentimenti-thin surface de Kooning preferred. Photographs taken by Ferrara (figs. 3a–n; and p. 28, figs. 27a–c) record the history of these paintings in as many as seventeen stages. Around 1983, however, de Kooning started to proceed more rapidly through his painterly steps, eliminating some in the process. Initially, applications of pigment tended to follow preparatory drawings more closely, while the rotation of canvases became less frequent. Paintings that "worked" were worked on until their components fell into place; those that did not seem to have been set aside without prejudice. Many of the latter display marvelous shape-fragments and couplings and virtuosic strokes that de Kooning left unrevised as he moved to the next unencumbered pictorial opportunity.

Responding to the skepticism that greeted these pictures from 1983 to 1986 among those who, in the absence of the signs of struggle long thought to be the artist's hallmark, refused to credit them with an authoritative intention, de Kooning's assistant Larry Castagna offered this explanation: "People said, 'What is going on here? Is he becoming a factory?' But he was setting up a process. He wasn't done, then he'd start another. He made these paintings as a grouping. He fanned out. You've got to see them for what they are, like an army, this one big group."[52] Meanwhile, all who closely watched the change in momentum occur agree on its basic causes. "By then," Ferrara believes, "he'd made a conscious decision to be less self-critical, to err on the side of underworking rather than overworking [as he tended to do during the 1940s and 1950s]. He was trying to simplify, to concentrate on something he was best at, which is drawing. He had a warm, a cool, and a white. He knew his days were dwindling and he was propelled. He was not struggling. He wasn't trying to prove anything. He was just doing. It became like breathing. He just breathed them out."[53]

Thereafter the story becomes a sadder one, but it is not without its surprising creative episodes. By the end of 1985, aspects of de Kooning's condition deteriorated noticeably. More troubled by his memory lapses and less talkative than before — although still capable of jesting remarks and cryptic but insightful asides — the artist suffered increasing disorientation, and he rarely left the studio and its grounds. Within those surroundings, basic routines had long been established, and, spurred on by all engaged in their maintenance, he was able to work on a regular schedule with sustained concentration.

Inconsistencies threw him, however. By 1986, for example, he ceased painting small canvases altogether and stuck exclusively to the proportion of seven-to-eight he had favored since the mid-1970s.[54] After this point, de Kooning depended more and more on his assistants to block in the initial design and to lay down the interstitial whites, or when the latter was not done, to fill in the areas ("holidays" the artist called them, using housepainters' jargon) where he had left the matte off-white of the primed

canvases exposed instead of covering it with a brighter oil coat. All of this was done at Elaine's behest, although as late as 1988 her brother can be heard on a videotape urging the artist to draw on the canvas himself. "You've got the touch, Bill," Fried admonished and, indeed, he did.[55] The difference is readily apparent between those late pictures in which de Kooning's own incisive lines are intermittently visible under the painted surface and those (increasingly common after 1985 and 1986) in which the skittering, tensionless, and tonally unnuanced marks of the helpers show. In the very late paintings, moreover, the lack of spring and direction to the assistants' strokes seems to have deprived the artist of the resistant armature he needed to proceed; much of the reiterative painting that followed appears motivated by the attempt to tighten the loose underpinning the surrogates sketched in.

Also at Elaine's suggestion, the assistants prepared de Kooning's palette. Since 1980, when he began smearing thin films of pigment with a piece of cardboard or a Spackle knife, Ferrara, Chapman, and the others had enriched his paints with premixed medium to prevent their cracking. Although he later abandoned this practice, the unctuous solution remained the same, and as it sat out in open dishes for days it would thicken still more, so that many of his paintings, especially those from the second half of the decade, when his pace slowed, have a syrupy texture. The tackiness of their oil coats and the melting drag of one layer crossing another remain palpable in the sensuous weight of these paintings, which is quite different from the wafting quality of the more purely visual works that preceded them. Around 1985 and 1986, Elaine became nervous about some of the critical reaction to the predominantly red, white, and blue paintings of the previous three years, and she suggested to the assistants that they expand de Kooning's choice of colors. In addition to squeezing out his preferred primaries, they premixed alternative reds and blues and supplemented them with yellows, oranges, greens, and violets, which to varying degrees entered into his basic color scheme.[56]

54

a

b

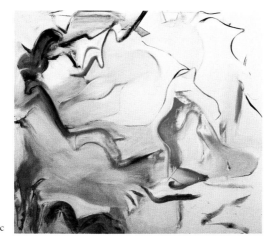

c

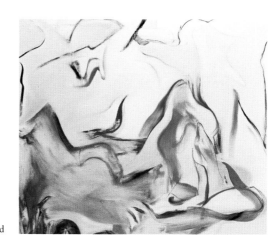

d

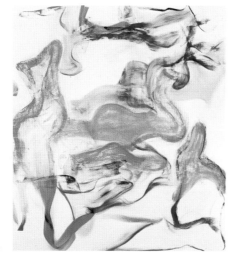

e

3a–n. Fourteen stages in the development of
Untitled XIII, 1982 (pl. 12).

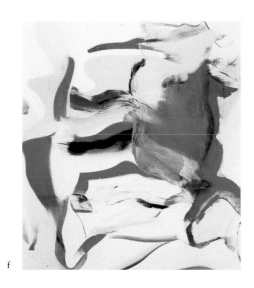

f

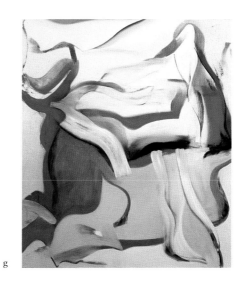

g

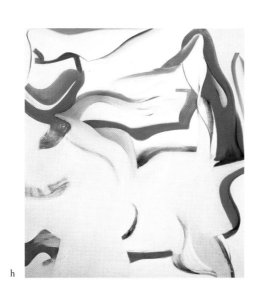

h

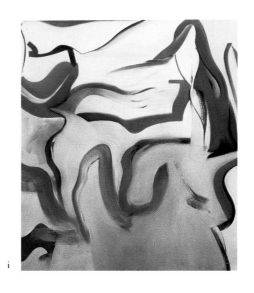

i

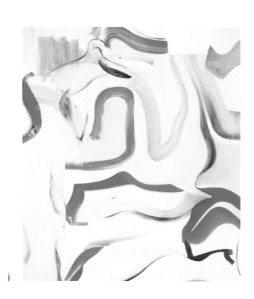

j

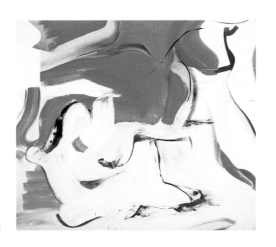

k

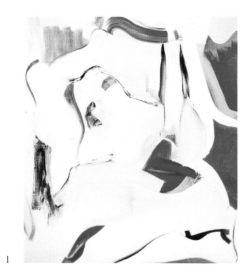

l

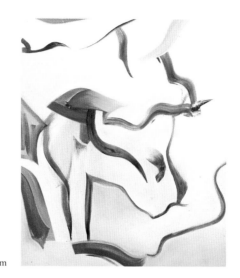

m

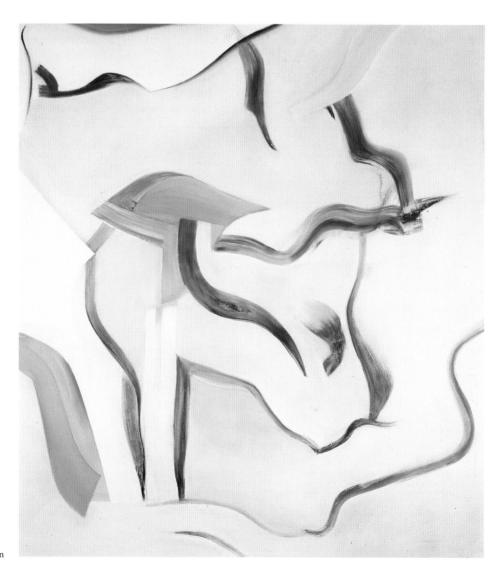

n

As with the drawings considered for enlargement, the assistants' involvement in such cases seems to have been based on principles of empirical preselection and multiple choice. Intuitively anticipating de Kooning's thoughts as he became more withdrawn, they would present the artist with a set of options consistent with his interests of the moment but would allow him to make the final decisions. Unfortunately, during the last three years he painted actively, this system broke down. In June 1987 Ferrara left de Kooning's service. Other than Elaine, he more than anyone had set the tone and ground rules for the studio and, like her, he was as attentive to the artist's needs as he was in awe of his talent. Antionette Gay, who replaced him, arrived at the point Ferrara had begun to feel his role had changed from artistic facilitator to caregiver. Lacking much painting experience of their own, Gay and, later, Jennifer McLauchlen did the best they could to fill the void. But Gay's taste intruded and, to a lesser extent, so did Chapman's. Although motivated by different concerns — Chapman, largely for technical reasons, wanted to banish the muddy hues that resulted from de Kooning's constant surface blending of certain complementaries, while Gay chose colors she thought compatible with those already in use or ones she simply "liked" — the substitutions they made radically altered the artist's vocabulary.[57] Ignoring the color charts over which de Kooning had labored in the 1960s and 1970s, a number of which were still scattered around the studio, Gay mixed an exotic range of pastels, and Chapman acquiesced insofar as they were more compatible than the harsh, contrasting reds, greens, blues, and oranges and their uncontrolled admixture.[58] Furthermore, Chapman recalls that to avoid repetition when copying a drawing onto a canvas, he occasionally would combine sections from two or more of the handful they recycled, effectively composing a new image from the fragments of old ones.

Although these interventions occurred after his departure, Ferrara seems to have spoken for his peers when he recalled his own last year in the studio as a "difficult time." As he remembers, "The impulse was tremendous to help Bill in any way you could. The temptation was to be overzealous."[59] The much-publicized speculation that de Kooning's assistants had actively injected themselves into his painting process for self-serving reasons appears to be groundless, however. Although one of them, Joanne Lowenthal, who was briefly on the scene in 1980, has suggested that Elaine allowed Ferrara to work on de Kooning's pictures,[60] the visual evidence and other accounts contradict her, except insofar as this claim applies to the preparatory drawing that disappeared under the work of the artist's own hand or to the occasional patched-in whites that in no way altered the compositions as he left them. De Kooning's various studio assistants have firmly denied in interviews conducted for this catalogue that they surreptitiously painted his paintings. The accusation that his work of the 1980s was to a greater extent their creation was a product of unfounded rumors that circulated in the absence of hard information coming out of the studio after 1983.

One set of facts and one negative logical test of these insinuations should be sufficient to disprove them. First, judging from the level of their formal training and from their own paintings, some of which show de Kooning's direct influence and so serve as a useful index of the assistants' imitative skills, no one in the artist's entourage at this time, including Elaine, had the manual dexterity to convincingly mimic his graphic line or painterly stroke even in small passages, much less to sustain such a ruse

throughout an entire painting. Second, the close variations in which modern forgers specialize seldom deviate far from the given master's "average best"—this so that their frauds do not attract unwanted attention by being too provocatively "original" in conception, on the one hand, or too obviously based on a docmented work, on the other. Neither Ferrara, Chapman, Fried, nor anyone else has ever attempted to hide the fact that reusing photographs of old works was a regular step in beginning new paintings; getting de Kooning "started" was the sole object of the exercise. Had anyone close to de Kooning intended to fake his work, in part or in whole, in the quantity that exists, it makes no sense at all that they should have devoted such effort to making incomplete or unresolved paintings, a substantial number of which can be found among the late work. A great artist's authentic thumbprint is frequently best seen in his or her failures, which are testament to the willingness to sacrifice tried-and-true formulas for the sake of a possible self-transcendence that more cautious talents rarely possess. Robert Rauschenberg makes it clear how well de Kooning was aware of this. "One night," he said, "I asked Bill how he felt about most of the New York painters painting like him. . . . He said, he didn't worry because they couldn't do the ones that don't work."[61]

That de Kooning's artistic energy was winding down and his periodic fixation on details was increasing is poignantly visible in the chromatic blur and whirling vortexes or in the heavily laminated arcs of many paintings made from late 1987 through mid-1989. Such hypnotic repetitions and perseverations are indeed symptomatic of neurological disorder. An action painter "captivated by the act," de Kooning eventually lost the ability to make the space-expanding gestural leaps that had been the essence of his art.[62] In the months before Elaine's death in February 1989, when she was in and out of the hospital and away from de Kooning's

studio, Lisa de Kooning, the artist's daughter, instructed Chapman and Gay to put a fresh canvas on the easel without projecting a drawing onto it. After some hesitation de Kooning inscribed a targetlike set of concentric circles near the middle and then reiterated them in an automatic motion. Several days later he returned to the painting and did the same in the upper right-hand corner. Some time after that he again approached the canvas and brushed a crisp, multicolored arabesque that might have been lifted whole, like a jigsaw-puzzle piece, from a painting of the 1940s or 1950s. And that was all. Between the first shape and the last lie extremes of compulsive activity and alert shape and muscle memory, but without the linear connective tissue he could not dynamically associate them sufficiently to stimulate further invention. Although de Kooning continued to paint over transcribed charcoal patterns for another year (through 1989 and into early 1990), around which time Chapman and Gay left the studio, his canvases lost their essential structure.

It is the nature of aging, however, that there are good days and bad. Until the very end, de Kooning's good days produced amazing visual events. The same formal modulations that resulted in garish, knotted pictures when his concentration wandered gave rise to an identifiable new look in those he was able to keep in focus. Starting between 1986 and 1987, their curves generally broadened and became more muscular and convoluted, while the spaces enclosed by these rippling lines flooded with color; combinations of high-keyed reds and yellows predominated even after the arbitrary pastels began to contaminate his palette. Despite, rather than because of, the solicitous interference of some of those around him, de Kooning used the last of his waning powers to make bold paintings that, if nothing else, render undeniable the purposefulness of the attenuation in his works of 1983 to 1987. While few of the very late canvases are individually successful, collectively they demonstrate that, even as his capacity to follow through on his intentions deserted him, de Kooning was, yet again, consciously shifting his course.

III. THAT'S WHAT FASCINATES ME . . . TO MAKE SOMETHING I CAN NEVER BE SURE OF, AND NO ONE ELSE CAN EITHER. I WILL NEVER KNOW AND NO ONE ELSE WILL EVER KNOW. WILLEM DE KOONING[63]

What, then, are we to make of the last phase of de Kooning's long, elliptical course? Mindful that the often spectral paintings of this period are the work of an artist nearing his life's conclusion, some have approached them as one might an elderly person, whose extended hand one grasps gingerly at first, fearing the brittleness of the bones, only to discover the actual firmness of the grip. However fine their linear skeleton, translucent their blanched or blushing skins, and diffuse their tinted veins, none of the late de Koonings is frail.

Whether expressed as solicitude or apologetic disparagement, the critical overcompensation for age frequently shown these paintings derives, I think, less from their appearance than from the way they disturb the composite mental picture many people have of the New York School of the 1940s and 1950s. Abstract Expressionism, to paraphrase W. B. Yeats, was not a country for old men. As things turned out, in fact, relatively few of de Kooning's generation reached that status. Hard living took its toll early, and the actuarial summary is grim: Gorky died at forty-four in 1948, Bradley Walker Tomlin at fifty-four in 1953, Jackson Pollock at forty-four in 1956, Franz Kline at fifty-two in 1962, William Baziotes at fifty-one in 1963, David Smith at fifty-nine in 1965, Ad Reinhardt at fifty-four in 1967, Barnett Newman at sixty-five in 1970, Mark Rothko by suicide at sixty-seven in 1970, and Philip Guston at sixty-seven in 1980. Like de Kooning, moreover, most of this group were late bloomers; their mature creative periods and public careers were thus even shorter than these statistics indicate. Only Hans Hofmann (1880–1966), Adolph Gottlieb (1903–1974), Clyfford Still (1904–1980), Robert Motherwell (1915–1991), and James Brooks (1906–1992) survived into their seventies or eighties.

While Reinhardt's and Rothko's darkly tonal work represented (more for aesthetic than for morbidly biographical reasons) what one might call terminal styles (figs. 4, 5), it was de Kooning and Guston who, alone among their peers, broke free of previously established modes in their last years to initiate distinctively new painterly approaches. At the start of these ultimate departures, each had roughly a decade ahead of him, but both proceeded as if time might be even shorter. Clocks were, indeed, ubiquitous in Guston's symbol-cluttered allegories (fig. 6), simultaneously signifying mortality and continuity, the closing of a circle and its unpredictably openended reinscription. In such boldly delineated images of the 1970s, Guston returned to a narrative approach and to the classical motifs and settings of his earliest work — and returned with a vengeance. Out of the delicately frayed gestural fabric of his 1950s abstract paintings and the clotted but still ambiguously figurative interplay of forms and atmospheres of those from the 1960s, Guston created new art that was recharged by apocalyptic caricatures of a world shattered by violence and mired in spiritual uncertainty. It was useless for him to rage at the dying of the light in the already penumbral desolation of his imagining. Instead, he howled at the absurd antics of his Ku Klux Klansmen, bean-head drunks, and other alter egos, who strained against the cumulative, inertial weight of their existence. At first dismissed as the Johnny-come-lately Pop vulgarities of a former mandarin of abstraction, Guston's testament, in fact, combined his knowledge, lost illusions, and fully paid-for self-absorption with a defiant vigor. In the long battle between desired serenity and ineradicable anxiety, it was anxiety, leavened by gallows humor, that had the final word. Not yet old, but at the end of his tether, Guston accepted his fate but never "let go."

4. Ad Reinhardt, *Abstract Painting*, 1963
oil on canvas, 60 x 60 in.
Collection The Museum of Modern Art, New York
Gift of Mrs. Morton J. Hornick

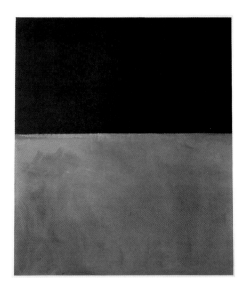

5. Mark Rothko, *Untitled (Black and Gray)*, 1970
synthetic polymer paint on canvas, 78 x 66 ¼ in.
Collection The Museum of Modern Art, New York
Gift of Mark Rothko Foundation, Inc.

After his own raucous "cartoons" of the mid-1960s and the lathered quasi-landscapes of the 1970s, de Kooning — ten years Guston's senior — took that next step. Until that time, the artist whose work was said by the painter and critic Fairfield Porter to have "rocked the eye"[64] had, like Guston, rocked back and forth between extremes of elegance and anguish. De Kooning's attacks of white-knuckle uncertainty were real enough, but his attitude toward them was pragmatic in ways that the myth often ignores. "My interest in desperation lies only in that sometimes I find myself having become desperate," he once said. "Very seldom do I start out that way."[65] Nor did he necessarily finish that way. However thrashed out de Kooning's paintings may seem, they are never expressionist in the sense of being the unmediated projections of some inner turmoil. Products of the careful grafting of formal fragments culled from disparate artistic sources — prehistoric, Renaissance, Baroque, high modern, and contemporary vernacular — that climaxed in the shredding, flaying, and provisional reconstitution of the image, even the famous Women of the 1950s were more impersonal than that.

De Kooning was a classical painter in an anti-classical age. The sinew of his art was traditional drawing endlessly adjusted to unstable volumes. Its flesh was pigment stretched to the limits of textural and chromatic self-definition. Women may indeed have driven him crazy (and he them) but it was the reinvention of overstressed classical models that tormented the artist more. His achievement of that end — through the struggle that began in the mid-1940s, when he first attacked the Picasso-Miró-Ingres paradigm synthesized by Gorky (fig. 7), and culminated in the mid-1950s, when the spark-throwing friction of *Composition* (1955), *Gotham News* (1955 – 1956), and *Easter Monday* (1955 –1956) smoothed out into the broad-brush abstractions, such as *Bolton Landing* (1957), of his last New York years and then into the radiant foam of *Rosy Fingered Dawn at Louse Point* (1963) — left him in a curious and, some thought, compromised position. Success was not allowed an artist so caught up in the drama of failure. Or so it seemed to those who insisted that he always fail on the same aesthetic terms. In the mid-1960s, when de Kooning's Manhattan gorgons turned to Long Island "cuties," some in his camp worried aloud that he had copped out, while others, long contemptuous of his efforts, viewed his florid new work as the last straw.

6. Philip Guston, *Flatlands*, 1970
oil on canvas, 70 x 114 ½ in.
Collection San Francisco Museum of Modern Art
Fractional gift of Byron R. Meyer

Hess (as usual, sympathetically close to the action) got it right. "So it is most appropriate," he wrote, "that de Kooning's pictures of the 1960s are drained of the anguish and look of despair which had so profoundly marked his earlier work. In the new Women, the mood is Joy."[66] Hess left the cause for celebration vague. In part he ascribed the change in style and spirit to the artist's move from an urban to a rural setting, and de Kooning's comments about his enthusiastic rediscovery of North Atlantic light buttress that interpretation. The underlying cause, however, seems to have been the freedom he had found in his novel fusion of drawing and painting. At last he could contour and model a form all at once, delineating the body and putting in the dimples in a single stroke. Invoking with irony the memorable phrase of his favorite philosopher, Kierkegaard, to

describe the graphic and psychic resonance of this new work, de Kooning captioned a 1963 pencil sketch "*No* fear but a lot of trembling."[67] While his foul-weather friends lamented the evident pleasure he took in this accomplishment, de Kooning proceeded to subject it to the rigors he habitually imposed on all painterly conventions. Often he did not meet his own high standard, but these lapses, rather than being seen as heroic, were now judged differently. Because the struggle that brought these paintings into being was wholly absorbed into sensual delight, it was, for some, as if the struggle had never occurred. De Kooning, the artist of Sisyphean effort, was henceforth under suspicion of having taken a long detour down easy street.

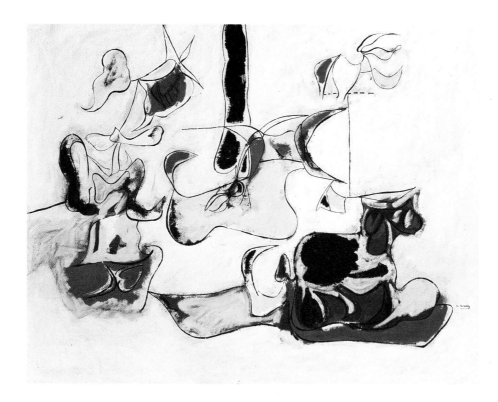

7. Arshile Gorky, *Garden in Sochi*, c. 1943
oil on canvas, 31 x 39 in.
Collection The Museum of Modern Art, New York

In the 1980s, the conflation of drawing and painting partially reasserted itself in de Kooning's work, but the tangible anxiety that had originally prompted his joining them (and consistently accompanied it) did not return. Quite the opposite. As the heavy, oleaginous currents and skimming riptides of color of the late 1970s paintings stilled and receded, the sheer hues and spare structure of his new work emerged—light, sharp-focused, and assured. After barely surviving the worst emotional and physical crisis of his life, de Kooning painted the return to his senses. Those who doubt the motives or circumstances of this about-face would have had him work against the grain of his talent and suffer for it publicly. Instead, having reversed the course of his life, he followed his talent's natural inclination with an astonishing deftness and poise.

Although these pictures belong to the artist's old age, they belong to their own moment as well and demand to be seen as a part of it. That moment was "The Eighties." Like "The Sixties," "The Eighties" spilled over its strict chronological limits while not quite fulfilling its epochal promise. Much has been made of the Lazarus-like revival of painting that took place during that decade after the fifteen-year predominance of experimental sculpture, performance, video, and other alternative media, all of which had been critically touted or decried as the nails in painting's coffin. If it was true, as Peter Schjeldahl claimed, that "about 1960, de Kooning dropped off the charts of public sensation in contemporary art," then the unforeseen explosion of bravura painting two decades later put him back on—or should have.

Those whom de Kooning once called the bookkeepers of art history are seriously inconvenienced by such temporal convolutions; they prefer to track each generation of artists through their careers as separate stylistic- or context-fixed groups rather

than to consider the more complex ways in which the "ages of man" lived by an individual may intersect with, deviate from, or reconnect with the march of historical time. Having declared all abstraction after the minimalist work of Frank Stella retrograde and all figurative painting after the advent of photo-mechanical reproduction obsolete, postmodernists of a conceptual bent had special difficulty accounting for the ongoing activity of artists whose early achievement they honored but whom they consigned to a past completely cut off from creative possibility in the present.[68] Meanwhile, in surveying the turgid mass of average 1980s painting, one is forced to conclude that the future of the art form rested at least as much with the old hands as with a rising vanguard that too often contented itself with acts of appropriation that recycled the images and mannerisms of its predecessors.

Setting the terms of this intergenerational relationship, Guston's artistic transformation from Abstract Expressionist prince to Neo-Expressionist frog not only laid the groundwork for younger artists working in similarly bold, iconic modes but placed him — despite obvious differences of motive and experience — in a forward position among their ranks that would have made any falsely "hip" move on his part look ridiculous and any unearned old-masterisms on theirs immediately detectable. His activity reinforced theirs and vice versa, making him in this period of aesthetic transition the artistic peer, not the parent, of Susan Rothenberg, Elizabeth Murray, and their contemporaries. If you wanted to know what a brush could do, how forms reacted to pressure, or how it felt to be alive at that time, you could look at Guston, just as you would artists thirty or forty years his junior, and be assured that the answer forthcoming was in the present tense. Although he died in the first year of the decade, Guston's late work is as much a part of "The Eighties" as it is a chapter in either his own unfolding story or that of his exact coevals.

De Kooning's canvases of the 1980s are "Eighties" paintings by the same token.[69] The difficulties he posed and the license he gave himself set a mark by which others then active can be measured. In scanning the thinly apportioned webbing of Brice Marden's mid-1980s to mid-1990s canvases, for example, one inevitably thinks of de Kooning's discursive tracery. Conversely, the raked color sediments of Gerhard Richter's recent abstractions flash in the mind as one scrutinizes the scraped-back layers of de Kooning's palette-knife-drawn pictures from 1980 to 1982. Stylistic debts or coincidences are of less interest in this regard than decisiveness and freshness of effect. While he plainly could not match the strenuous exertions of those who gave "The Eighties" its period look, de Kooning did not need to make his presence felt. Instead, he could occupy a place on the scene much like the one Merce Cunningham, in recent years, has assumed amidst those performing the choreography he once danced full tilt. Shuffling through the racing flurry of younger bodies, Cunningham now arrives on stage, plants his painfully arthritic feet squarely on the floor, and extends his arms in stop-start motions of such space-shaping precision and emotional eloquence that the movements of the finely trained chorus around him may seem, by comparison, cramped and jerky.

As de Kooning grew older, his reinvigorating determination required an increasing economy of means. The stages of technical simplification — and studio-assistant involvement — were gradual, marking distinct periods within the ten-year span that generally have passed unnoticed thus far. Far from uniform in appearance or facture, the paintings of the 1980s, seen apart from previous bodies of work but in their true variety, follow a distinct progression. Although the handful of transitional pictures reliably dated to 1980 are not the equals of the more fully resolved ones that followed in 1981 and 1982, de Kooning's shift in painterly attack was apparent already at the turn of the decade. Confronted by the flat, delicately smudged tints of old, sanded-down canvases, de Kooning as often as not left his brushes on the palette and approached the easel with a tube of oil color and a blade. Drawing directly on the surface with extruded paint that, when left untouched,

8a–d. Four details from *Pirate* (*Untitled II*), 1981 (pl. 2)

cut across the smooth, mottled undercoat in bright, trailing ridges, the artist would pull the excess away from the mark with a sharp utensil, spreading line into plane and, with a twist of the wrist, transforming a smear into a shape whose contour he might crop with an additional erasure stroke. So doing, he summoned from the shallows of his broad-brush paintings of the 1970s the floating biomorphs last seen in works such as *Pink Angels* (1945; p. 23, fig. 12) and *Fire Island* (1946). But with this difference: The comparable, often limblike forms of the earlier pictures are usually outlined in black and filled with color. However wispy, those found in *Pirate* (*Untitled II*) (1981, figs. 8a–d [details] and pl. 2), *Untitled III* (1981, pl. 3), and contemporaneous works are all of a piece. Like pennants in the breeze or seaweed in coastal pools, their alternately fringed or crisply defined perimeter is an integral part of a supple membrane. Almost instantaneously, it seems, flexing lozenges would appear and disappear under the artist's hand, slipping over or under adjacent veils, arcs, and S-curves or stopping short, only to find their undulation picked up by neighboring flotsam.

In the constantly evolving reciprocity of his painting and drawing, de Kooning now applied himself like a plasterer, layering in skim-coats of sparkling paste that he incised with soft charcoal and a hard paint-tube tip oozing fresh pigment, or that he stretched and trimmed with the practiced back-and-forth sweep of the housepainter. The dense, lateral strokes of *Untitled V* (1981, pl. 4) and the brilliant,

diaphanous tatters of *Pirate* are the divergent results of this practice; in *Untitled III* (1981) it is combined with brushed modulations. By 1982 this process was altered yet again. Although he still favored very thin coats of oil, de Kooning began at this time to rely more on brushwork and less on hard-edged implements. While the tapered interlacing of knifestrokes continued, he now blocked out the areas they framed with a liquid paint, filling in swollen-red or solar-yellow passages or editing out large sections entirely with white.

As with the works of his past, de Kooning's astonishing dexterity often leaves the impression that the image one sees came together — or came dramatically apart — in a single, intense burst of activity. The overall leanness of his surfaces encourages this belief. As noted earlier, however, photographic records show that most of the paintings of 1980–1982 gestated slowly and went through as many as a dozen or more distinct phases before reaching their final state. At the margins of works such as *Untitled V* (1982, pl. 7), and in the internal breaks in their fabric, one can visually separate the overlapping coats all the way down to the pigment-caulked and sandpaper-abraded tooth of the canvas. The optical consolidation of figure and ground, of a form's translucent skin and its opaque core — which the old masters arrived at by building up glazes — de Kooning achieved by adding and subtracting pigment until it fused into a thoroughly integrated whole. Submerged beneath the swirling whites that gradually swamp the gestural channels and surround the color masses of the paintings made from 1982 onward are countless shapes and linear inventions.

Almost thirty years earlier, de Kooning explained himself this way: "Sometimes, you know, I feel like a liberal! I'm a yes-man, first; then I take things out."[70] Since that time, nothing in his approach had changed but the degree and the method of cancellation. Everything, though, was different in the look of the pictures, which, for all their procedural similarities, ranged widely in structure and feeling. Whereas the gestures of *Untitled V* (1982) travel with a whiplash speed over and under their patchy ground, the light organic aggregates of *Untitled III* (1982, pl. 6) drift in a blanched atmosphere. The latter is suffused with erotic languor; the former snaps with energy. Still more dynamic is the churning, muscular *Untitled XV* (1982, pl. 10); and with its Phoenix-like blue shape rising from a conflagration of reds and yellows, *Untitled XII* (1982, pl. 9) is simply exalting. By the end of the year in which all these paintings were made, however, another mood took over, and another studio approach. In some respects unique among his paintings because of its fastidiously toned and grained forms, *Untitled XXIII* (1982, pl. 12) is otherwise indicative of the generally restricted palette and flatter graphic appearance of the work of the mid-1980s. An untitled painting of 1984 (pl. 23), with its pastel blues and powder pinks, comes nearest to it, and both canvases recall the early abstract *Elegy* (c. 1939; p. 17, fig. 6).

As before, red, white, and blue predominate, supplemented by yellow and black. Henceforth, however, these colors are applied almost entirely by brush, and the progression from drawing to painting becomes more and more consistent. Working from other pictures or from reproductions, de Kooning would sketch in a loosely mullioned pictorial design in charcoal, parts of which he would then fill in with paint, pulling his stroke up to, along, or away from the dark granular lines. In so doing, he would frequently drag dust into the surrounding white so that the transition from mark to adjacent plane became gently shaded, thereby creating the folding elisions of form and context that are the essence of what has been called his "liquified cubist" syntax. At the same time, de Kooning would cover the other sections of the drawing with primary hues, on occasion rendering exactly the narrowing and flaring of a previous charcoal gesture. From here on, he would modify and correct this warping framework by working simultaneously from the inside and the outside of its various components — accentuating or reversing the parallel curvature of congruent shapes or lines; cutting into one with the backsweep of a brushstroke that reinforced another; bridging the space between paired lines and thereby turning them into a unified form; feathering broad areas of white with red and yellow traces until they blushed throughout; rubbing down arabesques with the thumb, finger, or heel of his hand to fuse the overlaid marks that composed them; or blotting the surface with a paper towel to soften a contour or dampen the shine of oil-rich paint. (Thought by some to be the result of weakening eyesight or faltering control of his tools, the fuzzy quality in de Kooning's late paintings is rather the deliberate result of these last two techniques.)

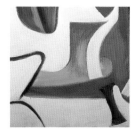
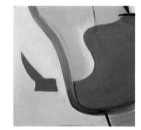

9a–d. Four details from *Untitled VII*, 1985 (pl. 26)

The variety of painterly operations to which de Kooning resorted in these canvases is remarkable, given the simplicity of their overall effect. Although they appear to be one-shot pictures when seen at a distance, one realizes upon closer inspection that they have been massaged into being over long hours. Their minimalism is *achieved*. Rather than fading to white, they are the consequence of purposeful eliminations. By 1984 and 1985, moreover, white at times obliterates all but the skeleton of de Kooning's original compositions. Careful inspection of the surfaces of two untitled paintings from 1984 and 1985 (pls. 24 and 29, respectively) reveals faint blue and black lines coursing under the translucent white, as well as low ridges and indentations in the enamel-like ground that are the opaque, tactile shadows of buried forms.

Within the same period, however, de Kooning was capable of making pictures of startling vividness. *Untitled XIII* (1985, pl. 27) blooms with yellow, pink and green silhouettes, while the interlocking biomorphs and bladelike colored tongues of *Untitled VII* (1985, figs. 9a–d [details] and pl. 26) are reminiscent of de Kooning's Gorky-inspired abstractions of the late 1930s and early 1940s, particularly *Untitled* (c. 1939), formerly in the collection of the photographer and painter Rudy Burckhardt, in which an arrowlike device, similar to the one near the left-hand margin of the later painting, also appears.

The oscillation between delicacy and boldness continued unabated throughout 1986 and 1987. On the one hand, there is *Untitled XXIV* (1986, pl. 33), with its mounding landscape background and its concentric tunnel-arcs to the right, or the bound-up yellow and blue volumes of an untitled painting from 1987 (pl. 36). On the other hand, there are caprices such as *Untitled VI* (1986, pl. 31) and the even more eccentric untitled painting from 1987 (pl. 34). One reads these paintings with some difficulty, unsure of how far de Kooning intended to take them — and whether he had succeeded in fulfilling his evolving pictorial ambition — or of what image or combination of images might have been their source. But the playfulness in them is undeniably infectious, and their intricacy is amazing. Painted near the last turning point of his creative life, their entanglements capture and hold the spirit of possibility.

The refinement of another untitled canvas of 1987 (pl. 35) is of a different order entirely. Spare, complete, and elegiac, its meandering, muted red strokes and perfectly positioned switchbacks are suspended in a blank, white field. Movement stops, space flattens, and form vibrates. That is all, and for always. Like much that precedes it, this preternaturally easeful picture reaches back and resynthesizes elements long familiar in de Kooning's work. The sense of altered remembrance results in part, no doubt, from the enlargement of old images, but the painting's impact owes at least as much to the stylistic adjustments and advances this technique precipitated. In the mid-1940s to early 1950s, when his work was at

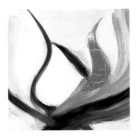 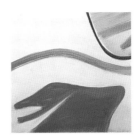

its most calligraphic, de Kooning often had drawn and painted with pliant, long-haired letterer's brushes dipped in ink, runny enamels, or dilute oil color. A flick of the arm left an alternately splayed or thread-like track, while the trimmed stripper's brushes both he and Gorky used to circumscribe and link their Miró-esque forms would, under varying pressure, spread and tighten in quill-pen arcs and scrolls. All these effects, subsumed in a continuously flowing line, could be accomplished in a single stroke, lending his abstractions a loose, eye-darting quickness and urgency. By comparison, the canvases of the 1980s are more graphic than calligraphic, more like signs than handwriting. This was consonant with de Kooning's taste for billboards, which he had referred to as far back as 1963 in an interview with David Sylvester (subsequently published with the apt title "Content is a Glimpse") and which, later in his life, became a recurrent topic in conversations with his assistants.[71] Where de Kooning once had pulled images — whether of women or abstract forms — apart in the struggle to pull them together, by the mid-1980s he was recording the subtle internal vibrations of shapes that, at least initially, read clearly against their predominantly white grounds.

De Kooning, of course, had trained as a sign-painter, and the trick of blocking in letters by laying in a simple, solid form and then tailoring it by deft outside-to-inside cropping was as much a part of his craft as was his looser, more discursive manner. In the 1980s this second technique supplanted the first.

However facile and abrupt they look, the pointed "characters" of his painterly script (sometimes resembling the Kufic lettering of Arab texts and decorative arts) and the Baroque serifs that sprout from his larger shapes are the almost illusionistic result of painstaking configuration and reconfiguration. Pictures that may appear hurried or slapdash nearly always, to some degree, have this quality to them as well. Even what seems to be the track of a single brushstroke is in most cases the blending or braiding of multiple marks. Thus there is a double reading to the long, winding line that emanates from the bottom right-hand edge of the untitled 1987 painting mentioned previously (pl. 35), which curves around toward the top right-hand corner and then returns back two-thirds of the way along the painting's upper margin, circuitously traveling a distance of some eight or nine feet. Uncoiling with gravity-defying grace, it seems at first uninterrupted and potentially endless, like some gently invasive vine. Yet precisely because it is not — because it has been so carefully extenuated by subtle forward reiteration — it slows our glance to such a degree that what initially seemed destined toward infinite length assumes the aspect of something infinitely protracted in time.

68

In gestural painting of de Kooning's sort, execution *is* content. Harold Rosenberg was on the right track when he coined the phrase Action Painting, but in his fervor he emphasized speed and spontaneity over patient artisanship. At the time he set forth his definition, with de Kooning uppermost in mind, this imbalance was less obvious and misleading than it has become since. The existentialist/expressionist motives said to prompt such art demanded catharsis. And catharsis won't wait. Rage, frenzy, and ecstatic release were therefore read into the pictures, whose physical makeup was more considered and whose aesthetic impact was more rhythmically structured and visually fluent than the violent scripts the critics handed their creators could account for.

There was, however, another reason for the rapidity with which de Kooning, in particular, worked: rather than being seized by irrepressible emotion, he moved fast lest the fleeting impressions that caught his imagination escape him. As far back as 1959, he would explain the discrepancy between painstaking method and urgent effect this way:

Well facing the future, you do it with discipline, you do it with the experience from the day before. This consciousness must have come at one time or another, so each new glimpse is determined by many, many, many glimpses before. In other words, from that point of view, I am an average technical, professional man. I have a vocation. I am an artist. In a way of speaking, there is a division of labor connected with it. In a certain way, I am a professional inspirationalist. I have those pots of light. I then proceed to work very calmly. The paintings look rather explosive, I've heard.[72]

The approach de Kooning describes is close in spirit to that of jazz musicians, whose impromptu riffs on old standards and simple melodies are prepared with constant practice and alertness. De Kooning could furiously repaint an entire picture in a day only because of his disciplined "experience from the day before." Even then, pictorial results could be deceptive. "Is it possible to paint a slow Action Painting?" Rosenberg finally asked him during a 1950s roundtable. "Yes," was his matter-of-fact answer.[73]

In the 1980s de Kooning painted fast *and* slow, but when it was the latter it was not just a sign that he was "slowing down." If anything, the opposite was true. When things came without resistance, as they often did in the years from 1983 to 1986, he would work on a canvas briskly for several days and then move on to the next. When things went less well — or, as in the period 1980–1982, when paintings were more cumulative by design — his deliberate blotting, rubbing, scraping, feathering, and graining lent the paintings a surface fragility and sometimes a calmness that poignantly qualifies the compositions' formal tensions. Diverse in effect and visual complexity, and variously complete or incomplete, all are touched by an exceptional workmanlike care that was emblematic of de Kooning's artistic vocation.

It has been said that toward the end, de Kooning painted in a near trance. Indeed, defenders sometimes have focused on this notion in vindication of the work. Conrad Fried, who was present in the studio on-and-off throughout the 1980s, thus answered an inquiry about de Kooning's state of mind in the following way:

To understand this man, you have to understand that he's been compulsively involved with painting all his life. It's like he's on automatic pilot, and it doesn't make any difference whether he knows what he's doing or not. He always thought if you knew what you were doing, you were going in the wrong direction, because then it's just craft. . . . He knows automatically what to do and how to do it. There's no left brain thinking, no logic, no rationale. He's solely thinking that it feels as if there ought to be a darker color, some vague nudging in his mind. And he listens to that.[74]

Although well-intentioned, Fried's explanation muddies the waters, given the fact that this was an artist who had declared explicitly, "The only certainty today is that one must be self-conscious."[75] The jump suggested by Fried's remarks from surrealist automatism (which de Kooning never really practiced) to flying on automatic pilot (that is, flying intellectually blind) is more than a semantic one. Tapping into the unconscious and consciously examining the results is far different than abandoning oneself entirely to reflex. Nevertheless, a similar metaphorical argument was

10. Pablo Picasso, *Self-Portrait*, 30 June 1972
graphite and colored pencil on paper, 25 ¾ x 20 in.
Collection Fuji Television Gallery, Tokyo

already in place long before de Kooning's mental capacities became an issue. "As [Henri] Focillon has written," Hess noted in a 1967 catalogue essay, "'there is a brain in the hand which, while drawing, will criticize, improvise, invent, erase — think new thoughts.'"[76] Paraphrasing this text, Hess continued: "There are things an artist is stuck with, and there are choices open to him. . . . Perhaps it is the brain in the wrist — a highly developed, self-critical center of physical actions, which works faster than the brain in the head can predict — that takes over."[77]

There is truth in this idea, as there is in Fried's more direct observation, despite his confusing apologetics. What remains to be resolved is how focused intuition defines the larger ambition that triggers or restrains that "brain in the hand." The ordinary difficulty in assessing this crucial independence of instinct and intent is compounded in the case of de Kooning's late work by the fact that the almost insouciant felicity of effect he was after so closely resembled aimless aesthetic self-gratification. "The subject matter in the abstract is *space*," de Kooning once said.[78] "The idea of space is given [to the artist] to change if he can."[79] That was the challenge at the beginning of his career. At its end, having made his own space, de Kooning (who once described the pleasure he derived from riding in cars he could not drive as "a sentiment for going from here to there")[80] rejoiced in his hard earned freedom of movement. "One nice thing about space," he declared, "is it just keeps on going."[81] Picture by picture, his tenacious will to go on as far as space would take him structured the open horizon before him and guided his traveling brush.

Moreover, de Kooning had established for himself an explicit aesthetic goal, and as the gradual metamorphosis of his 1980s work shows, he followed it. Pablo Picasso and Henri Matisse represented the two dominant poles by which artists of de Kooning's generation had set their own aesthetic compasses; and so in the late 1930s de Kooning told his friend Rudy Burckhardt that for him, "Picasso is the man to beat."[82] Although in his top form de Kooning equalled Picasso as a draftsman and in the subtlety of his painterly technique at times surpassed him, he could not best the protean master overall nor get out from under the long public shadow he cast. How much this vexed de Kooning is clear from Tom Ferrara's recollection of the arrival one day of an exhibition catalogue entitled *Expressionists After Picasso*, which included his work; it sent the artist stamping around the studio muttering, "When will they stop lumping me with him?"[83] Rivalry was only part of the problem. Already his ties with Picasso had loosened to the extent that in 1980, after touring the Museum of Modern Art's omnibus Picasso exhibition in the company of Elaine, Fourcade, Ferrara, and the show's curator, William Rubin, he complained to Ferrara of the cartoonlike black outlines that bounded the forms in so many of Picasso's paintings, particularly the late works.[84]

De Kooning and Picasso faced old age very differently, though they had much in common. Each, in his own context, was a Lion in Winter, unwilling to cede his place but essentially cut off from daily contact with colleagues or the outside world. That de Kooning recognized this affinity, and particularly its component of lonely self-reflection, is suggested by a poster-sized photograph left lying around the basement

11. Henri Matisse, *La Chevelure (The Flowing Hair)*, 1952
gouache on paper, cut and pasted, on white paper, 42 ½ x 31 ½ in.
Private collection

storage area of his studio where he kept works that had been given to him by other artists. It is David Douglas Duncan's famous photograph of Picasso, with his back to the camera, seated in a chair in the middle of a large, virtually barren white room in his house, Notre-Dame-de-Vie, staring at an easel against which are propped several recently completed paintings. The Baroque grandeur of the room is the very antithesis of the airy modernity of de Kooning's workspace, but Picasso's isolation and concentration — and the sense these convey that, outside this visual circuit between the painter and his painting, there is no world — closely match the impression made by photographs of de Kooning sitting in a heavy rocker facing his easel in a state of remoteness and total absorption.

Like de Kooning, Picasso accelerated his creative pace as his mortality pressed in on him, and like de Kooning, the often thinly drawn and brushed pictures he made — a large number of which were exhibited in May 1973 at the Palais des Papes in Avignon, just a month after his death — were widely interpreted as the desperate, flailing efforts of a self-indulgent artist long past his prime. (It is also noteworthy that, as was later the case with de Kooning, some of those most openly disappointed in or hesitant to accept Picasso's final works were the collectors and scholarly champions of his "classic" periods, while it was often the younger critical and artistic eyes that saw the unique qualities of the old man's work more clearly.) Overrun with cavaliers, Cupids, agreeably monstrous odalisques, and frantically kissing or fornicating couples and haunted by the hollow-eyed, skull-exposed self-portrait of 30 June 1972 (fig. 10), Picasso's last years were spent in a furiously sexual denial of death.

Although the silhouetted forms of women are evoked everywhere in de Kooning's late paintings by his pliant line, their bodies have vaporized, and the erotic restlessness they once shared with Picasso's women has vanished altogether. An exquisite sensuality abides, but it takes its quicksilver substance from memories that obviate the tensions of conquest. Beating Picasso was no longer an issue for de Kooning, either. They had parted ways. Almost inevitably, de Kooning was pulled in the direction of Matisse (fig. 11) — or, as he put it to Ferrara, "I let myself be influenced by him."[85]

De Kooning had felt the force of Matisse's example before. Conscious as he always was of the multiple gravitational fields of art history and of the decision-making independence that must be vigilantly maintained in their vicinity, de Kooning's use of the verb "let" is significant. Years earlier (when, as he said, "I thought I was painting 'my' Matisse") he had visited an exhibition of the older artist's works; "I just stayed five minutes," he recalled, "and ran out to keep that feeling."[86] The feeling, as he described it to Ferrara with lilting, sweeping hand gestures, was a "floating quality" he specifically associated with the first version Matisse's *Dance* (1909; p. 15, fig. 5), in the collection of the Museum of Modern Art.[87] This effect he explicitly contrasted with the Cézanne-inspired "fitting in" of brushstrokes that had preoccupied him most of his life, even through the landscapes of the mid- to late 1970s. But speaking with the art historian Judith Wolfe in 1980, he dismissed this practice as "boring" and announced his intention to get away from it.[88] "I remember liking Picasso and Braque more than Matisse," he elaborated. "Later, as I get older, it is such a nice thing to see a nice Matisse. I always thought he was innocent of that fitting. . . . When people say my later paintings are like Matisse, I say, 'You don't say,' and I'm very flattered."[89]

12. Piet Mondrian, *Broadway Boogie Woogie*, 1942–1943
oil on canvas, 50 x 50 in.
Collection The Museum of Modern Art, New York
Given anonymously

Mention of Matisse was, in fact, a constant in de Kooning's conversation of the 1980s. To Ferrara he talked about his attraction to the French master's "uncomplicatedness" and of his desire to rid his own painting of its psychological overtones.[90] To Courtney Sale, who made a 1982 film on the artist, he explained his satisfaction that, in Matisse, there's "no 'ism' there — he's just painting a painting."[91]

De Kooning set out to do the same thing, but his looping path took him by way of Matisse's formal opposite, Piet Mondrian (fig. 12). A compatriot whose vanguard ideas dominated aesthetic discourse in the Netherlands when the younger painter was in art school, Mondrian was of great but long-unresolved importance to de Kooning's thinking. On the one hand, he would say:

I'm crazy about Mondrian. I'm always spellbound by him. Something happens in the painting that I cannot take my eyes off. It has terrific tension. The optical illusion in Mondrian is that where the lines cross they make a little light.[92]

Mondrian's diligent craft, coupled with his intuitive application of his own compositional systems, also appealed to de Kooning:

Mondrian is the purest artist. He became the greatest layout man in the universe. Early on as students we all knew Mondrian. I was at a young age influenced with sign-making. Because of Mondrian a sign didn't have to be symmetrical like a sheet of music. Or like Beethoven was symmetrical. It could be asymmetrical. You could just lay something out — it didn't have to be measured out so perfectly.[93]

On the other hand, de Kooning repeatedly condemned the rigidity of Mondrian's orthodox Neo-Plasticist disciples. He had fled the Netherlands in part to escape the modernist academy they founded, only to discover that the influence of Mondrian — whom de Kooning met during the artist's wartime sojourn to New York (1940–1944) — had reached America and spawned imitators there as well. In written statements and interviews, de Kooning's ambivalent admiration for and wariness of Mondrian is

pronounced. Picasso bedeviled him by inventing the available new language of Cubism and then setting a barely achievable standard for its use; Mondrian stymied him by having apparently closed off the very opportunities he created. Speaking of his debt to the manifesto-driven painters and "isms" of early modern abstraction, he said: "I have learned a lot from all of them and they have confused me plenty too. . . . I like Lissitzky, Rodchenko, Tatlin, and Gabo; and I admire Kandinsky's painting very much. But Mondrian, that great merciless artist, is the only one who had nothing left over."[94]

In the end, it seems, de Kooning could no longer avoid the challenge this apparent dead end posed him. True to his paradoxical conviction that "if you take the attitude that it is not possible to do something, you have to prove it by doing it,"[95] he traded in what he called his "pots of light" (the bowls of gold or sandy yellows, aqueous blues, leaf greens, and flesh or earth reds, into which he dipped the brushes that brought forth his 1960s and 1970s pastorales) for a primary palette plus black and white.[96] Dispensing with pre-mixed hues, he opted instead for "the naturalism of Mondrian, where red is red and blue is blue"[97] — the naturalism, that is, of pure paint and straight-ahead painting, as distinct from the atmospheric naturalism that had previously preoccupied him.

This done, de Kooning subjected Mondrian's squared-off pictorial balancing act to the manipulations of his own surrealist-trained arm. All that in Mondrian's paintings vibrates in tight optical harmony, ripples and swoops in de Kooning's paintings of the 1980s.[98] Where Mondrian's juxtapositions of pure color blocks and ruled armatures are absolute, de Kooning lets saturated hues seep into the white, and white suffuse areas dominated by reds, yellows, and blues. Where Mondrian's vertical and horizontal lines stop and start abruptly or crisscross,

de Kooning's flutter and slip alongside, past, or around each other, knotting here and unraveling there. The Mondrian whose rectilinear architectures cut off at the root the organic *Art nouveau* and *Jugendstijl* aesthetics from whence they originated was thus invaded by the resurfacing tendrils of this transplanted and much-hybridized tradition.

As far back as 1959, Hess spoke of de Kooning's art as "the metaphysical 'equivalences' of Mondrian infinitely elaborated."[99] Although de Kooning postponed direct stylistic dialogue with the artist until his last decade, he had not missed the essential instability of the seemingly immutable system Mondrian had invented. It was a system that he had left to no one in particular, and that had been claimed by none of his peers, until it became apparent in the 1980s that de Kooning—for whom the confrontation with Mondrian was his final piece of unfinished business—was its principal heir.

If a man is influenced on the basis that Mondrian is clear, I would like to ask Mondrian if he is so clear. Obviously, he wasn't clear, because he kept on painting. Mondrian is not geometric, he does not paint straight lines. . . . What is called Mondrian's optical illusion is not an optical illusion. A Mondrian keeps changing in front of us.[100]

Like all that preceded them, de Kooning's paintings of the 1980s also "keep changing in front of us" and will not stop. Although the physically unrestrained but epicurean voluptuousness of Matisse was de Kooning's stated goal, it was the "dynamic equilibrium" of Mondrian, utterly transformed by his own technical mastery and intelligence, that provided him the means. The work inspired by that conscious aim is still new to us. Until now little of it has been seen by the general public, and even (perhaps especially) for those lucky enough to have had access to them, the pictures keep rearranging themselves in the mind's eye and upsetting established wisdom about the artist whose career they conclude.

That is as it should be. The de Kooning of anguished uncertainties is but one dimension of the painter's complex and evolving character. The de Kooning who suffered and aged but succeeded in creating images of an almost disembodied beauty is another. Looking forward to these paintings from those of his youth and maturity, there is much to be learned. Looking back from them to his earlier, more celebrated work should, in time, correct the myth-restricted perspective long imposed upon it. Looking at them as a self-sufficient group, they reveal a formal and emotional scope that is astounding. Lastly, looking at them one by one, they provoke a bright mortal vertigo that only an artist of rigorous talent could have brought back from the edge to show us—and that only de Kooning has done thus far. In the end, therefore, it is not just identifcation with or compassion for the man that compels our attention, though as we watch him approach the final days of his creative existence such feelings play a justly greater part in our appreciation of his work. It is what he saw in the evanescent light and what he made of it that matters most.

In Willem de Kooning's studio all is quiet. It has been this way for four years. We have come to look at the last paintings made here and to get our bearings. So much seems familiar from the countless photographs taken over the years, assiduously perused by those who have explored these precincts only in their imagination: the cantilevered roof, high balcony, and gangplank overlook; the diagonal stairs leading from the library and sleeping quarters to the working floor; the floor itself, a bleached, speckled terrazzo inspired by Matisse's habit of laying down newspaper to bounce the sunlight upward. Light permeates the space from all directions. Through the long row of picture windows running down both sides of the main room at right angles to the easel wall, between the steps, through the fretwork pillars, over transoms it travels, detailing the eccentric lines of the building in the same way that the variously pure or impure whites of de Kooning's late paintings frame and suffuse their graphic structure.

Part refuge, part workshop, part folly, the building is a unique architectural amalgam — an American-style split-level house of its era articulated with a Dutch accent. Every normally discrete domestic area can be seen from another: the basement is as open to view as the kitchen, and even the upstairs bedrooms look out, and can be looked into, through glass partitions. The studio can be seen from outside as well. Films of the painter painting were shot this way, and friends, family, and aides remember watching for long periods as he worked, oblivious to their presence. The locus of his art and his life, de Kooning's one experiment in modernist, three-dimensional design is visually active and accessible from all vantage points.

On the banquet-sized rolling tables where de Kooning mixed his paints, boxes of oil colors are still stacked and brushes are laid out. Although he no longer crosses the threshold of his studio, it has been left intact (at the insistence of his daughter, Lisa,

who watches over him from the house next door) so that if the artist should by some miracle rouse himself, it would not seem strange or denuded to him. For the same reason, paintings remain as he left them, propped on carts and against the wall. Some testify silently to the frustrations he endured; others, whose marvelous configurations float in emptiness like rainbow-hued zephyrs, evoke the man people remember drawing in the air with his hand. Indeed, it is as if the immaterial rays, arcs, backward curves, and ovoids his gestures described had settled on canvas like looping jetstreams or tinctured mists.

From the back, one can hear the sounds of the women charged with looking after the artist, who sits in the living room at the opposite end of the house from the studio. Their voices are not somber, but vivacious and warmly familiar. Nor is there anything secretive about the duties they perform; there is merely a customary respect for the privacy of the person in their care. For a brief moment, in this place where the eye moves so freely through space, his white hair and immobile profile are visible. It is a last fleeting look at the man whose "slipping glimpse" missed nothing. The sadness one feels at this sight is of a subdued kind, proportionate to the reality. As exceptional as he was in every respect, de Kooning is now old in the way that others less exceptional become old. That is all. There is another, unsettling emotion one experiences, however, and it is of a different kind altogether. It is the sense not just of a world poorer than before but of one permanently reordered. So it has been. For the first time in over a half-century, de Kooning is not the working contemporary of every other painter alive.

NOTES

It is the normal practice to refer to artists by their last names, but the fact that Elaine and Willem de Kooning shared a common name renders it impossible to do so in both cases in this essay without creating confusion. In referring to Elaine de Kooning by her first name here, I trust the reader will understand that no disrespect is intended.

Unless otherwise indicated, all quotations and information from the following sources derive from notes taken during the author's interviews with them: Larry Castagna, Robert Chapman, Tom Ferrara, Conrad Fried, Connie Fox, Antionette Gay, Jennifer McLauchlen, and Jill Weinberg. Conversations with Lisa de Kooning; Rudy Burckhardt; Robert Dash; Emily Kilgore; Denise, Ernestine, and Ibram Lassaw; Oliver Sacks; Peter Schjeldahl; Rose Slivka; Joan Ward; and the staff of the Willem de Kooning Conservatorship office form an essential part of the background to this text. Gary Garrels took part in most of the interviews cited below and his expertise and generous collaboration were invaluable to the formulation of this account.

1 Quoted in Bert Schierbeek, *Willem de Kooning*, exh. cat. (Amsterdam: Stedelijk Museum, 1968), unpaginated.

2 In Harold Rosenberg, "Interview with Willem de Kooning," *De Kooning* (New York: Harry N. Abrams, 1974), p. 47; reprinted from *ARTnews* 7, no. 5 (September 1972), pp. 54–59.

3 Peter Schjeldahl, "De Kooning Alone," *Art Journal* 48, no. 3 (Fall 1989), p. 247; special issue, "Willem de Kooning, On His Eighty-Fifth Brithday," edited by Bill Berkson and Rackstraw Downes.

4 Quoted by Robert Chapman, interview with the author.

5 Willem de Kooning, "Content is a Glimpse,"excerpts from an interview with David Sylvester, *Location* 1, no. 1 (Spring 1963); reprinted in Thomas B. Hess, *Willem de Kooning*, exh. cat. (New York: Museum of Modern Art, 1968), p. 149.

6 De Kooning in "Inner Monologue," audiotape, Summer 1959, transcribed by Marie-Anne Sichère, p. 8.

7 Ibid, p. 9.

8 In conversations with the author in the early and mid-1980s, both Rudy Burckhardt and Elaine de Kooning described, in almost exactly the same terms used in this text, the waning of the coffee-hour gatherings in the automats and the advent of heavy drinking in bars.

9 Quoted in Curtis Bill Pepper, "The Indomitable de Kooning," *New York Times Magazine*, 20 November 1983, p. 90.

10 Ibid, p. 70.

11 Connie Fox, interview with the author. Fox remembered accompanying Elaine and Willem de Kooning to the opening of his 1978 exhibition at the Guggenheim Museum. His drinking was aggravated by the crush of attention he received on such occasions. To keep him away from bars prior to the reception, Elaine arranged for them all to pay a call on Aristodemis Kaldis, a painter friend who was then wheelchair-bound in his work-littered Manhattan hotel room studio. As in all such situations, Fox recalls, once de Kooning started looking at and talking about paintings, "the lights went on." Thus the plan succeeded and in part set the model that Elaine followed throughout the 1980s of rallying around old acquaintances in controlled social settings. It should be noted that de Kooning went for long periods without drinking, even during the most difficult years of his addiction, and it is reported that he never painted while drinking.

12 Pepper, supra, note 9, p. 70.

13 In 1985 de Kooning discovered an open bottle of vodka that accidentally had been left in view in a neighboring house, and he took it back with him to the studio. There, tucking it away under his palette, he took periodic nips over the course of the afternoon until his assistants, noticing his light spirits, found the source and removed it. It was his only lapse, and those present recall that the artist, who was caught before his darker drinking mood set in, was especially lucid and playful.

14 This listing of assistants is based on the accounting records of Frances Shilowich. Dates of their arrival on the scene and their departure from it are nonetheless approximate, since this network of assistants was largely composed of friends or acquaintances who hung around the studio before and sometimes after their official employment. It is worth recalling that while the kind of improvisational painting de Kooning practiced differs greatly from the more programmatic production of other artists who have organized their studios around the use of assistants (think of Peter Paul Rubens or Frank Stella), de Kooning, of his own accord, turned to younger artists for practical help. Hess jokingly notes that in the early 1960s, when the artist moved into his new quarters in Long Island, these helpers "were nicknamed 'de Kooning's Peace Corps'" (Thomas B. Hess, *De Kooning: Recent Paintings* [New York: Walker and Company, 1967], p. 38).

15 Chapman, interview with the author.

16 Ibid.

17 Tom Ferrara, interview with the author.

18 Chapman, interview with the author.

19 What follows in this paragraph is based primarily on conversations with Jill Weinberg, who became Fourcade's assistant in September 1977.

20 Ferrara, interview with the author.

21 Weinberg, interview with the author.

22 As recorded on videotapes made by Chapman, Gay, and Fried in 1988.

23 Ferrara, interview with the author.

24 Next to his easel, de Kooning pinned up the swirling circular lithograph he had contributed to a portfolio of prints accompanying John Ashberry's poem "Self-Portrait in a Convex Mirror" (San Francisco: The Arion Press, 1984). And to the left, a section of thickly enlaced vine was propped against the wall, a natural "stick man" configured like the arabesques of de Kooning's paintings and suggestive of its Art Nouveau beginnings. De Kooning's keen appreciation of aesthetic correspondences never failed him, and his immediate surroundings reflected that acuity in every detail.

25 De Kooning's reluctance to sign paintings after 1975, Ferrara believes, was related to his increasing displeasure at being reduced to the public legend and commercial entity that bore his name. The work itself, he told Ferrara, was his signature. When the act of signing didn't aggravate him in this way, it simply bored him, and he would do it only to accommodate the demands of Fourcade and others when paintings left the studio for exhibition and sale. The specific request that he sign on the front of *Untitled III* (1981, in the collection of the Hirshhorn Museum) he accommodated in the same spirit, although he had long since given up this practice and, finding it hard to integrate letters spontaneously into the composition, had to resort to a signpainter's mall-stick to complete the task to his satisfaction. On the whole, he was equally unwilling to sign retroactively the large cache of drawings (sorted and grouped by Ferrara and the assistants as part of their duties) that were stored in the studio. Once, however, he spontaneously set about the task with the idea that it would be "good for my estate." But after doing a relatively small number, he stopped and left the balance unsigned. After 1986 de Kooning found writing difficult and was no longer able to sign his name, though he continued to paint fluently.

26 As canvases were placed on the easel — usually in a horizontal position to start — they were numbered on the stretcher in pencil. At the beginning of their involvement in 1980, Ferrara, Chapman, and others incidentally engaged in the studio routines would follow a method according to which the year would be listed and then a letter of the alphabet would be assigned to indicate the painting's place in the annual sequence. When de Kooning's productivity increased to the point that all twenty-six letters had been used up, they would begin the sequence again, adding a numeral to distinguish the second alphabetical series of that year from the first. To eliminate the possible confusion inherent in this system, a new one was instituted in 1982. From that time onward, paintings were simply given a number in the order that de Kooning began work on them, following a two-digit code for the year in question. Neither of these practices took into account the fact that some paintings were finished after others that had been started later in the series. Hence, exact dating of the completion of individual works is impossible, and it is correspondingly difficult to judge how the development of one canvas, long in progress, might have affected the resolution of another painted entirely in the interval. By 1984, however, monitoring the evolution of the artist's ideas from picture to picture became less of a problem, since at this time de Kooning moved from one canvas to the next more or less in succession. By the late 1980s, Chapman began gathering paintings left around the studio to which no further revisions had been made and put labels on them with the date they were collected and consigned to storage. Thus a substantial quantity of paintings have labels with the same date, although they were not all completed on the same day. This information derives from conversations with the Willem de Kooning Conservatorship office and Tom Ferrara.

27 Avis Berman, "Willem de Kooning: 'I Am Only Halfway Through,'" *ARTnews* 81, no. 2 (February 1982), p. 71.

28 As studio photographs of works-in-progress attest, the superimposition of original drawings or tracing-paper copies onto the canvas as a shortcut method of adding to or realigning the composition of a painting dates back at least to the mid-1940s. Although the use of a projector partially supplanted this technique, de Kooning continued to rely on the direct transfer of images by means of such tracings well into the 1980s. Photographs taken of the studio in 1982, for instance, show such sheets on the ground near his easel (see "Architectural Digest Visits: Willem de Kooning," *Architectural Digest*, January 1982, p. 59). De Kooning's standard procedure was to stick the drawing directly to the (often wet) paint surface — which accounts for the smears and blushes of color that appear on some of the two dozen surviving examples found in his studio — after having reinscribed the image on the front of the vellum onto the back with heavy charcoal so that the pressure of redrawing the lines would leave a charcoal trace on the canvas. If the outcome did not please him, de Kooning would simply reposition the tracing or choose another. In any event, he used such graphic ghosts of past work only as a starting point for further variations; he never simply quoted himself directly.

29 Chapman, interview with the author.

30 The task of trying to match photographs used to project images onto the canvas with the paintings that resulted has scarcely begun and promises to be a daunting one, given the extent to which these underdrawings were modified during the course of de Kooning's painting process. Thus far only two obvious correlations between a source drawing and final painting have been found. The first is notable not least because it is one of the relatively few paintings with a vignetted rather than all-over image. The tricolor red-and-blue-over-white painting dates from 1986 and is clearly an abstracted version of a 1966–1967 charcoal drawing (see p. 25, figs. 15 and 16). The second example involves a 1987 painting that is based on a small (8 ½-by-11-inch) sketch from 1980, loosely drawn in pen and ink. Here, the projected image on paper is allowed to bleed off the edge of the canvas. While the first work generalizes but otherwise adheres quite closely to the linear structure of its prototype, the second shows evidence of de Kooning having elaborated and honed the most elegant curves from the rapid noodling of the original drawing.

31 These observations were reported by Emily Kilgore and Connie Fox, in conversations with the author.

32 Ferrara, interview with the author.

33 Robert Rauschenberg, artist's statement, *Art Journal* 48, no. 3 (Fall 1989), p. 232.

34 Fox, interview with the author.

35 Previously reported by this author in "Master Bill," *Art Journal* 48, no. 3 (Fall 1989), p. 243.

36 Pepper, supra, note 9, p. 70.

37 Philip Pearlstein, "Re: De Kooning," *Art Journal* 48, no. 3 (Fall 1989), p. 233.

38 Ferrara, interview with the author.

39 Pepper, supra, note 9, pp. 88, 90.

40 Chuck Close, in conversation with the author.

41 Robert Katz, "Not a Pretty Picture," *Esquire*, April 1991, p. 111.

42 Harold L. Klawans, "The Collector," *MD*, December 1992, pp. 74–79.

43 Quoted in Kay Larson, "Alzheimer's Expressionism: The Conundrum of de Kooning's Last Paintings," *Village Voice*, 31 May 1994, p. 42. Larson's open invitation to reconsider de Kooning's paintings from the 1980s in a favorable light, but with complete candor about his mental and physical state when he made them, is of special interest, given her stern criticism of his work of the 1960s and 1970s. "The mystery of de Kooning can be be pared down to a single question" she wrote of those earlier works: "How can someone that good be that bad?" (Larson, "Sacred Enigma," *New York*, 9 January 1984, p. 51). In the 1994 *Village Voice* article she wrote: "You could say that de Kooning lost focus in the '60s. You could say he began to find himself in the '70s, and finally took charge in the '80s. You could easily say something like that — if you didn't know he had Alzheimer's" (p. 41). While I disagree with her severe judgment of the earlier works, I do share her implicit belief here that, despite his infirmities, the paintings of the last decade of de Kooning's career constitute a kind of last-minute renaissance.

44 Ibid.

45 Oliver Sacks, "Letters," *Art and Antiques*, January 1990, p. 20.

46 Sacks, "Introduction," *The Man Who Mistook his Wife for a Hat and Other Clinical Tales* (New York: Harper Perennial, 1990), p. 6.

47 Sacks, supra, note 46, p. 20.

48 Thomas B. Hess, *Abstract Painting: Background and American Phase* (New York: The Viking Press, 1951), p. 104.

49 Harold Rosenberg, "De Kooning," *Vogue*, September 1964, p. 148.

50 Honoré de Balzac, "Le Chef-d'oeuvre inconnu," *La Comédie humaine*, vol. 10 (Paris: Bibliothèque de la Pléiade, Editions Gallimard, 1979), p. 436 (quotation translated by the author).

51 Hess, supra, note 5, p. 23.

52 Larry Castagna, interview with the author.

53 Ferrara, interview with the author.

54 One incident, in particular, sheds light on his total involvement with this format — the creation of the triptych for St. Peter's Church in Manhattan (p. 30, fig. 29), discussed at length by Gary Garrels in his essay in this book (on pp. 28–30). The change in pictorial structure this commission entailed stayed the artist's hand. Having completed the central panel (which measures eighty by seventy inches), de Kooning was at a loss as to how to carry his gesture over to the right-hand canvas (the two side panels are wholly atypical verticals, measuring eighty by thirty inches each), and he spent days rehearsing the connective stroke without making a mark. Chapman, who watched him, is convinced that the unfamiliar spatial dynamics of the segmented painting confused and stymied him. In the end, after making the leap and finishing the two wing-panels, de Kooning and Fourcade composed the second triptych (pl. 25) by arranging existing paintings of standard dimensions. It was that work which was temporarily installed at St. Peter's.

55 As recorded on a videotape made in 1988 by Chapman, Gay, and Fried.

56 This information is based on conversations with Ferrara and Chapman.

57 Antoinette Gay, interview with the author.

58 Chapman, interview with the author.

59 Ferrara, interview with the author.

60 Lowenthal is quoted in Lee Hall, *Elaine and Bill, Portrait of a Marriage: The Lives of Willem and Elaine de Kooning* (New York: HarperCollins, 1993), p. 286.

61 Rauschenberg, supra, note 33.

62 Ferrara, interview with the author.

63 Rosenberg, supra, note 2, p. 51.

64 Hess (supra, note 5, p. 26) recounts Porter's observation that the color values in de Koonings paintings are so close they make "your eyes rock."

65 Willem de Kooning, in a paper read 18 February 1949, at one of the Friday evenings of "Subjects of the Artist: A New Art School"at 35 East Eighth Street, New York. Published for the first time in Hess, supra, note 5, pp. 15–16; reprinted as "A Desperate View," in *Willem de Kooning: Het Noordatlantisch licht/The North Atlantic Light, 1960–1983*, exh. cat. (Amsterdam: Stedelijk Museum, 1983), p. 67.

66 Hess, supra, note 14, p. 43.

67 Ibid, p. 17. Hess quotes this inscription as "Plenty of trembling, but no fear," but the correct version of the text, as noted by the Willem de Kooning Conservatorship office, adds a special insistence.

68 Paradigmatic of this view is Douglas Crimp's "The End of Painting," *October* 16 (Spring 1981), pp. 69–86.

69 It was de Kooning's habit on occasion to add his own brush marks to reproductions of works that interested or provoked him in some way. During her last visit to the studio sometime in the early 1990s, Ernestine Lassaw recalls him leaning over from his rocker to "retouch" the image on the cover of a book on Soutine, one of his favorite painters. There is a kind of poetry in his having done the same to the cover of the January 1990 issue of *Art in America* that featured Martin Puryear's *Lever #4* (1989). De Kooning's single purplish-gray mark echoes and partially cancels the bold black form of Puryear's monolithic sculpture. Inasmuch as Puryear's shape derives from the biomorphic vocabulary upon which de Kooning's own work was based, and to which he contributed so much, this brief response to the work of an artist who came fully into the fore in the 1990s represents an intuitive recognition of and dialogue with the rising generation.

70 Quoted in Selden Rodman, *Conversations with Artists* (New York: The Devin-Adair Co., 1957), p. 102.

71 Ferrara, interview with the author.

72 De Kooning, supra, note 6, p. 4.

73 From *Willem de Kooning: Artist*, a film by Robert Snyder, Master and Masterworks Productions, 1967–1994 (quotation transcribed by the author).

74 Quoted in Catherine Barnett, "The Conundrum of Willem de Kooning," *Art and Antiques*, November 1989, p. 70. At the worst, Fried's logic is based on a half-truth that can easily be turned into a weapon against de Kooning and his work. Using almost the same language as Fried, Hilton Kramer, one of de Kooning's most aggressive and longstanding antagonists, did just that in an interview for the BBC television special "The de Kooning Affair." He described the aging artist as "flying on instruments," in a style in which the

suspension of intellectual, formal judgment would barely be noticed. It is useful in this regard to recall Hess's comment that "de Kooning is an intellectual who thinks with his pictures" (Thomas B. Hess, *Willem de Kooning: Drawings* [Greenwich, Conn.: New York Graphic Society, Ltd., A Paul Bianchini Book, n.d.], p. 27). Despite gradual deficits in his verbal and other faculties, de Kooning kept on "think[ing] with his pictures" until near the very end.

75 De Kooning, supra, note 66, p. 67.

76 Hess, supra, note 14, p. 29.

77 Ibid, p. 38.

78 De Kooning, supra, note 65, p. 67.

79 Ibid.

80 De Kooning, supra, note 6, p. 13.

81 Ibid, p. 14.

82 Harry F. Gaugh, "De Kooning in Retrospect," *ARTnews* 83, no. 3 (March 1984), p. 94.

83 Ferrara, interview with the author.

84 During the years of renewed productivity, de Kooning stayed close to home and rarely went to New York City except to see his doctor or dentist. With the exception of his visit to the 1980 Picasso retrospective at the Museum of Modern Art and the 1981 Arshile Gorky retrospective at the Guggenheim Museum, he stopped attending exhibitions in the city, contenting himself instead with the images in books from his extensive library — books that he would take into the studio and pile on tables or place next to the rocker that faced his easel. In addition to the incident regarding the *Expressionist After Picasso* catalogue, Tom Ferrara recalls de Kooning's general discomfort whenever the subject of his place in history came up in discussion. Rather than being motivated by basic doubts about his relative stature as an artist, Ferrara believes that his reaction had more to do with his resistance to being locked into his past in any way that would impinge on his freedom of action in the studio. For similar reasons, perhaps, de Kooning passed up his own public lionization by ducking out early from the opening of his 1983 retrospective at the Whitney Museum of American Art. Before he left, he ran into Rudy Burckhardt, with whom (like many others from his early years in New York) he had lost touch. Burckhardt remembers him saying, "I think I'll stay around for a while," which is as good an indication as we have of his forward-looking attitude at the time. On the exhibition's last day, moreover, de Kooning went back and was pleased to see that it was crowded. On noticing that there was an admission fee, he teasingly asked Ferrara, "Are they charging money? Shouldn't I be getting a cut?"

85 Ferrara, interview with the author.

86 Sally Yard, "Conversation with Willem de Kooning,"unpublished interview, 14 October 1976, p. 8 (French version in Marie-Anne Sichère, ed., *Willem de Kooning: Écrits et propos* [Paris: École nationale supérieure des beaux-arts, 1973]). The exhibition de Kooning referred to took place in 1927 at the Valentine-Dudensing Gallery almost fifty years earlier. The painting he mentally "took away" with him on this occasion was a 1927 still life featuring a large violet area that inspired him to go home and rework a painting then in-progress in his studio. "That 'Matisse,'" he told Yard (meaning his own painting), "was done in housepaint except for that cobalt violet. I went out and bought the cobalt violet — I had to have that." Significantly, cobalt violet was one of the relatively few secondary colors he added

in the 1980s to his basic palette of red, yellow, blue, black, and white. Sometimes juxtaposed or mixed with a complementary golden yellow in a number of works from the mid- to late 1980s, cobalt violet was used to produce rich but soft tonal shifts that were distinct from the higher contrast of his primary hues as well as from the premixed pastels provided him by assistants after 1988.

87 Ferrara, interview with the author.

88 Judith Wolfe, *Willem de Kooning: Works from 1951–1981*, exh. cat. (East Hampton, N.Y.: Guild Hall of East Hampton, 1981), p. 16.

89 Ibid. "Innocent" is also a telling choice of words inasmuch as it represents the opposite of knowledge. De Kooning's use of the word to describe something acquired over time rather than lost in mature life suggests that during the last phase of his career he turned away not just from Cézanne — "that's where modern art came from," he told Wolfe — but from the formal Cubist program for which Cézanne's work was the paradigm. Like Guston, who had said, "a little innocence takes a lot of preparation," de Kooning, the anti-systematic painter par excellence, was not only distancing himself from the system he had contended with and relied upon more than any other; he was seeking a "natural" way to paint that only a fully assimilated second nature makes possible.

90 Ferrara, interview with the author.

91 *De Kooning on de Kooning*, produced by Courtney Sale and directed by Charlotte Zwerin, Direct Cinema, 1981 (quotation transcribed by the author).

92 In Rosenberg, supra, note 2, p. 43.

93 Yard, supra, note 86, p. 2.

94 De Kooning, "What Abstract Art Means to Me," in Hess, supra, note 5, p. 145.

95 De Kooning, supra, note 65, p. 67.

96 De Kooning, supra, note 6, p. 6.

97 Ibid, p. 8.

98 It is noteworthy in this connection that the "floating" quality de Kooning identified with Matisse is also found in Mondrian's "plus-minus" paintings and drawings of the mid-teens or in works such as his *Composition with Color Planes* (1917). In a more syncopated fashion, the same effect reappears in *Broadway Boogie-Woogie* (1942–1943, fig. 12) and *Victory Boogie-Woogie* (1943–1944). To that extent, de Kooning's late painting not only loosens the rigid enclosures of Mondrian's classic grid works but catches the drift of his unlocked planar compositions, early and late.

99 Thomas B. Hess, "Reviews and Previews: Willem de Kooning," *ARTnews* 58, no. 4 (May 1959), p. 13.

100 De Kooning in "Artists' Sessions at Studio 35" (edited by Robert Goodnough), in *Modern Artists in America*, first series, edited by Robert Motherwell and Ad Reinhardt (New York: Wittenborn Schultz, 1951), p. 20.

EXHIBITION PLATES

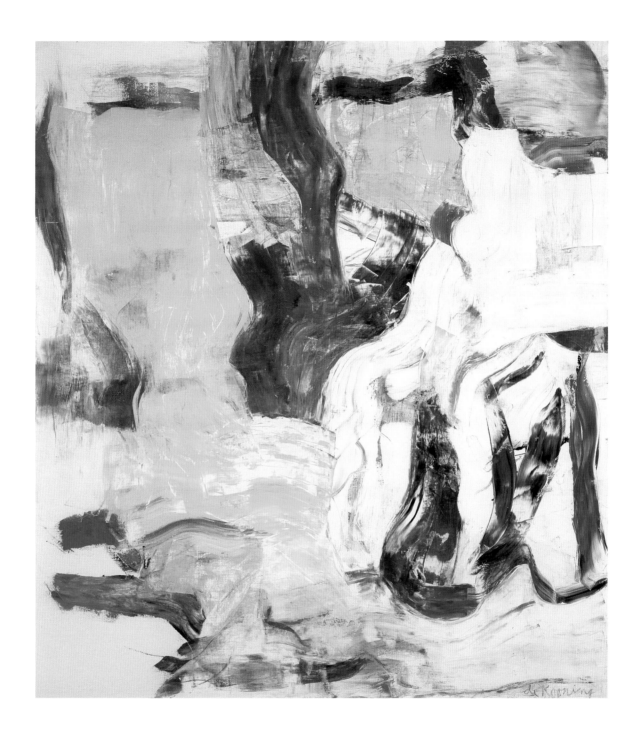

I

UNTITLED I

1981

COLLECTION MR. AND MRS. ROBERT LEHRMAN, WASHINGTON, D.C.

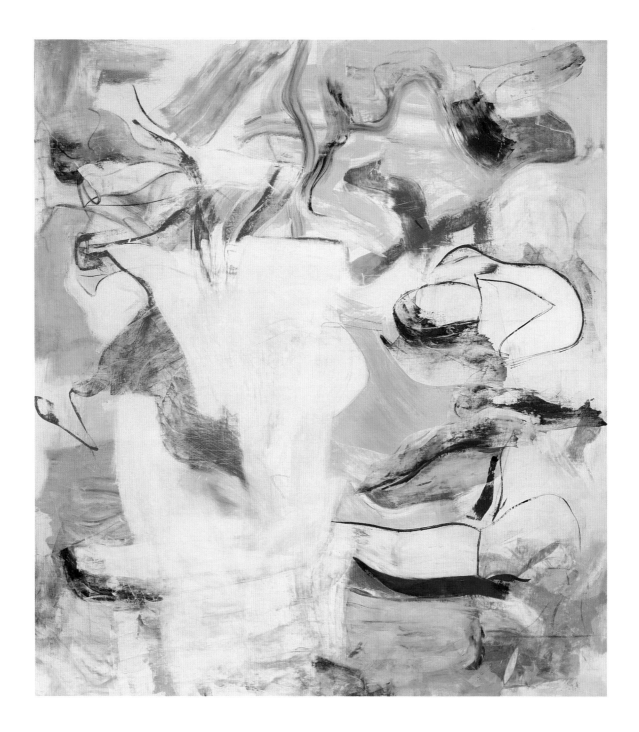

2

PIRATE (UNTITLED II)

1981

COLLECTION THE MUSEUM OF MODERN ART, NEW YORK
SIDNEY AND HARRIET JANIS COLLECTION FUND

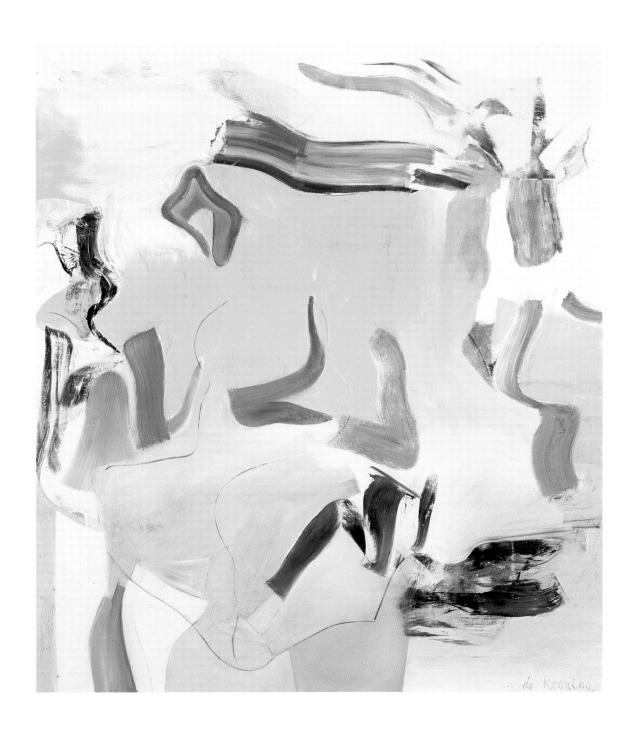

3

UNTITLED III

1981

COLLECTION HIRSHHORN MUSEUM AND SCULPTURE GARDEN, SMITHSONIAN INSTITUTION, WASHINGTON, D.C.
PARTIAL GIFT OF JOSEPH H. HIRSHHORN BY EXCHANGE, AND MUSEUM PURCHASE, 1982

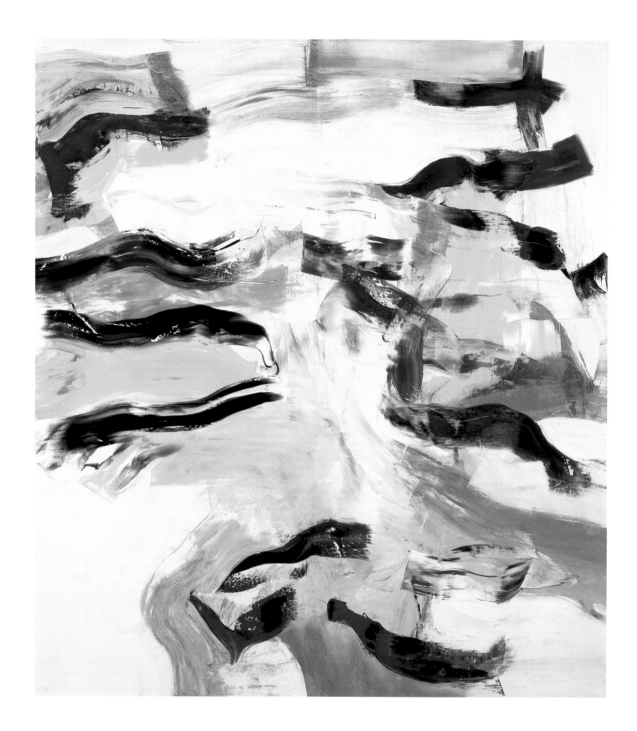

4

UNTITLED V

1981

COURTESY ROBERT MILLER GALLERY, NEW YORK

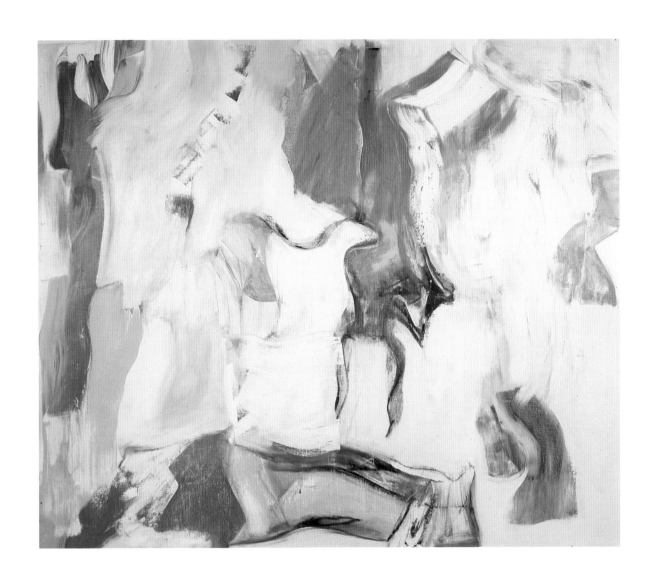

5

UNTITLED VI

1981

PRIVATE COLLECTION

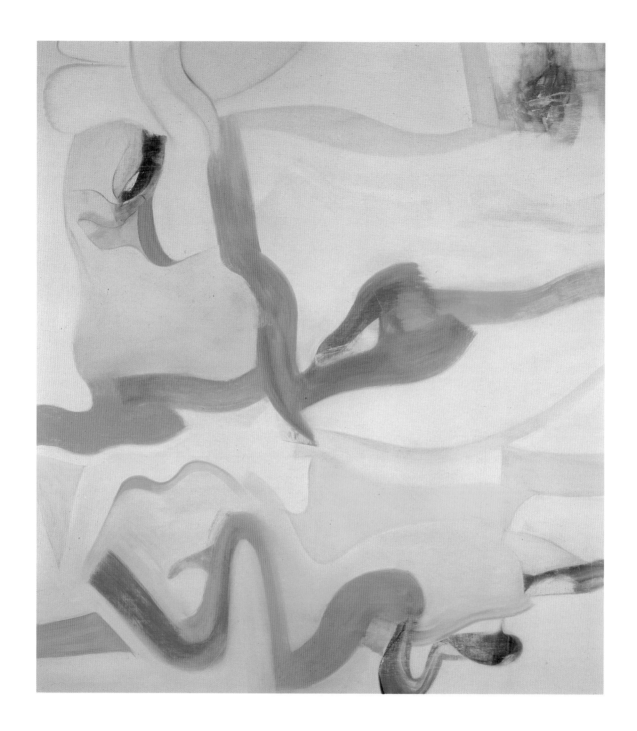

6

UNTITLED III

1982

COLLECTION PAINEWEBBER GROUP INC., NEW YORK

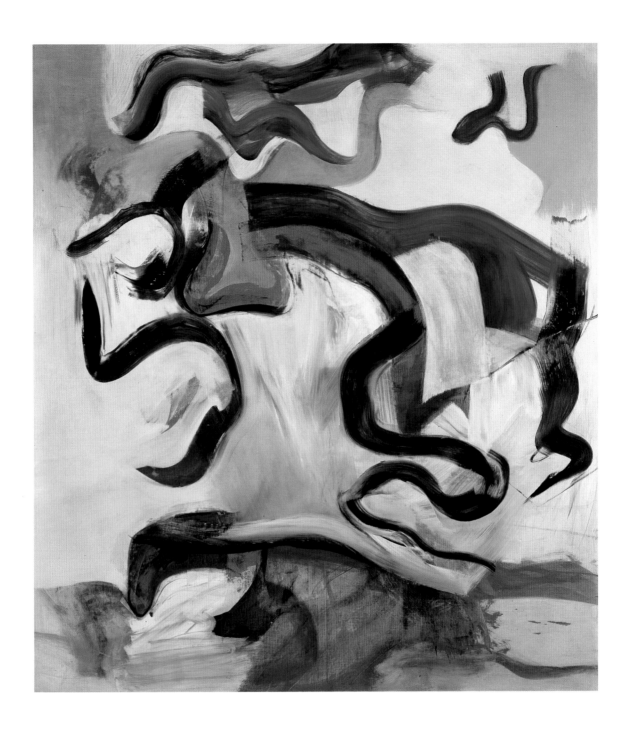

7

UNTITLED V

1982

COLLECTION PHILIP JOHNSON

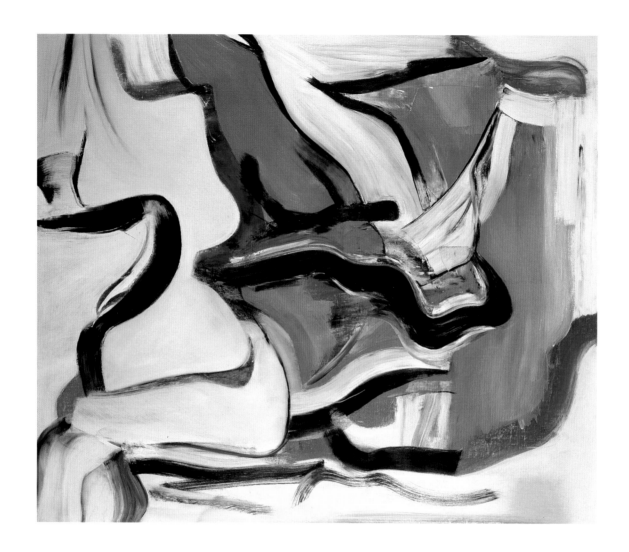

8

UNTITLED IX

1982

COLLECTION THE ARTIST

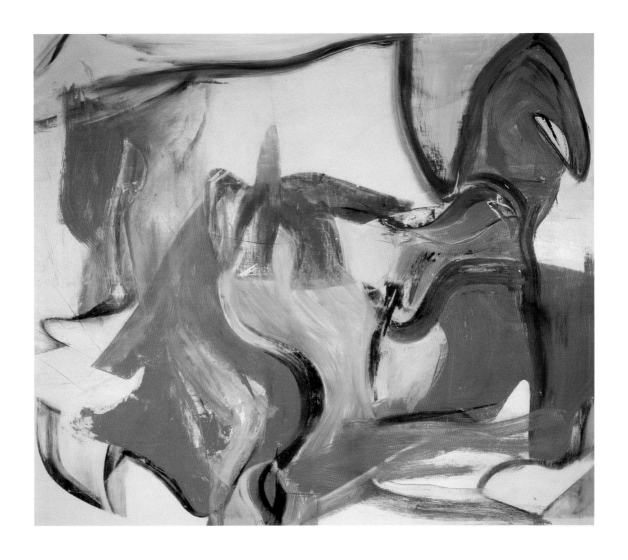

9

UNTITLED XII

1982

COLLECTION RONNIE AND SAMUEL HEYMAN, NEW YORK

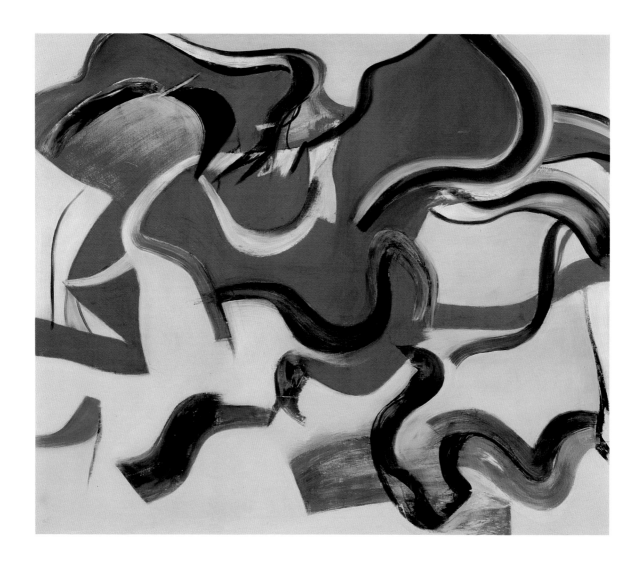

UNTITLED XV

1982

COLLECTION STEVE MARTIN

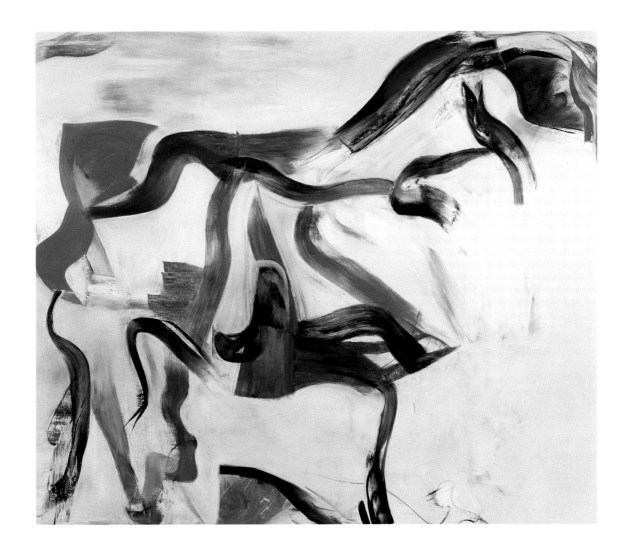

11

UNTITLED XXII

1982

COLLECTION SAN FRANCISCO MUSEUM OF MODERN ART
PROMISED GIFT OF PHYLLIS WATTIS

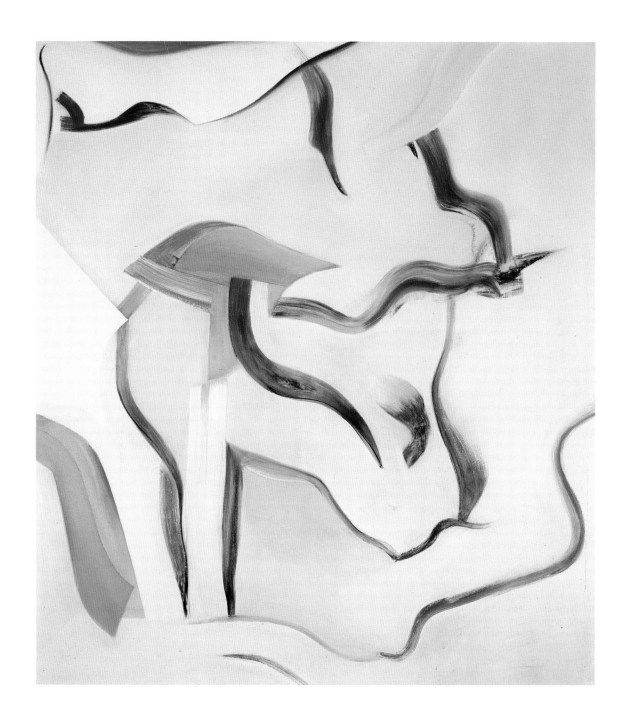

12

UNTITLED XXIII

1982

COLLECTION THE ARTIST

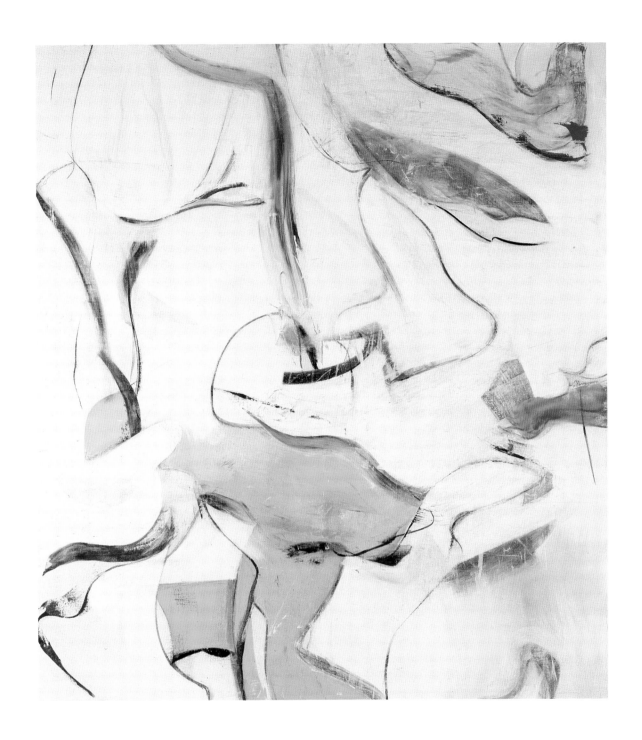

1 3

MORNING: THE SPRINGS (UNTITLED I)

1983

COLLECTION STEDELIJK MUSEUM, AMSTERDAM
ACQUIRED WITH FINANCIAL SUPPORT FROM THE VERENIGING REMBRANDT

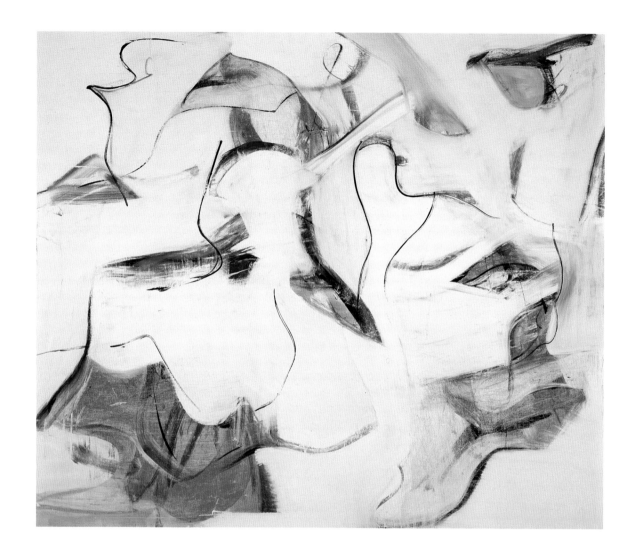

14

UNTITLED II

1983

COLLECTION SAN FRANCISCO MUSEUM OF MODERN ART
FRACTIONAL GIFT OF MIMI AND PETER HAAS

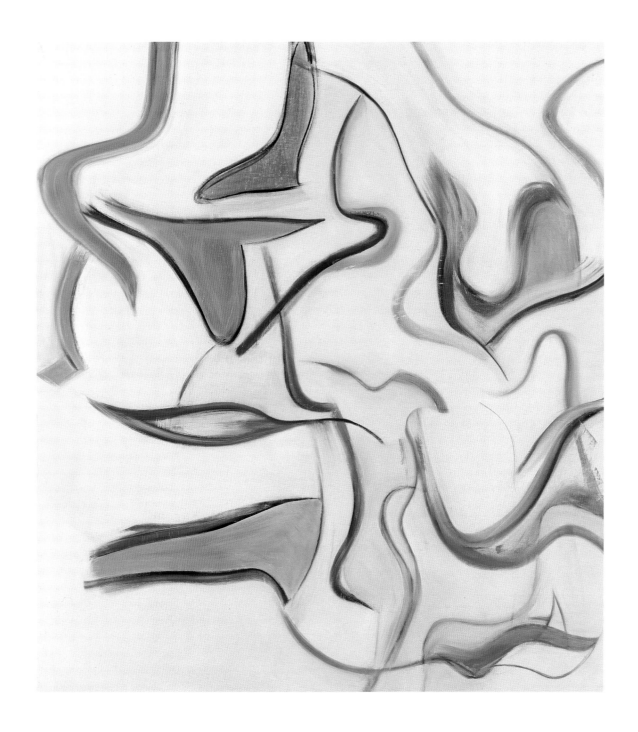

15

UNTITLED III

1983

COURTESY SBC COMMUNICATIONS INC., SAN ANTONIO, TEXAS

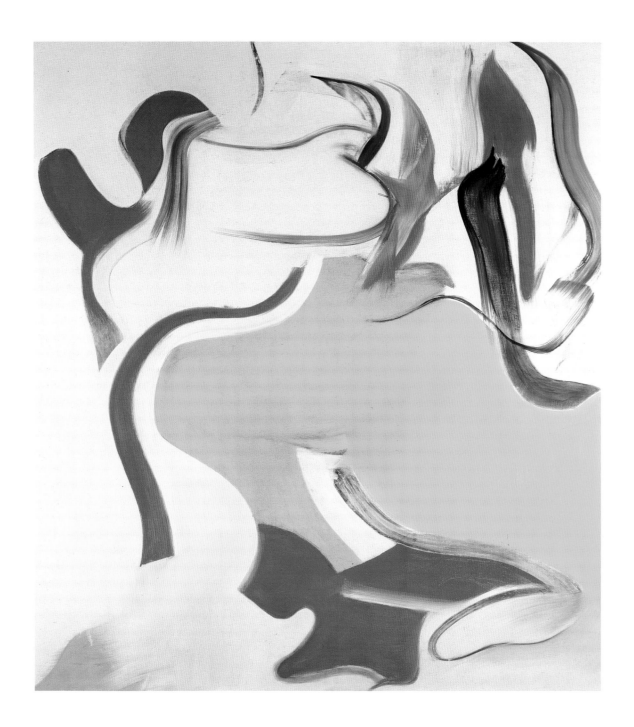

16

UNTITLED V

1983

COLLECTION MR. AND MRS. DAVID N. PINCUS

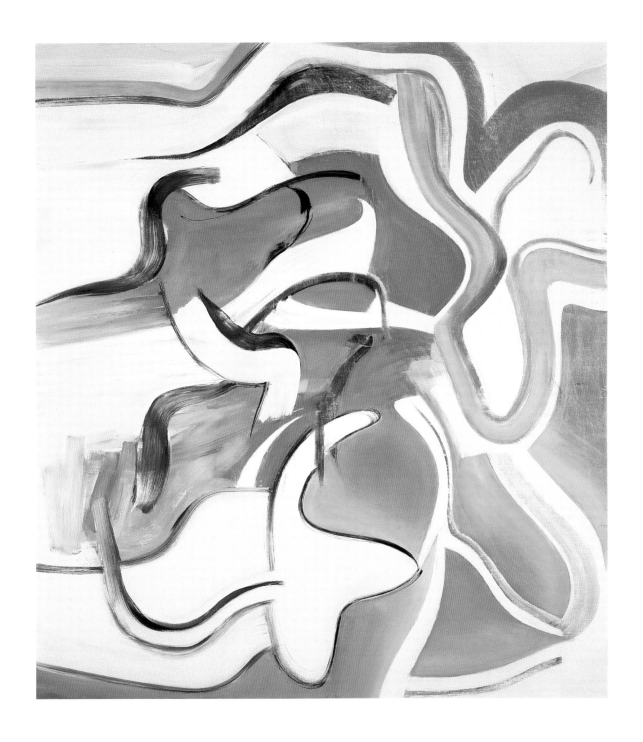

1 7

UNTITLED XII

1983

COLLECTION WALKER ART CENTER, MINNEAPOLIS
PARTIAL GIFT OF RALPH AND PEGGY BURNET, 1993

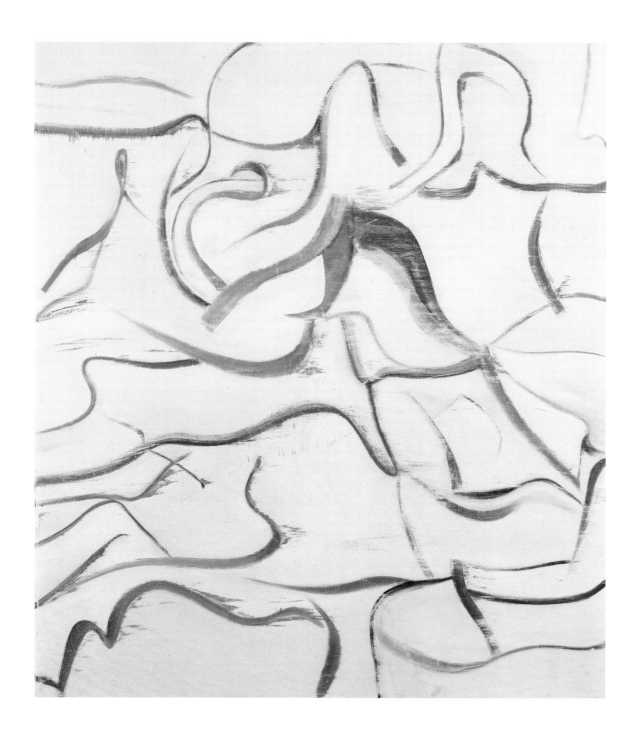

18

UNTITLED XV

1983

COLLECTION EMILY FISHER LANDAU, NEW YORK

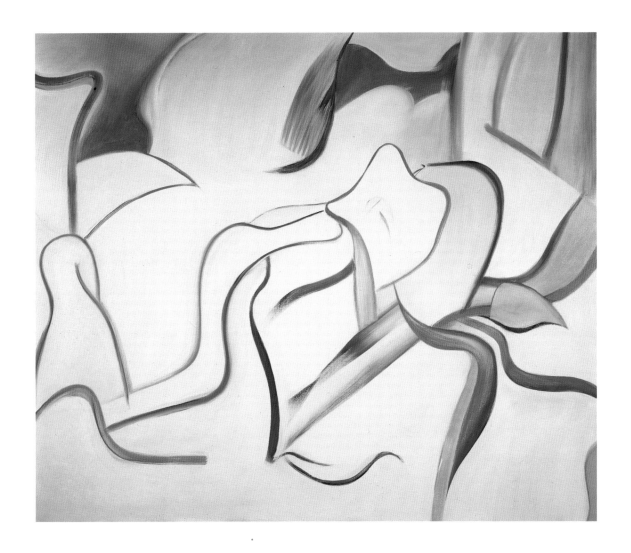

19

UNTITLED XIX

1983

PRIVATE COLLECTION, SAN FRANCISCO

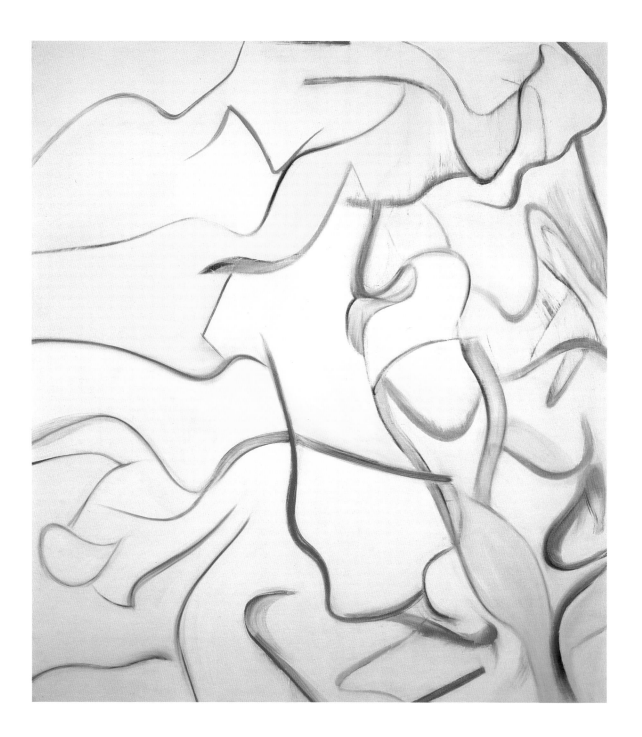

20

UNTITLED IV

1984

COLLECTION THE ARTIST

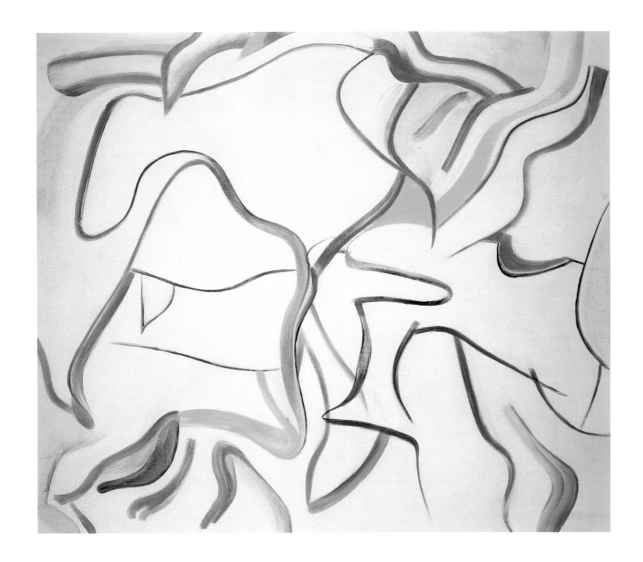

2 I

UNTITLED X

1984

COLLECTION SAN FRANCISCO MUSEUM OF MODERN ART
FRACTIONAL GIFT OF HELEN AND CHARLES SCHWAB

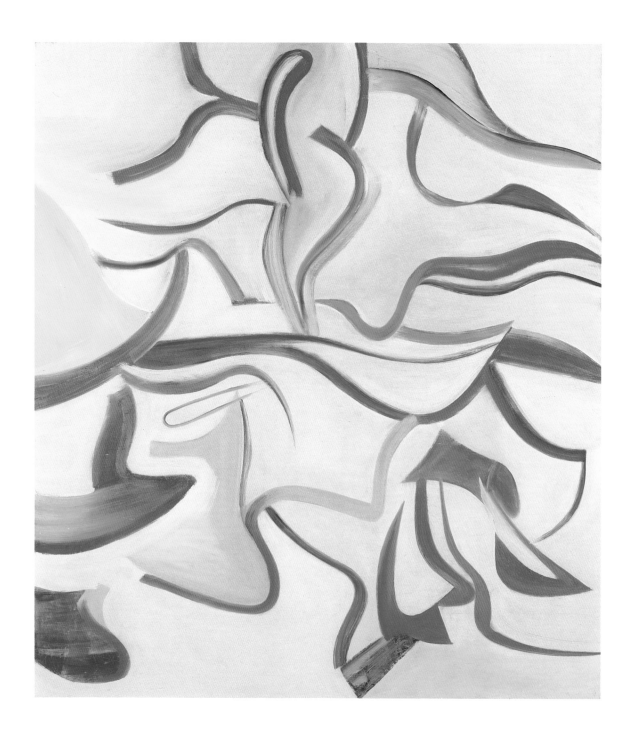

2 2

UNTITLED XVII

1984

COLLECTION M. ANTHONY FISHER

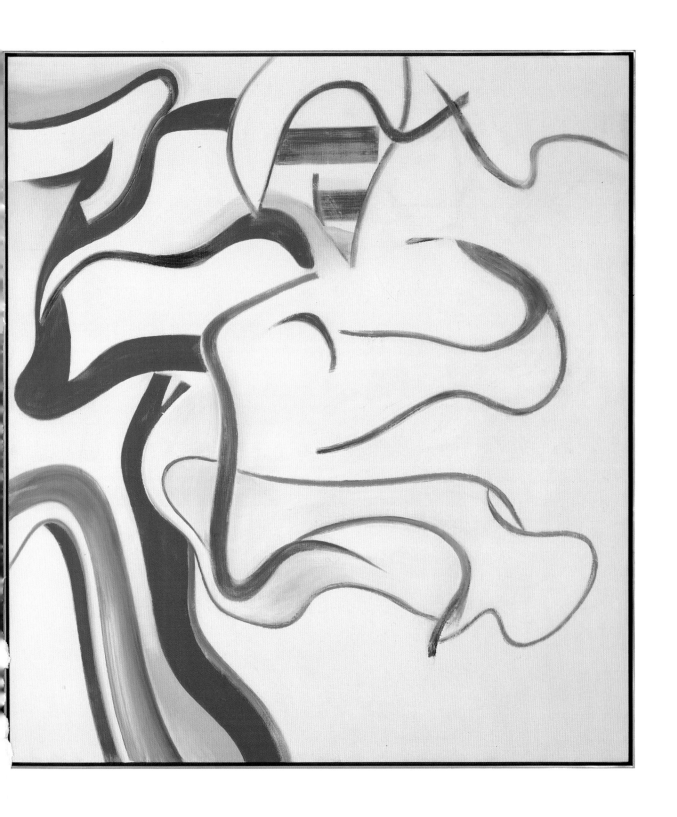

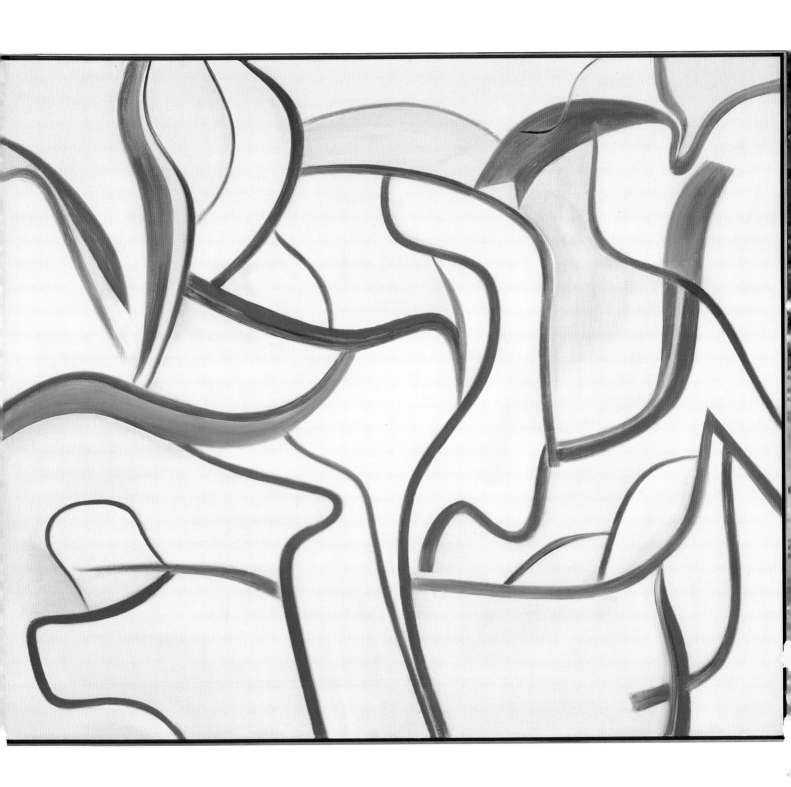

Luton Sixth Form College
Learning Resources Centre

25

TRIPTYCH (UNTITLED V, UNTITLED II, UNTITLED IV)

1985

COLLECTION THE ARTIST

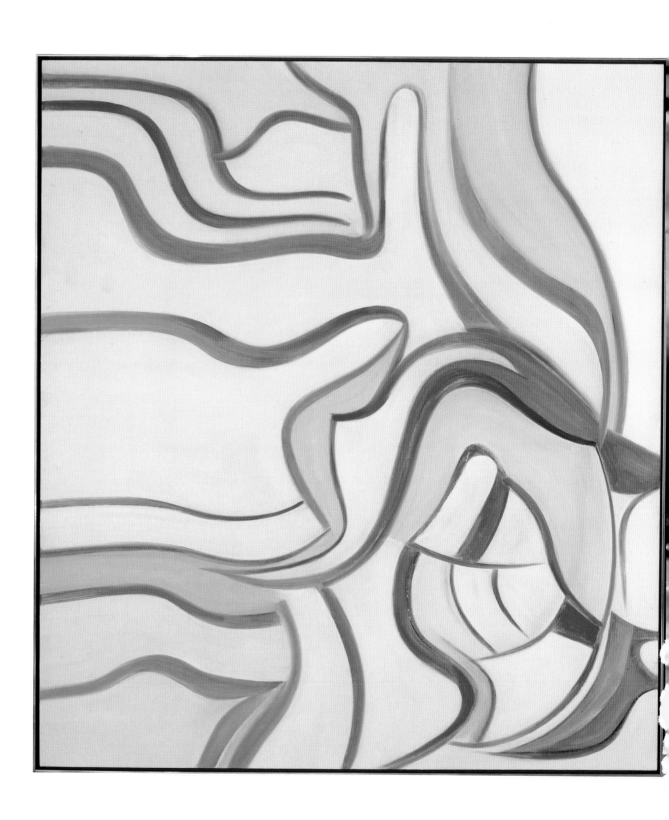

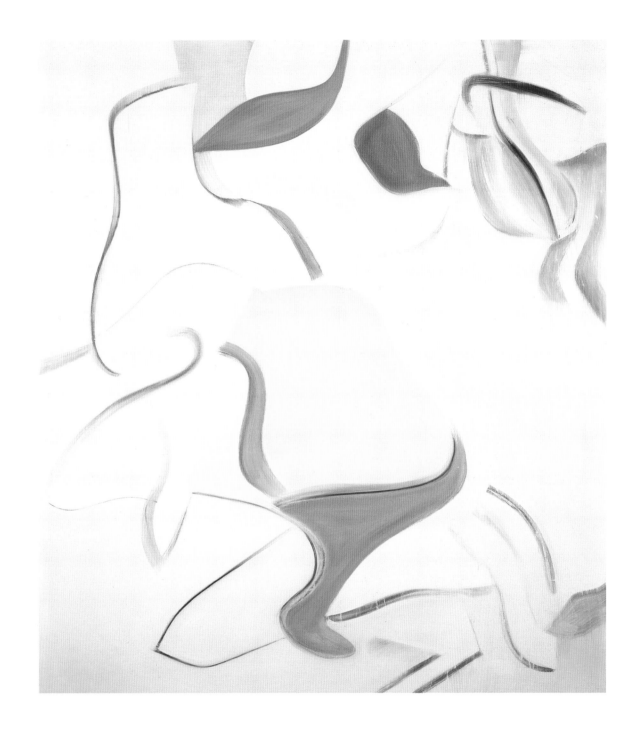

23

[NO TITLE]

1984

COLLECTION THE ARTIST

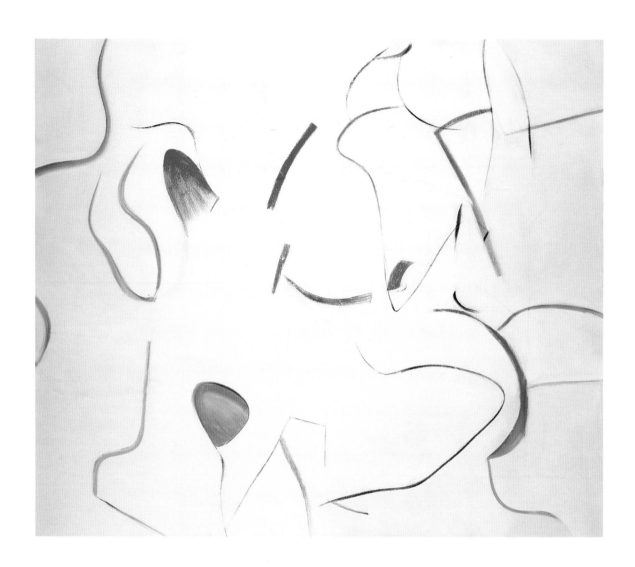

24

[NO TITLE]

1984

COLLECTION THE ARTIST

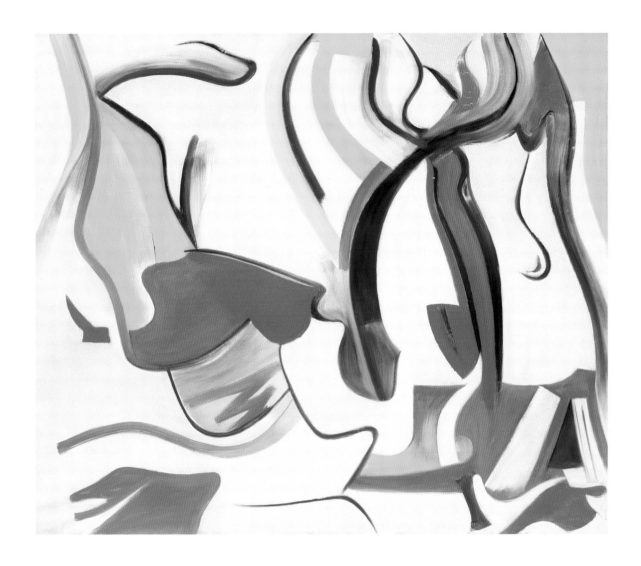

26

UNTITLED VII

1985

COLLECTION THE MUSEUM OF MODERN ART, NEW YORK
PURCHASE AND GIFT OF MILLY AND ARNOLD GLIMCHER, 1991

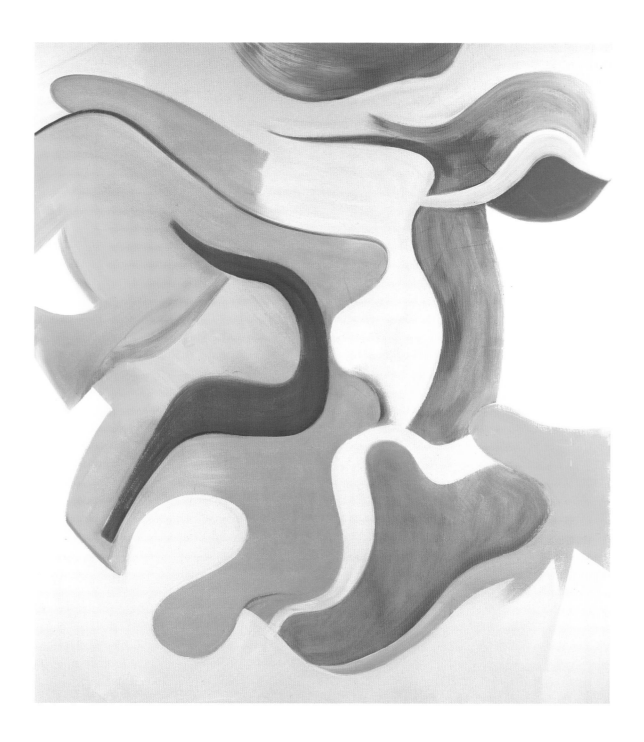

27

UNTITLED XIII

1985

COLLECTION THE CLEVELAND MUSEUM OF ART
LEONARD C. HANNA, JR., FUND

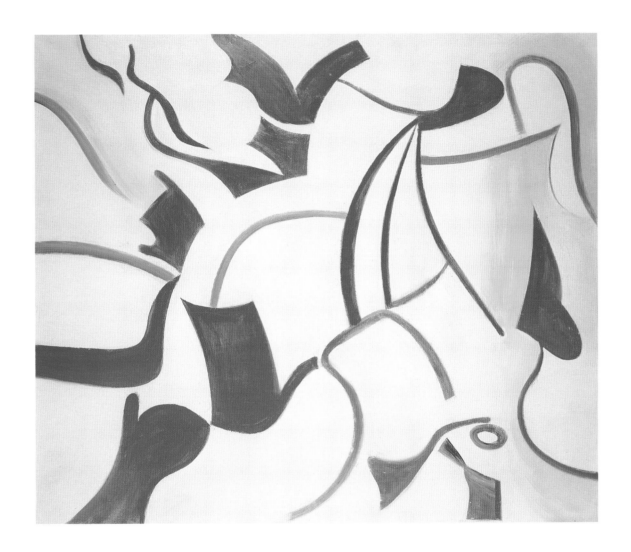

28

UNTITLED XX

1985

COLLECTION THE ARTIST

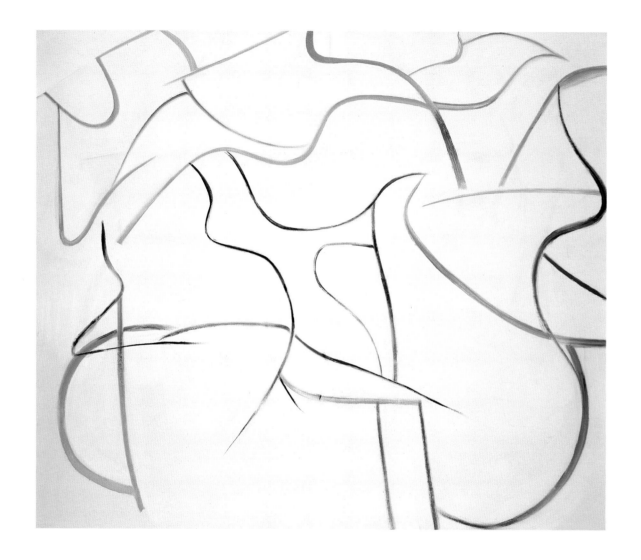

29

[NO TITLE]

1985

COLLECTION THE ARTIST

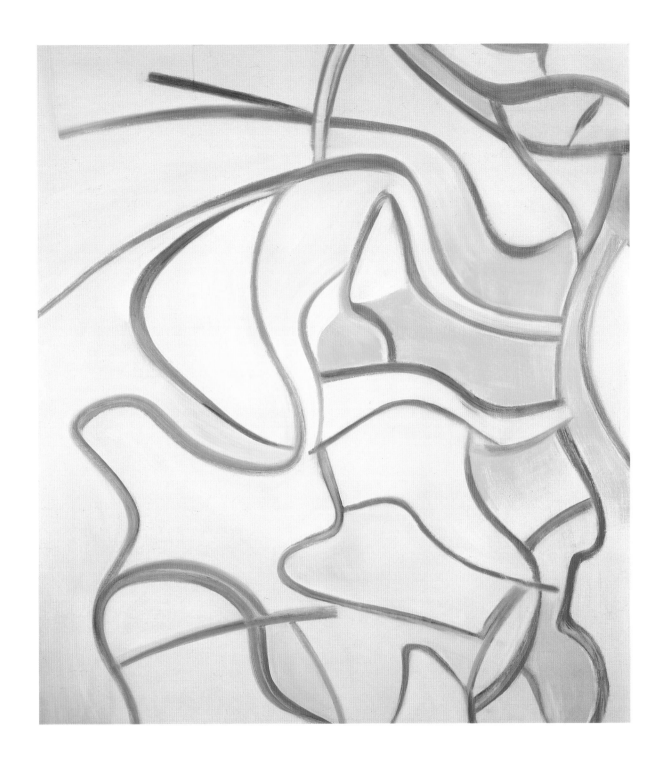

30

UNTITLED II

1986

COLLECTION SAN FRANCISCO MUSEUM OF MODERN ART
FRACTIONAL PURCHASE THROUGH THE JOHN AND FRANCES BOWES FUND

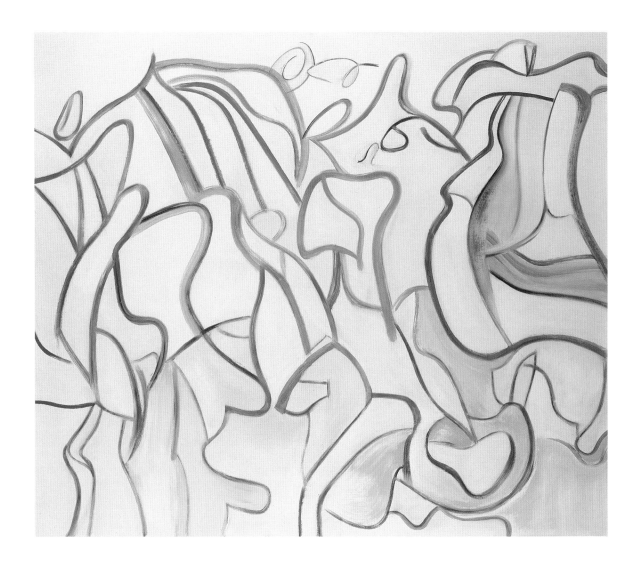

31

UNTITLED VI

1986

PRIVATE COLLECTION

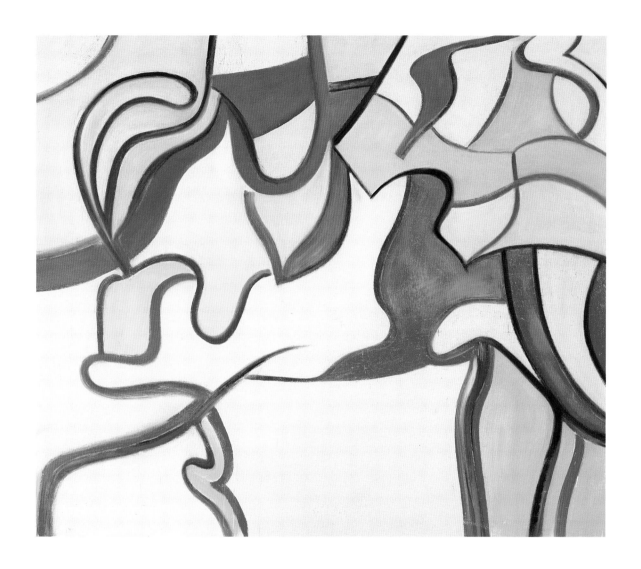

32

UNTITLED VIII

1986

PRIVATE COLLECTION

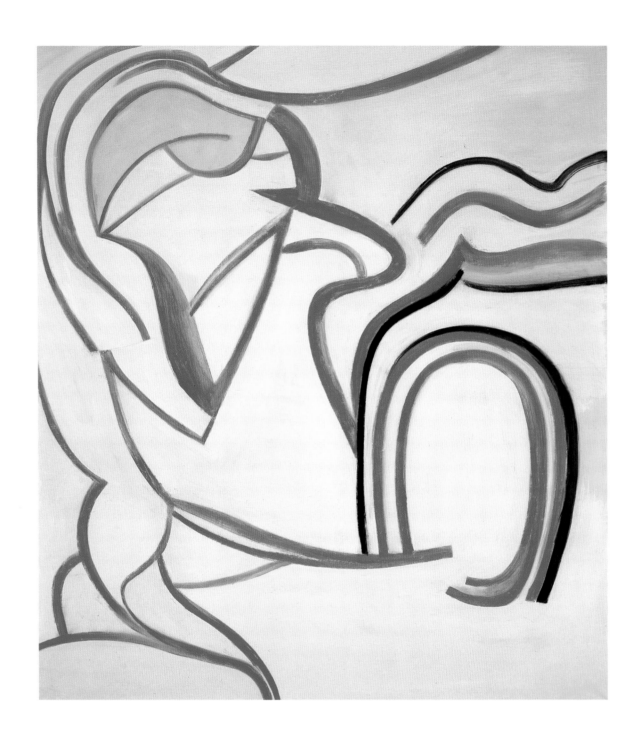

33

UNTITLED XXIV

1986

COLLECTION THE ARTIST

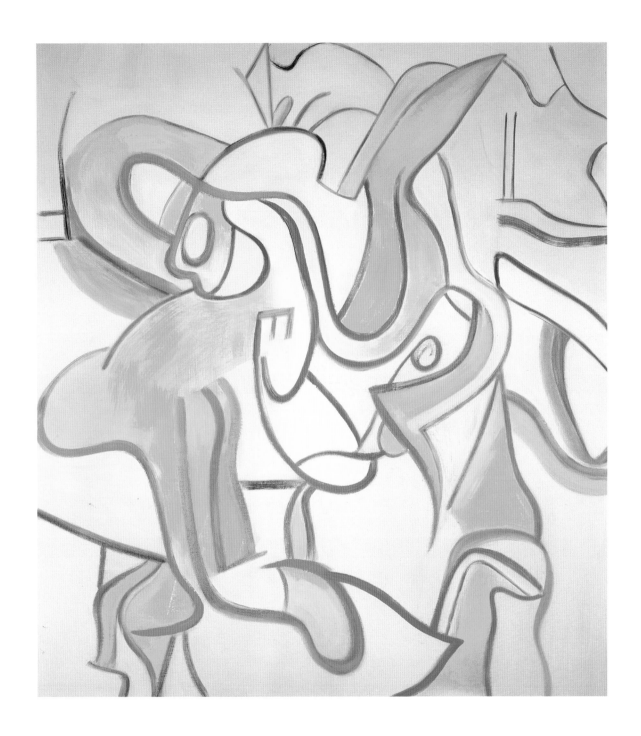

34

[NO TITLE]

1987

COLLECTION THE ARTIST

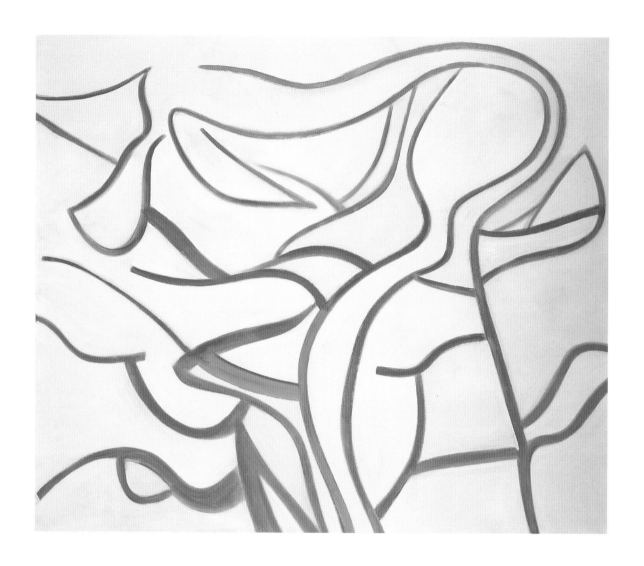

35

[NO TITLE]

1987

COLLECTION THE ARTIST

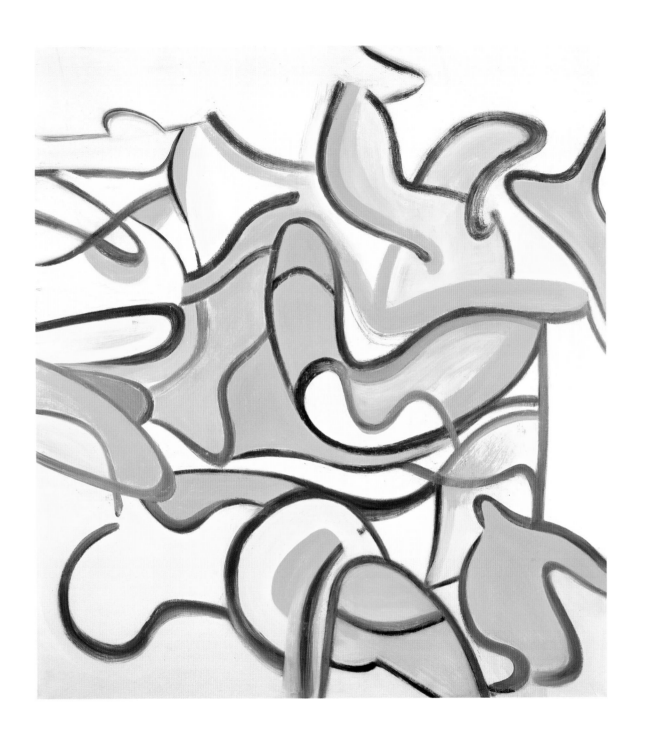

36

[NO TITLE]

1987

COLLECTION THE ARTIST

ANNOTATED CHECKLIST OF THE EXHIBITION

In the entries that follow, dimensions of works are given in inches and centimeters; height precedes width. Provenance information is arranged chronologically, from the earliest to the most recent transaction. Entries in the exhibition history and literature sections are listed chronologically.

JOHN LOSITO CURATORIAL ASSISTANT, SAN FRANCISCO MUSEUM OF MODERN ART

1 **UNTITLED I** 1981
oil on canvas
88 x 77 in. (223.5 x 195.6 cm)
Collection Mr. and Mrs. Robert Lehrman,
Washington, D.C.
(shown in U.S. only)

PROVENANCE

Through Xavier Fourcade, Inc., New York
Private collection
Collection S. I. Newhouse, New York

EXHIBITION HISTORY

Xavier Fourcade, Inc., New York. *Willem de Kooning: New Paintings, 1981–1982*, 17 March–1 May 1982.

LITERATURE

Berman, Avis. "Willem de Kooning: 'I Am Only Halfway Through.'" *ARTnews* 81, no. 2 (February 1982), pp. 68–73.

Wilkie, Ken. "Willem de Kooning: Portrait of a Modern Master." *Holland Herald* 17, no. 3 (1982), pp. 22–25, 28–31, 33 (ill. p. 30).

Sollers, Philippe. *De Kooning, vite*. Paris: Editions de la Différence, 1988. 2 vols. (ill. no. 104).

Zilczer, Judith. *Willem de Kooning: From the Hirshhorn Museum Collection*. Washington, D.C.: Hirshhorn Museum and Sculpture Garden, Smithsonian Institution, in association with Rizzoli International, 1993 (ill. p. 195, in studio view).

2 **PIRATE (UNTITLED II)** 1981
oil on canvas
88 x 76 ¼ in. (223.5 x 194.9 cm)
Collection The Museum of Modern Art, New York
Sidney and Harriet Janis Collection Fund

PROVENANCE

Through Xavier Fourcade, Inc., New York
Robert Mnuchin, New York
Gagosian Gallery, Inc., New York

EXHIBITION HISTORY

Xavier Fourcade, Inc., New York. *Willem de Kooning: New Paintings, 1981–1982*, 17 March–1 May 1982.

Stedelijk Museum, Amsterdam. *Willem de Kooning: Het Noordatlantisch licht/The North Atlantic Light, 1960–1983*, 11 May–3 July 1983 (cat. no. 34, ill. p. 57). Traveled to Louisiana Museum of Modern Art, Humlebaek, Denmark, 15 July–4 September 1983 (cat. no. 31, ill. p. 23); Moderna Museet, Stockholm, 17 September–30 October 1983 (cat. no. 35, ill. unpaginated).

Whitney Museum of American Art, New York. *Willem de Kooning Retrospective Exhibition*, 15 December 1983–26 February 1984. Exh. cat. *Willem de Kooning: Drawings, Paintings, Sculpture* (cat. no. 251, ill. p. 234). Painting did not travel with the exhibition but was reproduced in the catalogue for Akademie der Künste, Berlin, 11 March–29 April 1984 (cat. no. 251, ill. p. 234).

National Gallery of Art, Washington, D. C. *Willem de Kooning: Paintings*, 8 May–5 September 1994 (cat. no. 75, ill. p. 214). Traveled to Metropolitan Museum of Art, New York, 11 October 1994–8 January 1995; Tate Gallery, London, 15 February–7 May 1995.

LITERATURE

Larson, Kay. "De Kooning Adrift." *New York*, 12 April 1982, pp. 58–59 (ill. p. 58).

Schjeldahl, Peter. "Delights by de Kooning." *Village Voice*, 13 April 1982, p. 79 (installation photograph p. 79).

Ratcliff, Carter. "A Season in New York." *Art International* 25, nos. 7–8 (September–October 1982), p. 56 (ill.).

Peters, Din. "Willem de Kooning: Paintings 1960–1982." *Studio International* 196, no. 1001 (August 1983), pp. 4–5.

Hughes, Robert. "Painting's Vocabulary Builder." *Time*, 9 January 1984, pp. 62–63 (ill. p. 63).

Sollers, Philippe. *De Kooning, vite*. Paris: Editions de la Différence, 1988. 2 vols. (ill. no. 105).

Waldman, Diane. *Willem de Kooning*. New York: Harry N. Abrams, 1988 (ill. pl. 107).

Willem de Kooning. Tokyo: Kodansha, 1993 (ill. pl. 83).

Cateforis, David. *Willem de Kooning*. New York: Rizzoli, 1994 (ill. pl. 15).

De Kooning, Elaine. *The Spirit of Abstract Expressionism: Selected Writings*. New York: George Braziller, 1994.

Baker, Kenneth. "De Kooning Blowout in Washington." *San Francisco Chronicle*, 7 May 1994, pp. E1, E3 (ill. p. E1).

Gopnik, Adam. "The Last Action Hero." *New Yorker*, 23 May 1994, pp. 83–88 (ill. p. 83).

Sherer, Deborah. "Mito de Kooning." *Vogue Italia*, June 1994, p. 24 (ill.).

Kuspit, Donald. "Body of Evidence: Old School Master." *Artforum* 33, no. 3 (November 1994), pp. 75–79, 113 (ill. p. 79).

3 **UNTITLED III** 1981
oil on canvas
88 x 77 in. (223.5 x 195.6 cm)
Collection Hirshhorn Museum and Sculpture Garden, Smithsonian Institution, Washington, D.C.
Partial gift of Joseph H. Hirshhorn by exchange, and Museum Purchase, 1982

PROVENANCE

Through Xavier Fourcade, Inc., New York

EXHIBITION HISTORY

Hirshhorn Museum and Sculpture Garden, Smithsonian Institution, Washington, D.C. *Five Distinguished Alumni: The WPA Federal Art Project, An Exhibiton Honoring the Franklin Delano Roosevelt Centennial*, 21 January–22 February 1982 (cat. no. 9, ill. unpaginated).

Xavier Fourcade, Inc., New York. *Willem de Kooning: New Paintings, 1981–1982*, 17 March–1 May 1982 (ill. announcement cover).

Stedelijk Museum, Amsterdam. *Willem de Kooning: Het Noordatlantisch licht/The North Atlantic Light, 1960–1983*, 11 May–3 July 1983 (cat. no. 35, ill. p. 58). Traveled to Louisiana Museum of Modern Art, Humlebaek, Denmark, 15 July–4 September 1983 (cat. no. 32, ill. p. 26); Moderna Museet, Stockholm, 17 September–30 October 1983 (cat. no. 36, ill. unpaginated).

Whitney Museum of American Art, New York. *Willem de Kooning Retrospective Exhibition*, 15 December 1983 – 26 February 1984. Exh. cat. *Willem de Kooning: Drawings, Paintings, Sculpture* (cat. no. 252, ill. p. 235). Traveled to Akademie der Künste, Berlin, 11 March – 29 April 1984 (cat. no. 252, ill. p. 235); Musée national d'art moderne, Centre Georges Pompidou, Paris, 28 June – 24 September 1984 (ill. p. 143).

Hirshhorn Museum and Sculpture Garden, Smithsonian Institution, Washington, D.C. *Willem de Kooning: From the Hirshhorn Museum Collection*, 21 October 1993 – 9 January 1994 (cat. no. 49, ill. p. 147). Traveled to Fundació "la Caixa," Centre Cultural, Barcelona, 17 February – 3 April 1994 (cat. no. 49, ill. p. 141); High Museum of Art, Atlanta, 13 September – 27 November 1994; Museum of Fine Arts, Boston, 10 December 1994 – 19 February 1995; Museum of Fine Arts, Houston, 19 March – 28 May 1995.

LITERATURE

"El gran legado de los abstractos de Kooning y Motherwell." *Goya* 166 (January – February 1982), p. 227 (ill.).

Berman, Avis. "Willem de Kooning: 'I Am Only Halfway Through.'" *ARTnews* 81, no. 2 (February 1982), pp. 68 – 73.

Schjeldahl, Peter. "Delights by de Kooning." *Village Voice*, 13 April 1982, p. 79 (installation photograph p. 79).

"Willem de Kooning: Xavier Fourcade." *ARTnews* 81, no. 6 (Summer 1982), p. 195.

Rose, Barbara. "De Kooning and Hockney: New Approaches to Drawing." *Vogue*, July 1982, pp. 194, 250 (ill. p. 194).

Campbell, Lawerence. "Willem de Kooning at Fourcade." *Art in America* 70, no. 8 (September 1982), p. 161.

Wilkie, Ken. "Willem de Kooning: Portrait of a Modern Master." *Holland Herald* 17, no. 3 (1982), pp. 22 – 25, 28 – 31, 33 (ill. p. 24).

Gaugh, Harry F. *Willem de Kooning*. New York: Abbeville Press, 1983 (ill. frontispiece).

Cooke, Lynne. "Stockholm: Willem de Kooning." *Burlington Magazine* 125 (November 1983), p. 718.

Pepper, Curtis Bill. "The Indomitable de Kooning." *New York Times Magazine*, 20 November 1983, pp. 42 – 47, 66, 70, 86, 90, 94 (ill. pp. 46 – 47).

Sollers, Philippe. *De Kooning, vite*. Paris: Editions de la Différence, 1988. 2 vols. (ill. no. 106).

Waldman, Diane. *Willem de Kooning*. New York: Harry N. Abrams, 1988 (ill. pl. 108).

Goddard, Donald. *American Painting*. New York: Distributed by Macmillan for Hugh Lauter Levin Associates, 1990 (ill. p. 249).

Willem de Kooning. Tokyo: Kodansha, 1993 (ill. pl. 53).

Davidson, Susan. "Hirshhorn Looks Back at de Kooning." *Washingtonian*, October 1993, p. 26 (ill.).

Tully, Judd. "De Kooning at 90." *Art and Auction* 16, no. 4 (November 1993), pp. 114 – 119, 162 (ill. p. 119).

—————. "Een Hofhouding van Curatoren." *Art and Value* 2, no. 1 (1994), pp. 54 – 61 (ill. p. 61).

Wolfe, Judith. "Van Wim tot Bill de Kooning: zeven decennia thematiek en vorm." *Jong Holland* 10, no. 1 (1994), pp. 6 – 28 (ill. p. 29).

Serra, Catalina. "Barcelona acoge la única escala europea de la exposición de Willem de Kooning." *El País*, 18 February 1994, p. 34 (ill.).

Schiff, Bennett. "For de Kooning, Painting Has Been 'A Way of Living.'" *Smithsonian*, April 1994, pp. 108 – 119 (ill. p. 116).

Forman, Debbie. "De Kooning's Daring Journey into Artistic Chaos — and Back Again." *Cape Cod Times*, 24 December 1994, pp. C1, C6 (ill. p. C1).

Cateforis, David. "Willem de Kooning." *Art Journal* 53, no. 4 (Winter 1994), pp. 86 – 89.

4 **UNTITLED V** 1981
oil on canvas
80 x 70 in. (203.2 x 177.8 cm)
Courtesy Robert Miller Gallery, New York

PROVENANCE

Estate of Xavier Fourcade
Private collection

EXHIBITION HISTORY

Xavier Fourcade, Inc., New York. *Willem de Kooning: New Paintings, 1981–1982*, 17 March–1 May 1982.

LA Louver, Venice, California. *American European Painting*, 10 August–25 September 1982.

Stedelijk Museum, Amsterdam. *Willem de Kooning: Het Noordatlantisch licht/The North Atlantic Light, 1960–1983*, 11 May–3 July 1983 (cat. no. 36, ill. p. 59). Traveled to Louisiana Museum of Modern Art, Humlebaek, Denmark, 15 July–4 September 1983 (cat. no. 33, ill. p. 27); Moderna Museet, Stockholm, 17 September–30 October 1983 (cat. no. 37, ill. unpaginated).

Clara Hatton Gallery, Colorado State University, Fort Collins. *Willem de Kooning: Recent Works*, 6–30 March 1984 (cat. no. 4, ill. p. 3).

Musée national d'art moderne, Centre Georges Pompidou, Paris. *L'Époque, la mode, la morale, la passion: Aspects de l'art d'aujourd'hui, 1977–1987*, 21 May–17 August 1987 (ill. p. 142).

Robert Miller Gallery, New York. *Abstract-Figurative*, 29 June–13 August 1993.

National Gallery of Art, Washington, D.C. *Willem de Kooning: Paintings*, 8 May–5 September 1994 (cat. no. 76, ill. p. 215). Traveled to Metropolitan Museum of Art, New York, 11 October 1994–8 January 1995; Tate Gallery, London, 15 February–7 May 1995.

LITERATURE

Torngrist, Arne. "Willem de Kooning pa Moderna Museet ett maleri drunknai." *Dagens Nyheter*, 28 September 1983.

Cooke, Lynne. "Stockholm: Willem de Kooning." *Burlington Magazine* 125 (November 1983), p. 718.

Sotheby's, New York. "Contemporary Art from the Estate of Xavier Fourcade," sale cat., 4 November 1987, lot 22 (ill.).

Tully, Judd. "De Kooning at 90." *Art and Auction* 16, no. 4 (November 1993), pp. 114–119, 162.

——————. "Les Vieux artistes sont-ils bons à jeter?" *Beaux Arts* 123 (May 1994), pp. 97–104 (ill. p. 103).

Larson, Kay. "Alzheimer's Expressionism: The Conundrum of de Kooning's Last Paintings." *Village Voice*, 31 May 1994, pp. 40–43 (ill. cover and p. 40).

Delattre, Pierre. "Willem de Kooning Paintings." *The: Santa Fe's Monthly Magazine of the Arts* 3, no. 2 (August 1994), pp. 24–27 (ill. p. 24).

5 **UNTITLED VI** 1981
oil on canvas
77 x 88 in. (195.6 x 223.5 cm)
Private collection

PROVENANCE

Through Xavier Fourcade, Inc., New York
Collection Warner Communications, Inc. New York

EXHIBITION HISTORY

Xavier Fourcade, Inc., New York. *Willem de Kooning: New Paintings, 1981–1982*, 17 March–1 May 1982.

Whitney Museum of American Art, New York. *Willem de Kooning Retrospective Exhibition*, 15 December 1983–26 February 1984. Exh. cat. *Willem de Kooning: Drawings, Paintings, Sculpture* (cat. no. 253, ill. p. 236). Traveled to Akademie der Künste, Berlin, 11 March–29 April 1984 (cat. no. 253, ill. p. 236); Musée national d'art moderne, Centre Georges Pompidou, Paris, 28 June–24 September 1984 (ill. p. 141).

LITERATURE

Hale, Nike. "Art Freed from the Rules: de Kooning's New Works." *Art/World*, March–April 1982, pp. 1, 4 (ill. p. 1; listed incorrectly as *Untitled III*, 1981).

Campbell, Lawerence. "Willem de Kooning at Fourcade." *Art in America* 70, no. 8 (September 1982), p. 161 (ill.).

6 **UNTITLED III** 1982
oil on canvas
80 x 70 in. (203.2 x 177.8 cm)
Collection PaineWebber Group Inc., New York

PROVENANCE

Through Xavier Fourcade, Inc., New York
Margo Leavin Gallery, Los Angeles
Collection Steve Martin, Los Angeles
Gagosian Gallery, New York

EXHIBITION HISTORY

Stedelijk Museum, Amsterdam. *Willem
de Kooning: Het Noordatlantisch licht/The North
Atlantic Light, 1960–1983*, 11 May–3 July 1983
(cat. no. 37, ill. p. 60). Traveled to Louisiana
Museum of Modern Art, Humlebaek, Denmark,
15 July–4 September 1983 (cat. no. 34); Moderna
Museet, Stockholm, 17 September–30 October 1983
(cat. no. 38, ill. unpaginated).

Xavier Fourcade, Inc., New York. *Willem
de Kooning: New Paintings, Sculpture and Drawings*,
12 May–23 June 1984 (ill. unpaginated).

Margo Leavin Gallery, Los Angeles. *Willem de
Kooning: Paintings*, 17 January–21 February 1987.

LITERATURE

Gaugh, Harry F. *Willem de Kooning*. New York:
Abbeville Press, 1983 (ill. pl. 102).

Sorensen, Rolf. "En Av Suveranerna." *Gefle
Dagblad*, 20 September 1983 (ill.).

Olsson, Stig. "Willem de Kooning en rese bland konst-
narer." *Dala-Demokraten*, 12 October 1983 (ill.).

Nordern, Vera. "Myter berattar om det djupt mansk-
liga." *Varmlands Folkblad*, 25 October 1983 (ill.).

Sicurd, Marie-Claude. "De Kooning." *Up*, June
1984, pp. 45–47, 66 (ill.).

Wolfe, Judith. "Van Wim tot Bill de Kooning: zeven
decennia thematiek en vorm." *Jong Holland* 10,
no. 1 (1994), pp. 6–28 (ill. p. 26).

7 **UNTITLED V** 1982
oil on canvas
80 x 70 in. (203.2 x 177.8 cm)
Collection Philip Johnson

PROVENANCE

Through Xavier Fourcade, Inc., New York

EXHIBITION HISTORY

Galerie Maeght Lelong, New York. *De Kooning:
Selected Works*, 16 December 1983–27 January
1984.

Xavier Fourcade, Inc., New York. *Willem
de Kooning: New Paintings, Sculpture and Drawings*,
12 May–23 June 1984 (ill. unpaginated).

LITERATURE

Robinson, John. "Willem de Kooning." *Arts
Magazine* 59, no. 1 (September 1984), p. 35.

8 **UNTITLED IX** 1982
oil on canvas
70 x 80 in. (177.8 x 203.2 cm)
Collection the artist

9 **UNTITLED XII** 1982
oil on canvas
70 x 80 in. (177.8 x 203.2 cm)
Collection Ronnie and Samuel Heyman, New York
(shown in U.S. only)

PROVENANCE

Through Xavier Fourcade, Inc., New York
Collection Bruce A. Beal, Boston
Saatchi Collection, London

EXHIBITION HISTORY

Whitney Museum of American Art, New York. *Willem de Kooning Retrospective Exhibition*, 15 December 1983 – 26 February 1984. Exh. cat. *Willem de Kooning: Drawings, Paintings, Sculpture* (cat. no. 254, ill. p. 237). Traveled to Akademie der Künste, Berlin, 11 March – 29 April 1984 (cat. no. 254, ill. p. 237); Musée national d'art moderne, Centre Georges Pompidou, Paris, 28 June – 24 September 1984 (ill. p. 142).

Städtische Galerie im Städelschen Kunstinstitut, Frankfurt am Main. *Max-Beckmann-Preis 1984 der Stadt Frankfurt am Main: Willem de Kooning*, 15 May – 11 June 1984 (ill. p. 35).

LITERATURE

Schjeldahl, Peter. "The Anti-Master Now." *Vanity Fair*, January 1984, pp. 66 – 73 (ill. p. 70).

Gaugh, Harry F. "De Kooning in Retrospect." *ARTnews* 83, no. 3 (March 1984), pp. 90 – 95 (ill. p. 93; incorrectly identified as *Untitled X*, 1982).

Coffelt, Beth. "Strokes of Genius." *Dial* 5, no. 5 (May 1984), pp. 28 – 33, 54 – 55 (ill.).

Willem de Kooning: New Paintings, Sculpture and Drawings. New York: Xavier Fourcade, Inc., 1984 (ill. cover and unpaginated).

Sollers, Philippe. *De Kooning, vite*. Paris: Editions de la Différence, 1988. 2 vols. (ill. no. 108).

Waldman, Diane. *Willem de Kooning*. New York: Harry N. Abrams, 1988 (ill. pl. 109).

Anfam, David. *Abstract Expressionism*. New York: Thames and Hudson, 1990 (ill. p. 181).

Christie's, New York. "Contemporary Art," 7 May 1990, sale cat., lot 44 (ill. p.99).

Baer, Martha. "Contemporary Art Sales." In *Christie's Review of the Season 1990*, pp. [140] – 142 (ill. p. [140] – 141).

Tully, Judd. "De Kooning at 90." *Art and Auction* 16, no. 4 (November 1993), pp. 114 – 119, 162.

B[evan], R[oger]. "De Kooning at Ninety." *Art Newspaper* 5, no. 38 (May 1994), p. 8 (ill.; incorrectly dated 1977).

10 **UNTITLED XV** 1982
oil on canvas
70 x 80 in. (177.8 x 203.2 cm)
Collection Steve Martin

PROVENANCE

Through Xavier Fourcade, Inc., New York
Margo Leavin Gallery, Los Angeles

EXHIBITION HISTORY

Galerie Daniel Templon, Paris. *Willem de Kooning: Peintures et sculptures récentes*, 14 June – 21 July 1984.

Galerie Hans Strelow, Düsseldorf. *Willem de Kooning: Bilder, Skulpturen, Zeichnungen*, 13 September – 20 October 1984.

Studio Marconi, Milan. *De Kooning: Dipinti, Disegni, Sculture*, 21 March – 30 April 1985 (ill. p. 44).

Margo Leavin Gallery, Los Angeles. *Willem de Kooning: Paintings*, 17 January – 21 February 1987.

LITERATURE

Castello, Michelangelo. "Il telaio informale: Willem de Kooning." *Tema Celeste* 5 (March 1985), pp. 14 – 18 (ill. p. 18).

Willem de Kooning. Tokyo: Kodansha, 1993 (ill. pl. 54).

11 **UNTITLED XXII** 1982
oil on canvas
77 x 88 in. (195.6 x 223.5 cm)
Collection San Francisco Museum of Modern Art
Promised gift of Phyllis Wattis

PROVENANCE

Through Matthew Marks Gallery, New York

EXHIBITION HISTORY

San Francisco Museum of Modern Art. *Into a New Museum: Recent Gifts and Other Acquisitions of Contemporary Art, Part I*, 18 January – 18 June 1995.

12 **UNTITLED XXIII** 1982
oil on canvas
80 x 70 in. (203.2 x 177.8 cm)
Collection the artist

13 MORNING: THE SPRINGS (UNTITLED I) 1983
oil on canvas
80 x 70 in. (203.2 x 177.8 cm)
Collection Stedelijk Museum, Amsterdam
Acquired with financial support from the
Vereniging Rembrandt
(shown in Europe only)

PROVENANCE

Through Xavier Fourcade, Inc., New York

EXHIBITION HISTORY

Stedelijk Museum, Amsterdam. *Willem
de Kooning: Het Noordatlantisch licht/The North
Atlantic Light, 1960–1983*, 11 May–3 July 1983
(cat. no. 38, ill. p. 61). Traveled to Louisiana
Museum of Modern Art, Humlebaek, Denmark,
15 July–4 September 1983 (cat. no. 35, ill. p. 22);
Moderna Museet, Stockholm, 17 September–
30 October 1983 (cat. no. 39, ill. unpaginated).

Xavier Fourcade, Inc., New York. *Willem
de Kooning: New Paintings, Sculpture and Drawings*,
12 May–23 June 1984 (ill. unpaginated).

Whitney Museum of American Art, New York.
Willem de Kooning Retrospective Exhibition. Shown
only at the Musée national d'art moderne, Centre
Georges Pompidou, Paris, 28 June–
24 September 1984 (ill. p. 144).

Stedelijk Museum, Amsterdam. *Het Materiaal/The
Material*, 5 May–29 August 1993.

National Gallery of Art, Washington, D.C. *Willem
de Kooning: Paintings*, 8 May–5 September 1994
(cat. no. 79, ill. p. 218). Traveled to Metropolitan
Museum of Art, New York, 11 October 1994–
8 January 1995; Tate Gallery, London, 15 February–
7 May 1995.

LITERATURE

Cooke, Lynne. "Stockholm: Willem de Kooning."
Burlington Magazine 125 (November 1983), p. 718
(ill. no. 73).

Joosten, Joop, compiler. *20 Jaar verzamelem/
20 Years of Collecting.* Amsterdam: Stedelijk
Museum, 1984 (ill. p. 105).

Waldman, Diane. *Willem de Kooning.* New York:
Harry N. Abrams, 1988 (ill. pl. 110).

Hughes, Robert. "Seeing the Face in the Fire." *Time*,
30 May 1994, pp. 62–64 (ill. p. 63).

————. "Eyeing the Glimpser." *Time
International*, 30 May 1994, pp. 60–62 (ill. p. 60).

14 UNTITLED II 1983
oil on canvas
70 x 80 in. (177.8 x 203.2 cm)
Collection San Francisco Museum of Modern Art
Fractional gift of Mimi and Peter Haas, 94.426

PROVENANCE

Through Matthew Marks Gallery, New York

EXHIBITION HISTORY

San Francisco Museum of Modern Art. *Into a New
Museum: Recent Gifts and Other Acquisitions of
Contemporary Art, Part I*, 18 January–18 June 1995.

LITERATURE

Baker, Kenneth. "SFMOMA Scoops Up Plenty of
New Art." *San Francisco Chronicle*, 8 December
1994, pp. E1, E4 (ill. p. E1).

Temko, Allan. "Art and Soul." *San Francisco Focus*,
January 1995, pp. 42–50, 102–103 (ill. p. 50).

"SFMOMA: A Floor-by-Floor Look at the Museum
of Modern Art." *San Francisco Chronicle*, 8 January
1995, p. 36.

Bonetti, David. "The New Deal." *San Francisco
Examiner Magazine*, 15 January 1995, pp. 20–23,
30, 32–33 (ill. p. 22).

15 UNTITLED III 1983
oil on canvas
88 x 77 in. (223.5 x 195.6 cm)
Courtesy SBC Communications Inc.,
San Antonio, Texas

PROVENANCE

Through Xavier Fourcade, Inc., New York

EXHIBITION HISTORY

Xavier Fourcade, Inc., New York. *Willem de Kooning: New Paintings, Sculpture and Drawings,* 12 May – 23 June 1984 (ill. unpaginated).

Anthony d'Offay Gallery, London. *Willem de Kooning: Recent Paintings, 1983 – 1986,* 21 November 1986 – 14 January 1987 (cat. no. 1, ill. unpaginated).

Anthony d'Offay Gallery, London. *Painting, Drawing, and Sculpture,* 2 March – 8 April 1994.

LITERATURE

Merkert, Jörn. "Willem de Kooning: Le Plaisir de réalité." *Art Press* 82 (June 1984), pp. 6 – 11 (ill. p. 10).

Sollers, Philippe. *De Kooning, vite.* Paris: Editions de la Différence, 1988. 2 vols. (ill. no. 112).

Lasker, Jonathan. "Willem de Kooning: Paintings for the Living." *Jong Holland* 10, no. 1 (1994), pp. 4 – 5 (ill. p. 5).

16 **UNTITLED V** 1983
oil on canvas
88 x 77 in. (223.5 x 195.6 cm)
Collection Mr. and Mrs. David N. Pincus

PROVENANCE

Through Xavier Fourcade, Inc., New York

EXHIBITION HISTORY

Xavier Fourcade, Inc., New York. *In Honor of de Kooning,* 8 December 1983 – 21 January 1984 (ill. unpaginated).

Xavier Fourcade, Inc., New York. *Willem de Kooning: New Paintings, Sculpture and Drawings,* 12 May – 23 June 1984 (ill. unpaginated and on announcement cover).

Anthony d'Offay Gallery, London. *Willem de Kooning: Paintings and Sculpture, 1971–1983,* 21 November 1984 – 11 January 1985 (cat. no. 15, ill. unpaginated).

LITERATURE

Leiser, Erwin. "Willem de Kooning." *Frankfurter Allgemeine Magazin,* 2 March 1984, pp. 30 – 36 (ill. p. 35).

Ratcliff, Carter. "The Past Undone: Willem de Kooning." *Art in America* 72, no. 6 (Summer 1984), pp. 114 – 123 (ill. p. 123).

Miller, Sanda. "Putting Flesh onto Oil Painting." *Times* (London), 4 December 1984.

Feaver, William. "Spotlight: de Kooning." *Vogue,* January 1985, pp. 84 – 88 (ill. pp. 86 – 87).

Mullaly, Terence. "Willem de Kooning." *Daily Telegraph* (London), 14 January 1985.

Packer, William. "Willem de Kooning: Anthony d'Offay Gallery: New York's Grand Old Man." *Financial Times* (London), 17 January 1985 (ill.).

Codognato, Mario. "Willem de Kooning: Changing Moods and Lights." *Domus* 658 (February 1985), p. 75 (ill.).

Tully, Judd. "Een hofhouding van curatoren." *Art and Value* 2, no. 1 (1994), pp. 54 – 61 (installation photograph p. 54).

Schlagheck, Irma. "Vom ihm haben viele Gelernt." *Art-Das Kunstmagazin* 4 (April 1994), p. 14 (ill. p. 27).

17 **UNTITLED XII** 1983
oil on canvas
80 x 70 in. (203.2 x 177.8 cm)
Collection Walker Art Center, Minneapolis
Partial gift of Ralph and Peggy Burnet, 1993

PROVENANCE

Through Matthew Marks Gallery, New York

EXHIBITION HISTORY

Xavier Fourcade, Inc., New York. *Willem de Kooning: New Paintings, Sculpture and Drawings,* 12 May – 23 June 1984 (ill. unpaginated).

Hill Gallery, Birmingham, Michigan. *Sense and Sensibility,* February – March 1985.

LITERATURE

Willem de Kooning: Paintings. Washington, D.C.: National Gallery of Art, and New Haven and London: Yale University Press, 1994 (ill. p. 200, in studio view).

18 UNTITLED XV 1983
oil on canvas
80 x 70 in. (203.2 x 177.8 cm)
Collection Emily Fisher Landau, New York

PROVENANCE

Through Xavier Fourcade, Inc., New York
Anthony d'Offay Gallery, London

EXHIBITION HISTORY

Anthony d'Offay Gallery, London. *Willem
de Kooning: Recent Paintings, 1983–1986*,
21 November 1986–14 January 1987 (cat. no. 4,
ill. unpaginated).

Whitney Museum of American Art, Fairfield County
Branch. *Enduring Creativity*, 15 April–15 June 1988
(ill. p. 17).

LITERATURE

Shone, Richard. "Willem de Kooning." *Vogue*,
November 1986, p. 10.

19 UNTITLED XIX 1983
oil on canvas
77 x 88 in. (195.6 x 223.5)
Private collection, San Francisco

PROVENANCE

Through Xavier Fourcade, Inc., New York
Private collection, New York

LITERATURE

Peters, Din. "Willem de Kooning: Paintings
1960–1982." *Studio International* 196, no. 1001
(August 1983), pp. 4–5.

Sollers, Philippe. *De Kooning, vite*. Paris: Editions de
la Différence, 1988. 2 vols. (ill. no. 114).

20 UNTITLED IV 1984
oil on canvas
88 x 77 in. (223.5 x 195.6 cm)
Collection the artist

EXHIBITION HISTORY

Xavier Fourcade, Inc., New York. *Willem
de Kooning: New Paintings, 1984–1985*,
17 October–16 November 1985 (not illustrated in cat.).

National Gallery of Art, Washington, D.C. *Willem
de Kooning: Paintings*, 8 May–5 September 1994
(cat. no. 82, ill. p. 221). Traveled to Metropolitan
Museum of Art, New York, 11 October 1994–
8 January 1995; Tate Gallery, London, 15 February–
7 May 1995.

LITERATURE

Horyn, Cathy. "The de Kooning Show and the No-
Shows at the National Gallery Party, a Collection of
Collectors." *Washington Post*, 6 May 1994, p. B4
(installation photograph).

Twardy, Chuck. "In the Mind's Eye." *News and
Observer*, 15 May 1994, pp. 1G, 3G (ill. p. 1G).

Pacheco, Patrick. "America's Dutch Master." *Art
and Antiques* 17, no. 7 (September 1994), pp. 74–79
(ill. p. 77).

Polcari, Stephen. "Washington, National Gallery:
Willem de Kooning." *Burlington Magazine* 136,
no. 1098 (September 1994), pp. 642–644 (ill. p. 643).

Hilton, Tim. "American Dreams." *Independent*,
5 February 1995, pp. 18–21 (ill. p. 21).

Auty, Giles. "Heightened Perception." *Spectator*,
25 February 1995 (ill. upside down).

Jackson, Kevin. "A Bigger Splash." *Arena*,
Spring 1995, pp. 22–28 (ill. p. 28).

Morley, Simon. "Willem de Kooning: Then and Now."
Art Monthly 184 (March 1995), pp. 6–9 (ill. p. 8).

21 UNTITLED X 1984
oil on canvas
77 x 88 in. (195.6 x 223.5 cm)
Collection San Francisco Museum of Modern Art
Fractional gift of Helen and Charles Schwab, 94.534

PROVENANCE

Through Matthew Marks Gallery, New York

EXHIBITION HISTORY

Margo Leavin Gallery, Los Angeles. *Willem de Kooning: Paintings*, 17 January–21 February 1987.

San Francisco Museum of Modern Art. *Into a New Museum: Recent Gifts and Other Acquisitions of Contemporary Art, Part I*, 18 January–18 June 1995.

LITERATURE

Kazanjian, Dodie. "Marks and Sparks." *Vogue*, February 1995, pp. 256–259, 296–297 (ill. p. 258, on its side).

22 **UNTITLED XVII** 1984
oil on canvas
80 x 70 in. (203.2 x 177.8 cm)
Collection M. Anthony Fisher

PROVENANCE

Through Xavier Fourcade, Inc., New York
Anthony d'Offay Gallery, London

EXHIBITION HISTORY

Xavier Fourcade, Inc., New York. *Willem de Kooning: New Paintings, 1984–1985*, 17 October–16 November 1985 (ill. unpaginated).

Anthony d'Offay Gallery, London. *Willem de Kooning: Recent Paintings, 1983–1986*, 21 November 1986–14 January 1987 (cat. no. 7, ill. unpaginated).

LITERATURE

Stavitsky, Gail. "Willem de Kooning." *Arts Magazine* 60, no. 5 (January 1986), pp. 143–144 (ill. p. 144).

Waldman, Diane. *Willem de Kooning.* New York: Harry N. Abrams, 1988 (ill. pl. 111).

Sheffield, Margaret. "Landau's Gifts." *Town and Country*, July 1993, p. 96 (ill.).

23 **[NO TITLE]** 1984
oil on canvas
80 x 70 in. (203.2 x 177.8 cm)
Collection the artist

24 **[NO TITLE]** 1984
oil on canvas
77 x 88 in. (195.6 x 223.5 cm)
Collection the artist

EXHIBITION HISTORY

Arthur M. Sackler Museum, Harvard University, Cambridge, Mass. *Jasper Johns, Richard Serra, and Willem de Kooning: Works Loaned by the Artists in Honor of Neil and Angelica Rudenstine*, 18 January–9 August 1992.

National Gallery of Art, Washington, D.C. *Willem de Kooning: Paintings*, 8 May–5 September 1994 (cat. no. 81, ill. p. 220). Traveled to Metropolitan Museum of Art, New York, 11 October 1994–8 January 1995; Tate Gallery, London, 15 February–7 May 1995.

25 **TRIPTYCH (UNTITLED V, UNTITLED II, UNTITLED IV)** 1985
oil on canvas
80 x 70 in. (203.2 x 177.8 cm), 77 x 88 in. (195.6 x 223.5 cm), 80 x 70 in. (203.2 x 177.8 cm)
Collection the artist

EXHIBITION HISTORY

Xavier Fourcade, Inc., New York. *Willem de Kooning: New Paintings, 1984–1985*, 17 October–16 November 1985 (ill. unpaginated).

St. Peter's Church, New York. Fall 1985.

Guild Hall Museum, East Hampton, New York. *Celebrating Willem de Kooning: Selected Paintings and Sculpture*, 25 June–31 July 1994 (cat. no. 10, ill. unpaginated).

LITERATURE

McGill, Douglas C. "Triptych Is Focus of Church Debate." *New York Times*, 28 February 1986, p. C13 (ill.).

Smith, Roberta. "Long Island Shows Concentrate on Painting." *New York Times*, 8 July 1994, p. C25.

Cook, John W. "A Willem de Kooning Triptych and St. Peter's Church." *Theological Education* 31, no. 1 (1994), pp. 59–73.

26 **UNTITLED VII** 1985
oil on canvas
70 x 80 in. (177.8 x 203.2 cm)
Collection The Museum of Modern Art, New York
Purchase and gift of Milly and Arnold Glimcher, 1991

PROVENANCE

Through Xavier Fourcade, Inc., New York
Private collection
The Pace Gallery, New York

EXHIBITION HISTORY

Xavier Fourcade, Inc., New York. *Willem
de Kooning: New Paintings, 1984–1985*,
17 October–16 November 1985 (ill. cover and
unpaginated and on announcement cover).

Pace Gallery, New York. *Willem de Kooning, Jean
Dubuffet: The Late Works*, 17 September–
16 October 1993 (cat. no. 5, ill. unpaginated).

LITERATURE

"Album: Willem de Kooning." *Arts Magazine* 60,
no. 2 (October 1985), pp. 134–135.

Sollers, Philippe. *De Kooning, vite*. Paris: Editions de
la Différence, 1988. 2 vols. (ill. no. 120).

Tully, Judd. "De Kooning at 90." *Art and Auction*
16, no. 4 (November 1993), pp. 114–119, 162.

Kaufman, Jason Edward. "The Museum of Modern
Art, New York: What We Buy and How We Do It —
Interview with Robert Storr." *Art Newspaper* 5,
no. 36 (March 1994), pp. 20–21.

27 **UNTITLED XIII** 1985
oil on canvas
80 x 70 in. (203.2 x 177.8 cm)
Collection The Cleveland Museum of Art
Leonard C. Hanna, Jr., Fund
(shown in U.S. only)

PROVENANCE

Through Xavier Fourcade, Inc., New York
Through Anthony d'Offay Gallery, London

EXHIBITION HISTORY

Xavier Fourcade, Inc., New York. *Willem de
Kooning: New Paintings, 1984–1985*, 17 October–
16 November 1985 (not illustrated in cat.).

Anthony d'Offay Gallery, London. *Willem
de Kooning: Recent Paintings, 1983–1986*,
21 November 1986–14 January 1987 (cat. no. 8,
ill. unpaginated).

LITERATURE

Decker, Andrew. "Who Will Represent de Kooning?"
ARTnews 88, no. 6 (Summer 1989), pp. 136–141
(ill. p. 141).

Barnett, Catherine. "The Conundrum of Willem
de Kooning." *Art and Antiques* 6, no. 9 (November
1989), pp. 62–73, 128 (ill. p. 71).

Jong Holland 10, no. 1 (1994) (ill. cover).

28 **UNTITLED XX** 1985
oil on canvas
70 x 80 in. (177.8 x 203.2 cm)
Collection the artist

EXHIBITION HISTORY

Xavier Fourcade, Inc., New York. *In Honor of
John Chamberlain*, 27 June–12 September 1986
(ill. unpaginated).

Anthony d'Offay Gallery, London. *Willem
de Kooning: Recent Paintings, 1983–1986*,
21 November 1986–14 January 1987 (cat. no. 9,
ill. unpaginated).

LITERATURE

Feaver, William. "Turns, Loops, Flicks of the Wrist."
Observer, 30 November 1986, p. 26.

Sollers, Philippe. *De Kooning, vite*. Paris: Editions de
la Différence, 1988. 2 vols. (ill. no. 122).

29 **[NO TITLE]** 1985
oil on canvas
77 x 88 in. (195.6 x 223.5 cm)
Collection the artist

EXHIBITION HISTORY

Guild Hall Museum, East Hampton, New York.
*Celebrating Willem de Kooning: Selected Paintings
and Sculpture*, 25 June–31 July 1994 (cat. no. 11,
ill. cover and unpaginated).

LITERATURE

Whitehouse, Beth. "Out East." *Newsday*, 28 June 1994, p. B3 (partial view in installation photograph).

30 **UNTITLED II** 1986
oil on canvas
88 x 77 in. (223.5 x 195.6 cm)
Collection San Francisco Museum of Modern Art
Fractional purchase through the John and Frances
Bowes Fund, 94.427

PROVENANCE

Through Matthew Marks Gallery, New York

EXHIBITION HISTORY

San Francisco Museum of Modern Art. *Into a New Museum: Recent Gifts and Other Acquisitions of Contemporary Art, Part I*, 18 January–18 June 1995.

LITERATURE

Baker, Kenneth. "A Vision of Modern Art by Consensus." *San Francisco Chronicle*, 18 January 1995, pp. E1, E5 (installation photograph p. E1).

31 **UNTITLED VI** 1986
oil on canvas
77 x 88 in. (195.6 x 223.5 cm)
Private collection

PROVENANCE

Through Xavier Fourcade, Inc., New York
Anthony d'Offay Gallery, London

EXHIBITION HISTORY

Anthony d'Offay Gallery, London. *Willem de Kooning: Recent Paintings, 1983–1986*, 21 November 1986–14 January 1987 (cat. no. 12, ill. unpaginated).

Musée national d'art moderne, Centre Georges Pompidou, Paris. *L'Époque, la mode, la morale, la passion: Aspects de l'art d'aujourd'hui, 1977–1987*, 21 May–17 August 1987 (ill. p. 143).

32 **UNTITLED VIII** 1986
oil on canvas
70 x 80 in. (177.8 x 203.2 cm)
Private collection
(shown in San Francisco and New York only)

PROVENANCE

Through Xavier Fourcade, Inc., New York

33 **UNTITLED XXIV** 1986
oil on canvas
88 x 77 in. (223.5 x 195.6 cm)
Collection the artist

34 **[NO TITLE]** 1987
oil on canvas
88 x 77 in. (223.5 x 195.6 cm)
Collection the artist

35 **[NO TITLE]** 1987
oil on canvas
77 x 88 in. (195.6 x 223.5 cm)
Collection the artist

LITERATURE

Wallach, Amei. "My Dinners with de Kooning." *Newsday*, Fanfare section, 24 April 1994, pp. 8–9, 24 (ill. in studio view).

36 **[NO TITLE]** 1987
oil on canvas
80 x 70 in. (203.2 x 177.8 cm)
Collection the artist

EXHIBITION HISTORY*

SOLO EXHIBITIONS

1981 *Willem de Kooning: Works from 1951–1981.* Guild Hall Museum, East Hampton, New York. 23 May–19 July. Catalogue with essay by Judith Wolfe and photographs of the artist by Hans Namuth.

1982 *Willem de Kooning: New Paintings, 1981–1982.* Xavier Fourcade, Inc., New York. 17 March–1 May.

Exhibition on the occasion of the visit of Queen Beatrix of the Netherlands to New York. Vista International Hotel, World Trade Center, New York. 24 April.

1983 *Willem de Kooning: Het Noordatlantisch licht/The North Atlantic Light, 1960–1983.* Stedelijk Museum, Amsterdam. 10 May–3 July. Traveled to Louisiana Museum, Humlebaek, Denmark, 16 July–4 September; and Moderna Museet, Stockholm, 17 September–30 October. Catalogue with essays by Edy de Wilde and Carter Ratcliff. Danish edition of catalogue published in *Louisiana Revy* 23, no. 3 (June 1983); Swedish edition of catalogue published under title *Nordatlantens ljus/The North Atlantic Light, 1960–1983.*

Willem de Kooning: Skulpturen. Josef-Haubrich-Kunsthalle, Cologne. 9 September–30 October. Catalogue with essay by Siegfried Gohr.

The Drawings of Willem de Kooning and *Willem de Kooning Retrospective Exhibition.* Whitney Museum of American Art, New York. Drawings: 7 December 1983–19 February 1984. Retrospective: 15 December 1983–26 February 1984. Traveled to Akademie der Künste, Berlin, 11 March–29 April 1984; and Musée national d'art moderne, Centre Georges Pompidou, Paris, 26 June–24 September 1984. Catalogue *Willem de Kooning: Drawings, Paintings, Sculpture* with essays by Paul Cummings, Jörn Merkert, and Claire Stoullig. German and French editions of catalogue published.

De Kooning: Selected Works. Galerie Maeght Lelong, New York. 16 December 1983–27 January 1984.

1984 *Willem de Kooning: Recent Works.* Clara Hatton Gallery, Colorado State University, Fort Collins. 6–30 March. Catalogue.

Willem de Kooning: New Paintings, Sculpture and Drawings. Xavier Fourcade, Inc., New York. 12 May–23 June. Catalogue.

Max-Beckmann-Preis 1984 der Stadt Frankfurt am Main: Willem de Kooning. Städtische Galerie im Städelschen Kunstinstitut, Frankfurt am Main. 16 May–16 June. Catalogue.

* This list comprises all solo and group exhibitions in which paintings by de Kooning from the 1980s were shown. Accompanying catalogues are noted.

Willem de Kooning: Peintures et sculptures récentes. Galerie Daniel Templon, Paris. 14 June – 21 July. Exhibition organized jointly with Galerie Hans Strelow, Düsseldorf, and presented there under the title *Willem de Kooning: Bilder, Skulpturen, Zeichnungen*, 13 September – 20 October.

Willem de Kooning: Paintings and Sculpture, 1971–1983. Anthony d'Offay Gallery, London. 21 November 1984 – 11 January 1985. Catalogue.

1985 *De Kooning: Dipinti, Disegni, Sculture*. Studio Marconi, Milan. 21 March – April. Catalogue.

 Willem de Kooning: New Paintings, 1984–1985. Xavier Fourcade, Inc., New York. 17 October – 16 November. Catalogue.

1986 *Willem de Kooning: Recent Paintings, 1983–1986*. Anthony d'Offay Gallery, London. 21 November 1986 – 14 January 1987. Catalogue with essay by Robert Rosenblum; essay reprinted in *Art Journal* 48, no. 3 (Fall 1989), p. 249.

1987 *Willem de Kooning: Paintings 1982–1986*. Margo Leavin Gallery, Los Angeles. 17 January – 21 February.

 Willem de Kooning: The New Paintings. Richard Gray Gallery, Chicago. 1 May – 20 June.

1990 *Willem de Kooning*. Galerie Karsten Greve, Cologne. 8 – 28 February. Traveled to Galerie Karsten Greve, Paris, 8 March – 18 April. Catalogue.

 Willem de Kooning: Works on Paper, 1954–1984. Organized by Contempo Modern Art Gallery, Eindhoven, the Netherlands. Traveled to European Fine Art Fair, Maastricht, the Netherlands, 10 – 18 March; and Tokyo Art Expo, 29 March – 2 April. Catalogue.

 Willem de Kooning: An Exhibition of Paintings. Salander-O'Reilly Galleries, New York. 4 September – 15 October. Catalogue with essays by Klaus Kertess and Robert Rosenblum.

 A Few Remarkable Paintings by Picasso and de Kooning. Heiner Bastian Fine Art, Berlin. Catalogue.

1991 *Willem de Kooning: Important Paintings and Works on Paper*. Salander-O'Reilly Galleries, Beverly Hills. 8 January – 9 February.

1993 *Willem de Kooning, Jean Dubuffet: The Late Works*. Pace Gallery, New York. 17 September – 16 October. Catalogue with essay by Peter Schjeldahl.

 Willem de Kooning: Fom the Hirshhorn Museum Collection. Hirshhorn Museum and Sculpture Garden, Smithsonian Institution, Washington, D.C. 21 October 1993 – 9 January 1994. Traveled to Fundació "la Caixa," Barcelona, 17 February – 3 April 1994; High Museum of Art, Atlanta, 13 September – 27 November 1994; Museum of Fine Arts, Boston, 10 December 1994 – 19 February 1995; and Museum of Fine Arts, Houston, 19 March – 28 May 1995. Catalogue by Judith Zilczer with essays by Lynne Cooke, Susan Lake, and Judith Zilczer. Catalan/Castilian edition of catalogue published under title *Willem de Kooning col-lecció Hirshhorn Museum*.

 De Kooning: Works on Paper. Barbara Mathes Gallery, New York. 23 October – 31 December.

1994 *Willem de Kooning: Paintings*. National Gallery of Art, Washington, D.C. 8 May – 5 September. Traveled to Metropolitan Museum of Art, New York, 6 October 1994 – 8 January 1995; and Tate Gallery, London, 15 February – 7 May 1995. Catalogue by Marla Prather, with essays by David Sylvester and Richard Shiff.

 Willem de Kooning, A Summer Exhibition: Selected Works 1950s–1980s. C & M Arts, New York. 7 June – 12 August.

 Celebrating Willem de Kooning: Selected Paintings and Sculpture. Guild Hall Museum, East Hampton, New York. 25 June – 31 July. Catalogue with essay by Klaus Kertess.

1982 *Five Distinguished Alumni, The W.P.A. Federal Art Project: An Exhibition Honoring the Franklin Delano Roosevelt Centennial.* Hirshhorn Museum and Sculpture Garden, Smithsonian Institution, Washington, D.C. 21 January–22 February. Catalogue.

'60–'80: Attitudes, Concepts, Images. Stedelijk Museum, Amsterdam. 9 April–11 July. Catalogue.

Abstract Expressionism Lives! Stamford Museum and Nature Center, Stamford, Connecticut. 19 September–7 November. Catalogue.

1983 *Drawings.* Xavier Fourcade, Inc., New York. 12 July–16 September.

In Honor of de Kooning. Xavier Fourcade, Inc., New York. 8 December 1983–21 January 1984. Catalogue.

1984 *Drawings Since 1974.* Hirshhorn Museum and Sculpture Garden, Smithsonian Institution, Washington, D.C. 14 March–13 May.

1985 *Eight Modern Masters.* Amarillo Art Center, Amarillo, Texas. 20 April–23 June. Catalogue.

1986 *In Honor of John Chamberlain.* Xavier Fourcade, Inc., New York. 27 June–12 September. Catalogue.

Major Acquisitions Since 1980: Selected Painting and Sculpture. Whitney Museum of American Art, New York. 18 September–30 November. Accompanied by the publication *Painting and Sculpture Acquisitions 1973–1986.*

1987 *1987 Biennial Exhibition.* Whitney Museum of American Art, New York. 10 April–5 July. Catalogue.

L'Époque, la mode, la morale, la passion: Aspects de l'art d'aujourd'hui, 1977–1987. Musée national d'art moderne, Centre Georges Pompidou, Paris. 21 May–17 August. Catalogue.

American Mastery: Eight Artists in the Permanent Collection of the Whitney Museum of American Art. Whitney Museum of American Art at Equitable Center, New York. 8 June 1987–21 May 1988. Catalogue.

Selected Works from the Collection of Asher B. Edelman. Thomas Ammann Fine Arts, Zurich. 17 June–18 September.

1988 *Enduring Creativity.* Whitney Museum of American Art at Champion, Stamford, Connecticut. 15 April–15 June. Catalogue.

Vital Signs: Organic Abstraction from the Permanent Collection. Whitney Museum of American Art, New York. 28 April–17 July. Catalogue.

1989 *Art in Place: Fifteen Years of Acquisitions.* Whitney Museum of American Art, New York. July–October. Catalogue.

1990 *Baltimore Collects: Painting and Sculpture Since 1960.* Baltimore Museum of Art. 27 May–22 July.

Hommage aan Vincent van Gogh: Twintig Posters/Homage to Vincent van Gogh: Twenty Posters. Stichting Vincent van Gogh, Amsterdam.

1991 *Royal Academy of Arts Summer Exhibition 1991.* Royal Academy of Arts, London. Summer. Catalogue.

1992 *Jasper Johns, Richard Serra, Willem de Kooning: Works Loaned by the Artists in Honor of Neil and Angelica Rudenstine*. Arthur M. Sackler Museum, Harvard University, Cambridge, Massachusetts. 18 January – 9 August.

1993 *Het Materiaal/The Material*. Stedelijk Museum, Amsterdam. 5 May – 29 August.

 The Permanent Collection: Recent Acquisitions. Walker Art Center, Minneapolis. 22 August – 17 October.

1994 *Painting, Drawing, and Sculpture*. Anthony d'Offay Gallery, London. 2 March – 8 April.

1995 *Into a New Museum: Recent Gifts and Other Acquisitions of Contemporary Art, Part I*. San Francisco Museum of Modern Art. 18 January – 18 June.

 Myth and Nature in American Painting. Tate Gallery, London. January – May.

 Texas Collects: Willem de Kooning and His Contemporaries. Museum of Fine Arts, Houston. 17 March – 21 May.

BIBLIOGRAPHY

This bibliography is limited to sources relevant to de Kooning's paintings of the 1980s. Exhibition catalogues are not included but are cited in the exhibition history. Earlier monographs essential to a study of de Kooning's career include *Willem de Kooning*, by Thomas B. Hess (New York: Museum of Modern Art, 1968) and *De Kooning*, by Harold Rosenberg (New York: Harry N. Abrams, 1974). The artist's early years in America are covered in Sally E. Yard's dissertation *Willem de Kooning: The First Twenty-Six Years in New York, 1927–1952* (Ann Arbor: University Microfilms, 1980). Important earlier exhibition catalogues include *Willem de Kooning* (Pittsburgh: Carnegie Institute, Museum of Art, 1979); *Willem de Kooning in East Hampton*, by Diane Waldman (New York: Solomon R. Guggenheim Museum, 1978); *The Sculpture of de Kooning with Related Paintings, Drawings and Lithographs,* by David Sylvester (London: Arts Council of Great Britain, 1977); and *De Kooning: Drawings/ Sculptures* by Philip Larson and Peter Schjeldahl (Minneapolis: Walker Art Center, and New York: E. P. Dutton, 1974).

Hess, Rosenberg, and Yard, cited above, provide the most comprehensive bibliographies, which are augmented by those in the exhibition catalogues *Willem de Kooning: Paintings* (Washington, D.C.: National Gallery of Art, and New Haven and London: Yale University Press, 1994) and *Willem de Kooning: Drawings, Paintings, Sculpture* (New York: Whitney Museum of American Art, in association with Prestel-Verlag, Munich, and W. W. Norton, New York and London, 1983).

Hess (1968), Rosenberg (1974), and the 1979 Carnegie Museum of Art catalogue reprint significant writings by and interviews with the artist. In the absence of a definitive English edition of these, the researcher is directed to *Willem de Kooning: Écrits et propos*, edited by Marie-Anne Sichère (Paris: École nationale supérieure des beaux-arts, 1993).

EUGENIE CANDAU LIBRARIAN, SAN FRANCISCO MUSEUM OF MODERN ART

BOOKS

Anfam, David. *Abstract Expressionism*. New York: Thames and Hudson, 1990.

Cateforis, David. *Willem de Kooning*. New York: Rizzoli, 1994.

Christopher, Ann, ed. *Royal Academy Illustrated 1991: A Souvenir of the 223rd Summer Exhibition*. London: Royal Academy of Arts, 1991.

De Kooning, Elaine. *The Spirit of Abstract Expressionism: Selected Writings*. New York: George Braziller, 1994. Reviewed by Kenneth Baker, *Washington Post Book World*, 31 July 1994.

Gaugh, Harry F. *Willem de Kooning*. New York: Abbeville Press, 1983. German edition published by C. J. Bucher, Munich, 1984.

Goddard, Donald. *American Painting*. New York: Distributed by Macmillan for Hugh Lauter Levin Associates, 1990.

Gohr, Siegfried. *Museum Ludwig Cologne: Paintings, Sculptures, Environments: From Expressionism to the Present Day*. Munich: Prestel-Verlag, 1986. English edition published on the occasion of the opening of the new Museum Ludwig, Cologne, 6 September 1986.

Hall, Lee. *Elaine and Bill, Portrait of a Marriage: The Lives of Willem and Elaine de Kooning*. New York: HarperCollins, 1993. Reviewed by Dore Ashton, *Washington Post Book World*, 25 July 1994; Robert Katz, *New York Times Book Review*, 1 August 1993; Michael Kimmelman, *New York Times*, 15 August 1993; Jo Ann Lewis, *Washington Post Book World*, 25 July 1993; Peter Plagens, *Newsweek*, 5 July 1993; Deborah Solomon, *Wall Street Journal*, 11 August 1993.

Joosten, Joop, compiler. *20 Jaar verzamelem/20 Years of Collecting*. Amsterdam: Stedelijk Museum, 1984.

Klawans, Harold L. "The Collector." In *Life, Death and In Between: Tales of Clinical Neurology*. New York: Paragon House, 1992. Reprinted in *MD* (New York), December 1992, pp. 74 – 79 (ill.).

Least Heat Moon, William. *The Red Couch*. New York: Alfred Van der Marck Editions, 1985. Photography by Kevin Clarke and Horst Wackerbarth.

Ruhrberg, Karl. *Twentieth Century Art: Painting and Sculpture in the Ludwig Museum*. New York: Rizzoli, 1986. German edition published by Klett-Cotta, Stuttgart. Selective catalogue published on the occasion of the opening of the new Museum Ludwig, Cologne, September 1986.

Schjeldahl, Peter. *The Hydrogen Jukebox*. Berkeley: University of California Press, 1991.

Schwarz, Rudolf. *Der Kaiserring: Kunstpreis der Stadt Goslar*. Goslar: Stadt Goslar, n.d.

Sollers, Philippe. *De Kooning, vite*. Paris: Editions de la Différence, 1988. 2 vols.

Waldman, Diane. *Willem de Kooning*. New York: Harry N. Abrams, in association with the National Museum of American Art, Smithsonian Institution, 1988.

Willem de Kooning. Tokyo: Kodansha, 1993.

Yard, Sally. *Willem de Kooning*. New York: Rizzoli, forthcoming.

JOURNAL ARTICLES AND REVIEWS

1981

Aldrich, Elizabeth. "De Kooning, Guild Hall." *Art/World*, 23 May–20 June 1981, pp. 1, 3. Rev. Guild Hall.

Harrison, Helen A. "De Kooning: 30 Years on the East End." *New York Times, Long Island Weekly*, 24 May 1981 (ill.). Rev. Guild Hall.

1982

Anderson, Susan Heller. "De Kooning Has Meeting with Queen." *New York Times*, 25 April 1982, p. 42 (ill.).

Berman, Avis. "Willem de Kooning: 'I Am Only Halfway Through.'" *ARTnews* 81, no. 2 (February 1982), cover and pp. 68–73 (ill.).

Campbell, Lawrence. "Willem de Kooning at Fourcade." *Art in America* 70, no. 8 (September 1982), p. 161 (ill.). Rev. Fourcade.

Carlson, Joan Tyor. "Architectural Digest Visits: Willem de Kooning." *Architectural Digest*, January 1982, pp. 58–67 (ill.).

"El Gran legado de los abstractos de Kooning y Motherwell." *Goya* 166 (January–February 1982), p. 227 (ill.). Rev. Fourcade.

Hale, Nike. "Art Freed From the Rules: de Kooning's New Works." *Art/World*, March–April 1982, pp. 1, 4 (ill.).

Klinkhamer-Zwartjes, Gerda. "Willem de Kooning." *Tableau* (Utrecht, Netherlands) 5, no. 1 (September–October 1982), pp. 72–74 (ill.).

Larson, Kay. "De Kooning Adrift." *New York*, 12 April 1982, pp. 58–59 (ill.). Rev. Fourcade.

Ratcliff, Carter. "A Season in New York." *Art International* 25, nos. 7–8 (September–October 1982), p. 56 (ill.). Rev. Fourcade.

Rose, Barbara. "De Kooning and Hockney: New Approaches to Drawing." *Vogue*, July 1982, pp. 194, 250 (ill.).

Russell, John. "Art: Lively Competitor to the Old de Kooning." *New York Times*, 16 April 1982. Rev. Fourcade.

Schjeldahl, Peter. "Delights by de Kooning." *Village Voice*, 13 April 1982, p. 79 (ill.). Reprinted in the author's *The Hydrogen Jukebox*. Berkeley: University of California Press, 1991. Rev. Fourcade.

Wilkie, Ken. "Willem de Kooning: Portrait of a Modern Master." *Holland Herald* 17, no. 3 (1982), pp. 22–25, 28–31, 33 (ill.).

"Willem de Kooning: Xavier Fourcade." *ARTnews* 81, no. 6 (Summer 1982), p. 195. Rev. Fourcade.

1983

Cooke, Lynne. "Stockholm: Willem de Kooning." *Burlington Magazine* 125 (November 1983), p. 718. Rev. North Atlantic Light.

Farber, Jules B. "Willem de Kooning: A Brief Homecoming." *International Herald Tribune*, 27 May 1983 (ill.).

Jong, Jacqueline de. "The North Atlantic Light." *Du*, September 1983, p. 57 (ill.). Rev. North Atlantic Light.

Kertess, Klaus. "Willem de Kooning's Profound Variety." *East Hampton Star*, 22 December 1983, sec. 2, p. 7. Rev. Whitney.

Mellow, James R. "Willem de Kooning." *Harper's Bazaar*, November 1983, pp. 207, 268 (ill.).

Metz, Tracy. "De Kooning: Painting's Prodigious Son." *Holland Herald* 18, no. 5 (1983), pp. 58–59 (ill.).

Norden, Vara. "Myter berattar om det djupt manskiga." *Varmlands Folkblad*, 25 October 1983 (ill.).

Olsson, Stig. "Willem de Kooning en rese bland konstnarer." *Dala-Demokraten*, 12 October 1983 (ill.).

Pepper, Curtis Bill. "The Indomitable de Kooning." *New York Times Magazine*, 20 November 1983, cover and pp. 42–47, 66, 70, 86, 90, 94 (ill.).

Peters, Din. "Willem de Kooning: Paintings 1960–1982." *Studio International* 196, no. 1001 (August 1983), pp. 4–5 (ill.). Rev. North Atlantic Light.

"Pour les 80 ans de de Kooning." *Connaissance des arts* 382 (December 1983), p. 37. Rev. Whitney.

Sorensen, Rolf. "En av Suveranerna." *Gefle Dagblad*, 20 September 1983 (ill.).

Tornquist, Arne. "Willem de Kooning pa Moderna Museet en maleriatt drukai." *Dagens Nyheter*, 28 September 1983. Rev. North Atlantic Light.

Wallach, Amei. "At 79, de Kooning Seeks Simplicity." *Newsday,* Part II section, 4 December 1983, cover and pp. 4–5, 21–22 (ill.).

1984

Amaya, Mario. "Scaling the Heights: de Kooning into Lichtenstein." *Studio International* 96, no. 1004 (1984), pp. 41–42. Rev. 1984 d'Offay.

Burn, Gordon. "White Canvas in a Private View." *Times* (London), 24 November 1984, p. 8 (ill.).

Coffelt, Beth. "Strokes of Genius." *Dial* 5, no. 5 (May 1984), pp. 28–33, 54–55 (ill.).

"Daniel Templon." *Gazette des beaux-arts* 104, no. 5 (supp.), p. 29. Rev. Daniel Templon.

Gaugh, Harry F. "De Kooning in Retrospect." *ARTnews* 83, no. 3 (March 1984), pp. 90–95 (ill.). Rev. Whitney.

Hughes, Robert. "Painting's Vocabulary Builder." *Time*, 9 January 1984, p. 62–63 (ill.). Rev. Whitney.

Jodidio, Philip. "Peindre le desordre de l'époque." *Connaissance des arts* 388 (June 1984), cover and pp. 46–53 (ill.). Rev. Whitney at Pompidou.

Larson, Kay. "Sacred Enigma." *New York*, 9 January 1984, pp. 51–52. Rev. Whitney.

Leiser, Erwin. "Willem de Kooning." *Frankfurter Allgemeine Magazin*, 2 March 1984, pp. 30–36 (ill.).

Levin, Kim. "Art: The Week in Review." *Village Voice*, 5 June 1984, p. 90. Rev. Fourcade.

Merkert, Jörn. "Willem de Kooning: Le plaisir de réalité." *Art Press* 82 (June 1984), pp. 6–11 (ill.).

Miller, Sanda. "Putting Flesh onto Oil Painting." *Times* (London), 4 December 1984. Rev. 1984 d'Offay.

Ratcliff, Carter. "The Past Undone: Willem de Kooning." *Art in America* 72, no. 6 (Summer 1984), pp. 114–123 (ill.). Rev. Whitney.

Robinson, John. "Willem de Kooning." *Arts Magazine* 59, no. 1 (September 1984), p. 35. Rev. Fourcade.

Rosand, David. "Proclaiming Flesh." *Times Literary Supplement*, 17 February 1984, p. 167. Rev. Whitney.

Russell, John. "De Kooning's Freedom Came Step by Exuberant Step." *New York Times*, 5 February 1984, pp. 29–30.

Saul, Julie. "Willem de Kooning: Whitney Museum of American Art." *Flash Art* 117 (April–May 1984), p. 35. Rev. Whitney.

Schjeldahl, Peter. "The Anti-Master Now." *Vanity Fair*, January 1984, pp. 66–73 (ill.).

Schneider, Angela. "Berlin, Akademie der Künste." *Pantheon* 42, no. 3 (1984), pp. 270–271. Rev. Whitney at Akademie der Künste.

Sicurd, Marie-Claude. "De Kooning," *Up*, June 1984, pp. 45–47, 66 (ill.).

Smith, Roberta. "De Kooning: The Light Fantastic." *Village Voice*, 10 January 1984, p. 77 (ill.). Rev. Whitney.

Spies, Werner. "Das inszenierte Zögern." *Frankfurter Allgemeine Zeitung*, 7 April 1984, p. 25. Reprinted in the author's *Rosarot vor Miami*. Munich: Prestel-Verlag, 1989. Rev. Whitney at Akademie der Künste.

Tillim, Sidney. "De Kooning." *Artforum* 22, no. 7 (March 1984), pp. 52–55. Rev. Whitney.

Tomkins, Calvin. "The Art World." *New Yorker*, 6 February 1984, pp. 74–80. Rev. Whitney.

Wolff, Theodore F. "The Brilliance, and the Wane of de Kooning's Artistic Genius." *Christian Science Monitor*, 4 January 1984. Rev. Whitney.

1985

"Album: Willem de Kooning." *Arts Magazine* 60, no. 2 (October 1985), pp. 134–135 (ill.). Illustrates works from Fourcade exhibition.

Castello, Michelangelo. "Il telaio Informale: Willem de Kooning." *Tema Celeste* 5 (March 1985), pp. 14–18 (ill.).

Codognato, Mario. "Willem de Kooning: Changing Moods and Lights." *Domus* 658 (February 1985), p. 75 (ill.).

Feaver, William. "Spotlight: de Kooning." *Vogue*, January 1985, pp. 84–88 (ill.).

Mathew, Ray. "Willem de Kooning's New Painting at Fourcade." *Art/World*, November 1985, pp. 1, 3 (ill.). Rev. Fourcade.

Mullaly, Terence. "Willem de Kooning." *Daily Telegraph* (London), 14 January 1985.

Packer, William. "Willem de Kooning, Anthony d'Offay Gallery: New York's Grand Old Man." *Financial Times* (London), 17 January 1985. Rev. 1984 d'Offay.

1986

Antal, István. "Vonallányok a tengerparton." *Müvészet* 27, nos. 11–12 (November–December 1986), pp. 68–70 (ill.). Rev. 1985 Fourcade.

McEwen, John. "King of the Canvas." *Sunday Times* (London), 7 June 1986, pp. 34–40 (ill.).

McGill, Douglas C. "Triptych is Focus of Church Debate." *New York Times*, 25 February 1986, p. C12 (ill.).

Poirier, Maurice. "Willem de Kooning: Xavier Fourcade." *ARTnews* 85, no. 1 (January 1986), p. 125 (ill.). Rev. 1985 Fourcade.

Schwabsky, Barry. "Willem de Kooning." *Arts Magazine* 60, no. 5 (January 1986), p. 127. Rev. 1985 Fourcade.

Stavitsky, Gail. "Willem de Kooning." *Arts Magazine* 60, no. 5 (January 1986), pp. 143–144 (ill.). Rev. 1985 Fourcade.

Storr, Robert. "De Kooning at Fourcade." *Art in America* 74, no. 2 (February 1986), p. 130 (ill.). Rev. 1985 Fourcade.

Yau, John. "New York: Willem de Kooning." *Artforum* 24, no. 6 (February 1986), p. 100 (ill.). Rev. 1985 Fourcade.

1987

Conal, Robbie. "Pick of the Week." *L.A. Weekly*, 16–22 January 1987, p. 22 (ill.). Rev. Margo Leavin.

Danto, Arthur C. "The Whitney Biennial, 1987." *Nation*, 16 May 1987. Reprinted in the author's *Encounters and Reflections*. New York: Farrar Straus Giroux, 1990. Rev. Whitney Biennial.

Rosand, David. "Editor's Statement: Style and the Aging Artist." *Art Journal* 46, no. 2 (Summer 1987), pp. 92–93 (ill.).

Schwabsky, Barry. "Diversion, Oblivion, and the Pursuit of New Objects: Reflections on Another Biennial." *Arts Magazine* 61, no. 10 (Summer 1987), p. 80. Rev. Whitney Biennial.

Sotheby's, New York. "Contemporary Art from the Estate of Xavier Fourcade." Sale cat., 4 November 1987, lot 22 (ill.).

Taylor, Sue. "Chicago: Willem de Kooning." *ARTnews* 86, no. 7 (September 1987), pp. 154–155 (ill.). Rev. Richard Gray.

Wilson, William. "The Art Galleries." *Los Angeles Times*, Calendar, 23 January 1987, p. 16 (ill.). Rev. Margo Leavin.

1989

Barnett, Catherine. "The Conundrum of Willem de Kooning." *Art and Antiques* 6, no. 9 (November 1989), cover and pp. 62–73, 128 (ill.).

"De Kooning's Daughter Petitions Court." *Art in America* 77, no. 7 (July 1989), p. 168.

Decker, Andrew. "Who Will Represent de Kooning?" *ARTnews* 88, no. 6 (Summer 1989), pp. 136–141 (ill.).

Johnson, Richard. "The Puzzle of Willem de Kooning." *New York Post*, 22 October 1989, p. 6.

Schaire, Jeffrey. "Alzheimer's Disease and Willem de Kooning." *Art and Antiques* 6, no. 9 (November 1989), p. 12.

Wick, Steve. "De Kooning: A Life Apart in His Art," *Los Angeles Times*, 25 May 1989, sec. 5, pp. 1, 9 (ill.). Also in *San Francisco Chronicle*, 30 May 1989, p. E3.

"Willem de Kooning, On His Eighty-Fifth Birthday." *Art Journal* 48, no. 3 (Fall 1989). Special issue on de Kooning edited by Bill Berkson and Rackstraw Downes. With essays by the editors and Rudy Burckhardt, Herman Cherry, Robert Creeley, Pat Passlof, Philip Pearlstein, Robert Rosenblum, Irving Sandler, Rose C. S. Slivka, Robert Storr, and others; and photographs and artists' statements.

1990

Baer, Martha. "Contemporary Art Sales." In *Christie's Review of the Season 1990*, pp. [140]–142 (ill.).

Brenson, Michael. "De Kooning: Masterworks from a Master Painter." *New York Times*, 7 September 1990, p. C24 (ill.). Rev. Salander-O'Reilly, New York.

Christie's, New York. "Contemporary Art." Sale cat., 7 May 1990, lot 44 (ill.).

"Galleries — Uptown." *New Yorker*, 8 October 1990. Rev. Salander-O'Reilly, New York.

"Goings on about Town." *New Yorker*, 24 September 1990. Rev. Salander-O'Reilly, New York.

Mahoney, Robert. *Arts Magazine* 65, no. 4 (December 1990), p. 103 (ill.). Rev. Salander-O'Reilly, New York.

Slivka, Rose C. S. "From the Studio." *East Hampton Star*, 25 January 1990, sec. 2. p. 9 (ill.).

————. "From the Studio." *East Hampton Star*, 22 February 1990, sec. 2, p. 7.

Tully, Judd. "The de Kooning Market: 'Tremendous Interest.'" *ARTnews* 89, no. 9 (November 1990), p. 41 (ill.).

Wallach, Amei. "Willem de Kooning, At Long Last." *Newsday*, 27 September 1990, pp. 3, 11. Rev. Salander-O'Reilly, New York.

Waterman, Daniel. "Willem de Kooning: Salander-O'Reilly," *ARTnews* 89, no. 9 (November 1990), pp. 159–160. Rev. Salander-O'Reilly, New York.

Wolff, Theodore F. "Modern Art's Father Figure." *Christian Science Monitor*, 5 October 1990, p. 12. Rev. Salander-O'Reilly, New York.

1991

Brach, Paul. "Auditioning for Posterity." *Art in America* 79, no. 1 (January 1991), pp. 110–113, 153 (ill.). Rev. Salander-O'Reilly, New York.

Collings, Matthew. "Senile Genius Puts Art World on the Spot." *Sunday Telegraph* (London), 29 December 1991, p. 11 (ill.).

Katz, Robert. "Not a Pretty Picture." *Esquire*, April 1991, pp. 108–118, 151 (ill.). Reprinted in Dutch edition, September 1991, pp. [54]–63 (ill.).

Zakian, Michael. "A Critic of Modernist Idealism." *Artweek*, 28 March 1991, p. 11. Rev. Salander-O'Reilly, Beverly Hills.

1993

"Art." *Philadelphia Inquirer*, 5 December 1993. Rev. Hirshhorn.

Davidson, Susan. "Hirshhorn Looks Back at de Kooning." *Washingtonian*, October 1993, p. 26 (ill.). Rev. Hirshhorn.

Gibson, Eric. "De Kooning Exhibit Offers Unexpected Insights." *Metropolitan Times* (Washington, D.C.), 8 November 1993, p. C17. Rev. Hirshhorn.

Kimmelman, Michael. "De Kooning, Dubuffet: The Late Works." *New York Times*, 1 October 1993 (ill.). Rev. Pace.

Sheffield, Margaret. "Landau's Gifts." *Town and Country*, July 1991, p. 96 (ill.).

Smith, Roberta. "'Work on Paper': Willem de Kooning." *New York Times*, 24 December 1993. Rev. Barbara Mathes.

Stein, Deidre. "Willem de Kooning: C&M," *ARTnews* 92, no. 6 (Summer 1993), p. 170. Rev. C&M.

Tully, Judd. "De Kooning at 90." *Art and Auction* 16, no. 4 (November 1993), cover and pp. 114–119, 162 (ill.).

Ullman, Joan. "De Kooning Studio Assistant Breaks Silence." *East Hampton Independent*, 1 September 1993, p. 45; 8 September 1993, pp. 17–18; 15 September 1993, pp. 18–19.

Vogel, Carol. "Inside Art: A de Kooning in the White House." *New York Times*, 22 October 1993 (ill.).

1994

"Abstract Opportunity Knocks." *Bridgewater* (New Jersey) *Courier-News*, 6 November 1994. Rev. National Gallery.

Anfam, David. "Washington and Barcelona: Willem de Kooning." *Burlington Magazine* 136 (April 1994), pp. 266–267 (ill.). Rev. Hirshhorn and Pace.

Baker, Kenneth. "De Kooning Blowout in Washington." *San Francisco Chronicle*, 7 May 1994, pp. E1, E3 (ill.). Rev. National Gallery.

——————. "SFMOMA Scoops Up Plenty of New Art." *San Francisco Chronicle*, 8 December 1994, pp. E1, E4 (ill.).

Bevan, Roger. "The de Kooning Form Book." *Art Newspaper* 5, no. 38 (May 1994) pp. 22, 24.

Boom, Henk. "Touwtrekken om de Kooning." *Algemeen Dagblad*, 22 February 1994, p. 11.

Braff, Phyllis. "A Hometown Tribute to de Kooning at 90." *New York Times,* 3 July 1994, Long Island edition, p. 13 (ill.). Rev. Guild Hall.

Cateforis, David. "Willem de Kooning." *Art Journal* 53, no. 4 (Winter 1994), pp. 86–89 (ill.). Rev. Hirshhorn and National Gallery.

Checkland, Sarah Jane. "Blank Expressions." *Times Magazine* (London), 9 April 1994, cover and pp. 8–11 (ill.).

Christie's, New York. "Contemporary Art." Sale cat., 3 May 1994, lot 66 (ill.)

Climent, Eliseu T. "El crepuscle dels tabús." *El Temps,* 8 March 1994. Rev. Hirshhorn at "la Caixa."

Cook, John. "A Willem de Kooning Triptych and St. Peter's Church." *Theological Education* 31, no. 1 (1994), pp. 59–73.

Cotter, Holland. "Art in Review." *New York Times*, 29 July 1994, p. C20. Rev. C&M.

——————. "Broad Pulse of de Kooning in Top Form." *New York Times*, 11 October 1994, pp. C15–16. Rev. National Gallery at Metropolitan.

Danto, Arthur C. "Art." *Nation*, 5 December 1994, pp. 700–704. Rev. National Gallery at Metropolitan.

Delattre, Pierre. "Willem de Kooning Painting." *The: Santa Fe's Monthly Magazine of the Arts* 3, no. 2 (August 1994), pp. 24–27 (ill.).

Dollar, Steve. "De Kooning's Signature Line Endures." *Atlanta Journal Constitution*, 7 August 1994, p. N4. Rev. National Gallery at Metropolitan.

Feaver, William. "The Incomparable de Kooning." *ARTnews* 93, no. 5 (May 1994), pp. 148–151 (ill.). Rev. National Gallery at Metropolitan.

Forman, Debbie. "De Kooning's Daring Journey into Artistic Chaos — and Back Again." *Cape Cod Times*, 24 December 1994, pp. C1, C6 (ill.). Rev. Hirshhorn at MFA Boston.

Fox, Catherine. "De Kooning at the High: His Is Legacy of Abstraction." *Atlanta Journal Constitution*, 25 September 1994, pp. N1, N3. Rev. Hirshhorn at High Museum.

Geracimos, Ann. "Standing in for a Famous Father." *Washington Times*, 9 May 1994, p. C12 (ill.).

Gibson, Eric. "Willem de Kooning at Ninety." *World and I* (Washington, D.C.), April 1994, pp. 138–143 (ill.). Rev. National Gallery.

Gopnik, Adam. "The Last Action Hero." *New Yorker*, 23 May, 1994, pp. 83–88 (ill.).

Gubernick, Lisa. "Artful Dealings." *Forbes*, 28 March 1994, p. 130.

Herrera, Hayden. "Willem de Kooning: A Space Odyssey." *Harper's Bazaar*, April 1994, pp. [190]–195, 230–231 (ill.).

Hughes, Robert. "Seeing the Face in the Fire." *Time*, 30 May 1994, pp. 62–64 (ill.). Reprinted in international edition under title "Eyeing the Glimpser," pp. 60–62 (ill.). Rev. National Gallery.

Katz, Vincent. "Willem and Elaine de Kooning: An Appreciation." *Print Collector's Newsletter* 25, no. 5 (November–December 1994), pp. 195–198.

Kaufman, Jason Edward. "The Museum of Modern Art, New York: What We Buy and How We Do It — Interview With Robert Storr." *Art Newspaper* 5, no. 36 (March 1994), pp. 20 – 21.

Kennelly, Eleanor. "De Kooning: Last of New York's Art Giants." *Washington Times*, 8 May 1994 (ill.). Rev. National Gallery.

Kimmelman, Michael. "America's Living Old Master." *New York Times*, 15 May 1994, p. 41 (ill.). Rev. National Gallery.

Knight, Christopher. "New World Ardor." *Los Angeles Times*, Calendar, 29 May 1994, pp. 3, 72. Rev. National Gallery.

Kohen, Helen. "1994 Art Season in New York is Filled with Promises Met." *Miami Herald*, 23 October 1994, pp. 11, 61. Rev. National Gallery at Metropolitan.

Kotz, Mary Lynn. "Art in the White House." *ARTnews* 93, no. 7 (September 1994), pp. 138 – 143 (ill.).

Kramer, Hilton. "The Ghost of Willem de Kooning." *Modern Painters* 7, no. 2 (Summer 1994), pp. 32 – 35 (ill.). Rev. National Gallery.

—————. "Puzzling de Kooning Show: A Must-See Despite Itself." *New York Observer*, 16 May 1984, pp. 1, 21. Rev. National Gallery.

—————. "Willem de Kooning at 90." *New Criterion* 12, no. 10 (June 1994), pp. 4 – 9. Rev. National Gallery.

Kuspit, Donald. "Body of Evidence: Old School Master." *Artforum* 33, no. 3 (November 1994), pp. 75 – 79, 113 (ill.).

Kutner, Janet. "Three Masters." *Dallas Morning News*, 6 November 1994. Rev. National Gallery at Metropolitan.

Larson, Kay. "Alzheimer's Expressionism: The Conundrum of de Kooning's Last Paintings." *Village Voice*, 31 May 1994, pp. 40 – 43 (ill.).

Lasker, Jonathan. "Willem de Kooning: Paintings for the Living." *Jong Holland* 10, no. 1 (1994), cover and pp. 4 – 5 (ill.).

Lipson, Karin. "Celebrating Layers of de Kooning's Life." *Newsday*, 8 July 1994. Rev. Guild Hall.

—————. "Complex Layers of de Kooning's Long Life." *Newsday*, 1 July 1994. Rev. Guild Hall.

Murdoch, Robert. "Art." *Europe* (Washington, D.C.), October 1994, pp. 45 – 46. Rev. National Gallery at Metropolitan.

"Els 90 anys de Kooning." *El Punt* (Barcelona), 13 – 19 February 1994, pp. 22, 29 (ill.). Rev. Hirshhorn at 'la Caixa.'

O'Donovan, Leo J. "Hallelujah Painting: Willem de Kooning." *America* (New York), 27 August 1994, pp. 19 – 20. Rev. National Gallery.

Pacheco, Patrick. "America's Dutch Master." *Art and Antiques* 17, no. 7 (September 1994), pp. 74 – 79 (ill.).

Perl, Jed. "Strokes of Genius." *Vogue*, May 1994, pp. 280 – 287, 327 – 328 (ill.). Rev. National Gallery.

Pincus, Robert L. "De Kooning Worthy of Grand Exhibit." *San Diego Union-Tribune*, 6 November 1994, pp. E1 – E3 (ill.). Rev. National Gallery at Metropolitan.

Plagens, Peter. "The Twilight of a God." *Newsweek*, 7 March 1994, pp. 64 – 66 (ill.). Reprinted in *Newsweek International Edition*, 14 March 1994, pp. 54 – 55 (ill.).

Polcari, Stephen. "Washington, National Gallery: Willem de Kooning." *Burlington Magazine* 136 (September 1994), pp. 642 – 644 (ill.). Rev. National Gallery.

Ratcliff, Carter. "Body of Evidence: New World Order." *Artforum* 33, no. 3 (November 1994), pp. 75 – 79, 113 (ill.). Rev. National Gallery.

Richard, Paul. "The Eye of the Storm." *Washington Post*, 8 May 1994, pp. G1, G6 – 7. Rev. National Gallery.

Santos Torroella, Rafael. "Willem de Kooning: en persona." *ABC de las artes*, 18 February 1994, pp. 30 – 32 (ill.). Rev. Hirshhorn at "la Caixa."

Schiff, Bennett. "For de Kooning, Painting Has Been 'A Way of Living.'" *Smithsonian*, April 1994, pp. 108 – 119 (ill.).

Schjeldahl, Peter. "Pulp of Joy." *Village Voice*, 1 November 1994, p. 68. Rev. National Gallery at Metropolitan.

Schlagheck, Irma. "Von ihm haben viele Gelernt." *Art-Das Kunstmagazin* 4 (April 1994), p. 14.

Seiffert, Leslie. "Unplotted, Perhaps, But with a Point." *Hackensack Record*, 30 December 1994, p. 9. Rev. National Gallery.

Serra, Catalina. "Barcelona acoge la única escala europea de la exposición de Willem de Kooning." *El País* (Barcelona), 18 February 1994, p. 34 (ill.). Rev. Hirshhorn at "la Caixa."

Sherer, Deborah. "Mito de Kooning." *Vogue Italia* 526 (June 1994), p. 24 (ill.).

Shuter, Marty. "Abstract Expressionism." *Savannah News/Press*, 9 October 1994, pp. 1F – 2F. Rev. Hirshhorn at High Museum.

Silver, Joanne. "A Journey in Paint." *Boston Herald*, 16 December 1994, p. 52 (ill.). Rev. Hirshhorn at MFA Boston.

Slivka, Rose C. S. "From the Studio." *East Hampton Star*, 7 July 1994, sec. 2, p. 7 (ill.); 14 July 1994. Rev. Guild Hall.

Smith, Roberta. "Long Island Shows Concentrate on Painting." *New York Times*, 8 July 1994, p. C25. Rev. Guild Hall

Solomon, Deborah. "Abstract Art's White House Debut." *New York Times*, Home section, 24 March 1994, pp. C1, C10 (ill.).

—————. "The Figure in the (Abstract) Canvas." *Wall Street Journal*, 6 May 1994. Rev. National Gallery.

Sotheby's, New York. "Contemporary Art, Part I." Sale cat., 4 May 1994, lot 46 (ill.).

Sozanski, Edward J. "De Kooning: The Best of a Long Career." *Philadelphia Inquirer*, 15 May 1994, pp. E1, E6.

——————. "Strokes of Genius." *Chicago Tribune*, 22 May 1994. Rev. National Gallery.

Spiegel, Olga. "Barcelona ocage la primera exposición en España de Willem de Kooning." *Vanguardia*, 18 February 1994, p. 57. Rev. Hirshhorn at "la Caixa."

Stevens, Mark. "De Kooning's Master Strokes." *Vanity Fair*, May 1994, pp. 143–148, 172, 175–179 (ill.).

——————. "The Master of Imperfection." *New Republic*, 4 July 1994, pp. 27–33. Rev. National Gallery.

Temin, Christine. "Rediscovering de Kooning." *Boston Globe*, 9 December 1994, pp. 49, 59. Rev. Hirshhorn at MFA Boston.

Tourigny, Maurice. "De Kooning." *Le Devoir* (Montreal), 5 November 1994, pp. C1–2. Rev. National Gallery at Metropolitan.

Tully, Judd. "Een hofhouding van curatoren." *Art and Value* 2, no. 1 (1994), pp. 54–61 (ill.).

——————. "Les Vieux artistes sont-ils bons à jeter?" *Beaux Arts* 123 (May 1994), pp. 97–104 (ill.). Rev. National Gallery.

Twardy, Chuck. "In the Mind's Eye." *News and Observer*, Arts and Entertainment section, 15 May 1994, pp. 1G, 3G (ill.). Rev. National Gallery.

Vogel, Carol. "Hope Springs Eternal at Contemporary Art Sales." *New York Times*, 5 May 1994, p. C22.

Wallace, Kent. "My Days with de Kooning." *Outlook*, June 1994, p. 23.

Wallach, Amei. "My Dinners with de Kooning," *Newsday*, Fanfare section, 24 April 1994, cover and pp. 8–9, 24 (ill.).

——————. "Romancing de Kooning's Early Work." *Newsday*, Fanfare section, 15 May 1994, p. 13. Rev. National Gallery.

Weil, Rex. "Willem de Kooning." *ARTnews* 93, no. 7 (September 1994), pp. 176, 178. Rev. National Gallery.

Weiss, Marion Wolberg. "Willem de Kooning at Guild Hall." *Dan's Papers* (Bridgehampton, New York), 1 July 1994 (ill.). Rev. Guild Hall.

Whitehouse, Beth. "Out East." *Newsday*, 28 June 1994, p. B3 (ill.).

"Willem de Kooning, figura clave del expresionismo abstracto." *Panorama: Fundación "la Caixa,"* February 1994, pp. 8–9 (ill.).

"Willem de Kooning: In His Dotage." *Economist*, 11 June 1994, p. 88. Rev. National Gallery.

Wolfe, Judith. "Van Wim tot Bill de Kooning: zeven decennia thematiek en vorm." *Jong Holland* 10, no. 1 (1994), cover and pp. 6–28 (ill.).

——————. "Willem de Kooning at 90: A Reprise of an Artist's Life." *East Hampton Star*, 21 April 1994, sec. 2, p. 20 (ill.).

Zilczer, Judith. "Willem de Kooning, obras de la colección del Hirshhorn Museum." *El Guía: arte del arco mediterráneo* 7, no. 2 (1994), pp. 16–23 (ill.). Also French edition. Rev. Hirshhorn at "la Caixa."

1995

"Artistic Style Defined." *New Hampshire Sunday News*, 8 January 1995 (ill.). Rev. Hirshorn at MFA Boston.

Auty, Giles. "Heightened Perception." *Spectator*, 25 February 1995. Rev. National Gallery at Tate.

Baker, Kenneth. "A Vision of Modern Art by Consensus." *San Francisco Chronicle*, 18 January 1995, pp. E1, E5 (ill.).

B[evan], R[oger]. "De Kooning and the Critics." *Art Newspaper* 6, no. 45 (February 1995), p. 14. Rev. National Gallery at Metropolitan.

Bonetti, David. "The New Deal." *San Francisco Examiner Magazine*, 15 January 1995, pp. 20–23, 30, 32–33 (ill.).

Brach, Paul. "De Kooning's Changes of Climate." *Art in America* 83, no. 1 (January 1995), pp. 70–77 (ill.). Rev. National Gallery.

"Carnivore of the Canvas." *Hampstead and Highgate Express*, 10 March 1995. Rev. National Gallery at Tate.

Colin, Barbara Flug. "Ways of Seeing de Kooning." *M/E/A/N/I/N/G* 17 (May 1995), pp. 27–29.

Cork, Richard. "Passions Brought to the Surface." *Times* (London), 21 February 1995, p. 37. Rev. National Gallery at Tate.

Dorment, Richard. "He Found Himself in a Tempest of Colour." *Daily Telegraph* (London), 15 February 1995. Rev. National Gallery at Tate.

Farson, Daniel. "Double Dutch." *Mail on Sunday* (London), 19 February 1995, p. 33. Rev. National Gallery at Tate.

Feaver, William. "Good-Time Viragos, Muses in High Heels." *Observer*, Review section, 19 February 1995, p. 8. Rev. National Gallery at Tate.

Haden-Guest, Anthony. "The Last Modernist." *Sunday Times Magazine* (London), 5 February 1995, pp. 23–37 (ill.).

Hall, James. "Sexual Enigmas." *Guardian* (London), 21 February 1995. Rev. National Gallery at Tate.

Hilton, Tim. "American Dreams." *Independent* (London), 5 February 1995, pp. 18–21 (ill.). Rev. National Gallery at Tate.

Jackson, Kevin. "A Bigger Splash." *Arena* (London), Spring 1995, pp. 22–28 (ill.). Rev. National Gallery at Tate.

Januszczak, Waldemar. "Game of Two Halves." *Sunday Times* (London), 26 February 1995, pp. 22–28 (ill.). Rev. National Gallery at Tate.

Kazanjian, Dodie. "Marks and Sparks." *Vogue*, February 1995, pp. 256–259, 296–297 (ill.).

Levy, Paul. "Mysteries from Cotan to de Kooning." *Wall Street Journal*, 18 March 1995, Europe edition. Rev. National Gallery at Tate.

Lucie-Smith, Edward. "Back to the Future." *Arts Review* (London), February 1995, pp. 29–31 (ill.). Rev. National Gallery at Tate.

Macmillan, Duncan. "Decoding de Kooning." *Scotsman*, 6 February 1995. Rev. National Gallery at Tate.

McEwen, John. "Oblivious to Greatness." *Sunday Telegraph* (London), 19 February 1995, p. 7. Rev. National Gallery at Tate.

Morley, Simon. "Willem de Kooning: Then and Now." *Art Monthly* 184 (March 1995), pp. 6–9 (ill.). Rev. National Gallery at Tate.

Packer, William. "A Talent Abused." *Financial Times* (London), 21 February 1995. Rev. National Gallery at Tate.

Sara, Mary. "Take Three Painters . . . and Down in One Day." *Yorkshire Post*, 20 March 1995. Rev. National Gallery at Tate.

Sewell, Brian. "Abstract Man, Action Woman." *Evening Standard* (London), 2 March 1995, pp. 30–31 (ill.). Rev. National Gallery at Tate.

Sherman, Mary. "MFA Show Brushes by Greatness of de Kooning." *Boston Herald*, 8 January 1995, pp. 49, 57. Rev. Hirshhorn at MFA Boston.

Sylvester, David. "When Body, Mind and Paint Dissolve." *Independent*, 15 February 1995 (ill.).

—————. "Letters: Putting the Record Straight on de Kooning." *Arts Review*, March 1995, p. 51.

Temko, Alan. "Art and Soul." *San Francisco Focus*, January 1995, pp. 42–50, 102–103 (ill.).

Whitfield, Sarah. "Smart Arts." *Harper's and Queen*, February 1995, p. 26 (ill.). Rev. National Gallery at Tate.

Whitford, Frank. "Coping with Canonization: Willem de Kooning's Struggle with Fame, Alcohol and Alzheimer's Disease." *Times Literary Supplement* (London), 10 March 1995. Rev. National Gallery at Tate and catalogue (*Willem de Kooning: Paintings*), Hirshhorn catalogue (*Willem de Kooning: From the Hirshhorn Museum Collection*), and *Elaine and Bill, Portrait of a Marriage: The Lives of Willem and Elaine de Kooning*, by Lee Hall.

FILMS AND VIDEOTAPES

De Kooning on de Kooning. New York: Direct Cinema, 1981. 58 min., sound and color. Produced by Courtney Sale and directed by Charlotte Zwerin. Reviewed by Suzaan Boettger, *San Francisco Chronicle*, 29 May 1982, p. 38 (ill.); Paul Richard, *Washington Post*, Style section, 3 March 1982, pp. D1, D3 (ill.).

Art Is a Way of Living: Willem de Kooning. Zurich: Erwin Leiser Filmproduktion, 1984. 30 min., sound and color. Produced and directed by Erwin Leiser.

The de Kooning Affair. London: BBC Television, 1991. 46 min., sound and color. Produced and directed for *The Late Show* by Anand Tucker. Revised version rebroadcast in 1995 as "Willem de Kooning: The Greatest Living Painter?"

Willem de Kooning: Artist. Los Angeles: Masters and Masterworks Productions, 1994. 32 min., color and sound. Produced and directed by Robert Snyder.

Elaine de Kooning Comments on Willem de Kooning's Retrospective at the Whitney. Produced and directed by Connie Fox, forthcoming.

ARCHIVAL SOURCES

Archives of American Art, Smithsonian Institution, Washington, D.C.

The Willem de Kooning Conservatorship office, New York

PRIZES AND AWARDS

Honorary Fellow of the Royal Academy of Visual Arts, The Hague, the Netherlands, 1982

Max Beckmann Prize, Frankfurt am Main, Germany, 1984

Kaiserring der Stadt Goslar, Germany, 1984

New York State Governor's Art Award, 1985

National Medal of Arts, Washington, D.C., 1986

Mayor's Liberty Medal, New York, 1986

Member of the Royal Academy of Fine Arts, Stockholm, 1986

Praemium Imperiale, The Japan Art Association, Tokyo, 1989

Distinguished Artist Award for Lifetime Achievement, College Art Association, New York, 1993

LENDERS TO THE EXHIBITION

THE CLEVELAND MUSEUM OF ART

M. ANTHONY FISHER

RONNIE AND SAMUEL HEYMAN, NEW YORK

HIRSHHORN MUSEUM AND SCULPTURE GARDEN, SMITHSONIAN INSTITUTION, WASHINGTON, D.C.

PHILIP JOHNSON

WILLEM DE KOONING

EMILY FISHER LANDAU, NEW YORK

MR. AND MRS. ROBERT LEHRMAN, WASHINGTON, D.C.

STEVE MARTIN

ROBERT MILLER GALLERY, NEW YORK

THE MUSEUM OF MODERN ART, NEW YORK

PAINEWEBBER GROUP INC., NEW YORK

MR. AND MRS. DAVID N. PINCUS

SAN FRANCISCO MUSEUM OF MODERN ART

SBC COMMUNICATIONS INC., SAN ANTONIO, TEXAS

STEDELIJK MUSEUM, AMSTERDAM

WALKER ART CENTER, MINNEAPOLIS

PRIVATE COLLECTIONS

142

SAN FRANCISCO MUSEUM OF MODERN ART

BOARD OF TRUSTEES, AS OF JUNE 15, 1995

CHAIRMAN
Elaine McKeon

PRESIDENT
Steven H. Oliver

SECRETARY/TREASURER
Elsa Spaulding

David A. Andrews
Gerson Bakar
Frances F. Bowes
John G. Bowes
Mrs. John R. Bradley*
Charles M. Collins
E. Morris Cox*
Shirley Ross Davis
Jean Douglas
William E. Downing
James G. Duff
Donald G. Fisher
Mrs. Milo S. Gates
Steven Grand-Jean
Susan Green
Max Gutierrez
Mimi L. Haas
Evelyn D. Haas*
Paul Hazen
Diane M. Heldfond
Luke Helms
Wellington S. Henderson, Jr.
Pamela Kramlich
Moses Lasky*
Gretchen Leach
W. Howard Lester
Byron R. Meyer
Eileen Michael
Stuart G. Moldaw
Robin Wright Moll
John A. Pritzker
Leanne Roberts
Arthur Rock

Agustin Rosas-Maxemin
Madeleine H. Russell
Albert R. Schreck
Toby Schreiber
Helen O'Neill Schwab
Kenneth F. Siebel, Jr.
Alan L. Stein
Dr. Norman C. Stone
Robert A. Swanson
Thomas B. Swift
Charlotte Mailliard Swig
Roselyne C. Swig
Mrs. Carter P. Thacher
Anne R. Thornton
Eugene E. Trefethen, Jr.*
Brooks Walker, Jr.
Mrs. Paul L. Wattis*
Judy Webb
Thomas W. Weisel
Patricia Wilson
Carolina Y.C. Woo
Mrs. Frank M. Woods

HONORARY TRUSTEES
Mrs. Wellington S. Henderson
Mrs. Sally Lilienthal
Mrs. Brooks Walker

EX-OFFICIO
Chotsie Blank
Barbara Herbert
Loretta Lowery
Jane Levy Reed
Carlene Reininga
Norah Stone
Tessa Wilcox

* Lifetime Trustee

WALKER ART CENTER

BOARD OF DIRECTORS, 1994–1995

CHAIRMAN
Lawrence Perlman

PRESIDENT
Ralph W. Burnet

VICE-PRESIDENTS
Andrew S. Duff
Martha Gabbert
Sarah Kling
Stephen E. Watson

SECRETARY
Kathy Halbreich

TREASURER
David M. Galligan

H. Brewster Atwater, Jr.
Steven L. Belton
Laura Chin
Arthur D. Collins, Jr.
Mrs. Julius E. Davis
Julia W. Dayton
M. Nazie Eftekhari
Jack Elliott
Jack W. Eugster
Esperanza Guerrero-Anderson
Roger L. Hale
Anita H. Kunin
Paul L. Landry
Sarah M. Lebedoff
Jeanne Levitt
André Lewis
Bruce A. Lilly

Nadine McGuire
Lucy Rogers
Harriet S. Spencer
John G. Taft
Philip Von Blon
Susan S. White
David M. Winton
Alice E. Wittenberg
C. Angus Wurtele

WALKER FAMILY MEMBERS
Katherine Walker Griffith
Ann Hatch
Wellington S. Henderson, Jr.
Mrs. Malcolm A. McCannel
Mrs. Michael Roeder
Adrian Walker
Brooks Walker, Jr.
Elaine B. Walker
John C. Walker
R. Walker Yeates

DIRECTOR EMERITUS
Martin Friedman

REPRODUCTION CREDITS

All works by Willem de Kooning © 1995 Willem de Kooning/Artists Rights Society, New York

Courtesy Acquavella Galleries, Inc., New York: 21 (bottom)

Courtesy The Cleveland Museum of Art: 106

Courtesy Jeffrey Deitch: 89

Courtesy Willem de Kooning Conservatorship office. Photo by Christopher Burke, Quesada/Burke, New York: cover, 8, 9, 13, 14, 25 (bottom), 26 (top right), 26 (center left), 26 (bottom right), 26 (bottom left), 27 (all), 30, 31, 32, 49, 88, 92, 94, 97, 100, 101, 103, 104, 104a (foldout), 107, 108, 109, 112, 113, 114, 115

Courtesy Willem de Kooning Conservatorship office. Photo by Paulus Leeser: 25 (top)

Courtesy Anthony d'Offay Gallery, London: 96, 98, 102, 110

Courtesy Anthony d'Offay Gallery, London. Photo by Prudence Cuming Associates Limited, London: 95

Courtesy Tom Ferrara: 28, 54, 55, 56

Courtesy Xavier Fourcade, Inc., New York: 87, 111

Courtesy Fuji Television Gallery, Tokyo: 69

Courtesy Hirshhorn Museum and Sculpture Garden, Smithsonian Institution, Washington, D.C. Photo by Lee Stalsworth: 22, 24, 29, 83

Courtesy Denise Lassaw: 44

Courtesy Mr. and Mrs. Robert Lehrman. Photo by Mark Gulezian: 81

Courtesy L.A. Films, Inc., Beverly Hills: 21 (top)

Courtesy L.A. Films, Inc., Beverly Hills. Photo © Douglas M. Parker Studio, Los Angeles: 90

Courtesy Matthew Marks Gallery, New York: 91

Photo © 1995 Succession H. Matisse, Paris/Artists Rights Society, New York: 70

Courtesy McKee Gallery. Photo by Otto E. Nelson, Fine Art Photography, New York: 61

Photos © Duane Michals, 1985; courtesy the artist: frontispiece

Courtesy Robert Miller Gallery, New York: 84

Courtesy Museum Ludwig, Cologne: 26 (top left)

Photo © 1995 The Museum of Modern Art, New York: 11, 38, 39, 40, 59, 60 (left and right), 62, 64 (left and right), 65 (left and right), 66 (left and right), 67 (left and right), 72, 75, 82, 105

Photo © 1995 The Museum of Modern Art, New York/Artists Rights Society, New York: 15

Courtesy National Museum of American Art, Smithsonian Institution, Washington, D.C.: 17 (bottom)

Courtesy PaineWebber Group, Inc., New York: 86

Courtesy private collection: 17 (top), 85, 99

Courtesy Stedelijk Museum, Amsterdam: 93

Courtesy Allan Stone Gallery, New York: 10, 20, 23 (right)

Courtesy Frederick Weisman Company, Los Angeles: 23 (left)

Luton Sixth Form College
Learning Resources Centre

WILLEM DE KOONING

THE LATE PAINTINGS, THE 1980s

EDITED BY JANET JENKINS WITH SIRI ENGBERG

PUBLICATION MANAGER: MICHELLE PIRANIO

DESIGNED BY LAURIE HAYCOCK MAKELA AND SANTIAGO PIEDRAFITA

TYPOGRAPHIC COMPOSITION BY ERIC MALENFANT

PRINTED IN THE UNITED STATES OF AMERICA BY WALLACE CARLSON COMPANY, MINNEAPOLIS

First Edition © 1995 San Francisco Museum of Modern Art and
Walker Art Center, Minneapolis

All rights reserved under International and Pan-American Copyright Conventions.
No part of this book may be reproduced or utilized in any form or by any means —
electronic or mechanical, including photocopying, recording, or by any informa-
tion storage-and-retrieval system — without permission in writing from the Walker
Art Center. Inquiries should be addressed to: Editor, Walker Art Center, Vineland
Place, Minneapolis, Minnesota 55403.

All works by Willem de Kooning © 1995 Willem de Kooning/Artists Rights Society,
New York.

Hardcover edition available through
 D.A.P./DISTRIBUTED ART PUBLISHERS, INC.
636 Broadway, 12th Floor, New York, New York 10012
Telephone: 212.473.5119 Fax: 212.673.2887

LIBRARY OF CONGRESS CATALOGING-IN-PUBLICATION DATA

De Kooning, Willem, 1904-
 Willem de Kooning : the late paintings, the 1980s. -- 1st ed.
 p. cm.
 Essays prepared by Gary Garrels and Robert Storr.
 San Francisco Museum of Modern Art, Oct. 3, 1995–
 Jan. 7, 1996;
Walker Art Center, Minneapolis, Feb. 3–May 8, 1996;
Städtisches Kunstmuseum, Bonn, Jun–Aug., 1996 and others.
 ISBN 0-935640-49-5 (hardcover)
 ISBN 0-935640-47-9 (paperback)
 1. De Kooning, Willem, 1904- --Exhibitions. I. Garrels, Gary.
II. Storr, Robert. III. San Francisco Museum of Modern Art.
IV. Title.
ND237.D334A4 1995
759.13 -- dc20 95-24574
 CIP

The paper in this book meets the guidelines for permanence and durability of the Committee
on Production Guidelines for Book Longevity of the Council on Library Resources. ∞